ALSO BY CULLEN MURPHY

Rubbish! The Archaeology of Garbage
(with William L. Rathje)

Just Curious: Essays

*The Word According to Eve: Women and the Bible
in Ancient Times and Our Own*

*Are We Rome? The Fall of an Empire and
the Fate of America*

*God's Jury: The Inquisition and
the Making of the Modern World*

CARTOON COUNTY

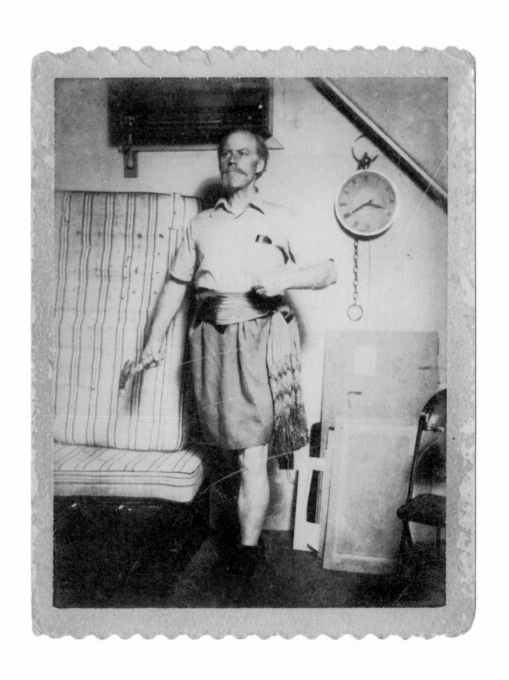

CARTOON COUNTY

MY FATHER AND HIS FRIENDS
IN THE GOLDEN AGE OF MAKE-BELIEVE

CULLEN MURPHY

FARRAR, STRAUS AND GIROUX NEW YORK

Farrar, Straus and Giroux
18 West 18th Street, New York 10011

Owing to limitations of space, illustration credits can be found on pages 259–60.

Library of Congress Cataloging-in-Publication Data
Names: Murphy, Cullen, author.
Title: Cartoon county : my father and his friends in the golden age of
 make-believe / Cullen Murphy.
Description: First edition. | New York : Farrar, Straus and Giroux, 2017. |
 Includes bibliographical references and index.
Identifiers: LCCN 2017001316 | ISBN 9780374298555 (hardcover) | ISBN
 9780374713041 (e-book)
Subjects: LCSH: Murphy, John Cullen. | Murphy, John Cullen—Friends and
 associates. | Cartoonists—United States—Biography. | Fairfield County
 (Conn.)—Biography.
Classification: LCC PN6727.M779 Z79 2017 | DDC 741.5/6973—dc23
LC record available at https://lccn.loc.gov/2017001316

Designed by Jonathan D. Lippincott

Our books may be purchased in bulk for promotional, educational, or
business use. Please contact your local bookseller or the Macmillan Corporate
and Premium Sales Department at 1-800-221-7945, extension 5442, or by
e-mail at MacmillanSpecialMarkets@macmillan.com.

www.fsgbooks.com
www.twitter.com/fsgbooks • www.facebook.com/fsgbooks

1 3 5 7 9 10 8 6 4 2

Frontispiece: The cartoonist and illustrator John Cullen Murphy
entering the court of King Arthur, circa A.D. 1970.

For my mother,
Joan Byrne Murphy,
and my brothers and sisters:
Cullene, Siobhan, Byrne, Finn,
Brendan, Cait, and Meg

The poetry of history lies in the quasi-miraculous fact that once, on this earth, once, on this familiar spot of ground, walked other men and women, as actual as we are today, thinking their own thoughts, swayed by their own passions, but now all gone, one generation vanishing into another, gone as utterly as we ourselves shall shortly be gone, like ghosts at cockcrow.

<div align="right">—G. M. Trevelyan</div>

CONTENTS

CARTOON COUNTY

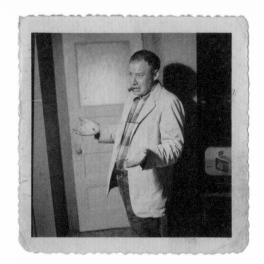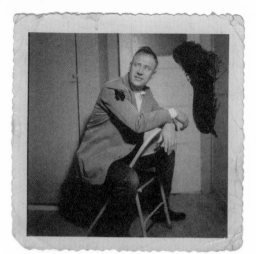
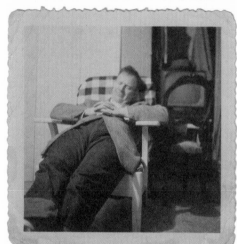
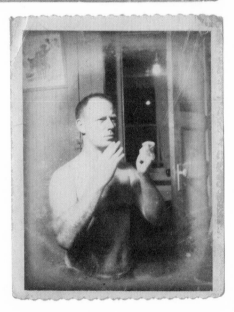

PROLOGUE

Click.

That was my after-school job—pressing down on the shutter release—from around the age of six until sometime in my teens. My father had bought a Polaroid camera in 1949, soon after the first one came on the market, the only instance in his life when he had been an early adopter (if you don't count Barry Goldwater). Every afternoon he took pictures of himself—maybe four or five, maybe a dozen or two. The camera, a portable Model 95, manufactured by a once-fabled company, was encased in molded leather veneer. Open the front panel and an accordion-like black bellows slid out on a track, the lens at the snout embedded in a proud silvery grille that might have graced a Bentley.

Before I was old enough to hold it steady or to sight through the viewfinder, the camera would be positioned on the shelf of a ladder. Or it would be placed on a table, raised to an appropriate angle and height by a variable foundation of tattered art books—an old Harper & Brothers edition of *Howard Pyle's Book of Pirates*; a scuffed, leather-bound *Divine Comedy*, illustrated by Gustave Doré; Arthur Rackham's *Aesop's Fables*; and George Bridgman's *Constructive Anatomy* or his *Book of a Hundred*

the fading squares with their deckled edges

Polaroid photographs of my father, John Cullen Murphy, posing for scenes he would draw in his first comic strip, *Big Ben Bolt*, mid-1950s.

Hands. My father would take his place in front of the camera and assemble himself into a pose.

Click.

Then he would pull out the exposed film from the end of the camera; wait thirty seconds for the picture to develop inside its sealed chemical packet; peel the finished photograph away from the moist, aromatic backing with a satisfying *pfffft*; and preserve the image with a swipe of chemical fixative. On the first try, something was usually not quite right with the picture. The rictus of terror was not horrifying enough, the laughter too demure, the pang of grief far below the level of heartrending pathos my father was seeking. He had acquired his mental map of emotional display from watching silent movies as a boy. These movies, with dialogue presented on title cards, had also made him a very good speller, though they don't explain why he had so many arcane words in his head, such as *monopsony* and *eleemosynary*. Visually, he always knew the effect he was looking for in the pictures I took, which was several degrees of enhancement beyond the truly authentic. Sometimes the critique of a photograph was technical or aesthetic. Too much light, or too little. Not sharp enough: I'd likely been wobbling with impatience on the ladder. The gun or the sword would look better in profile—didn't I think?—rather than frontally foreshortened. A lock of a woman's wig might have fallen into my father's eyes, obscuring the desired gleam of ecstasy or grimace of torment. Or the dress he was wearing was all wrong: see, there's nothing interesting about the way it drapes. Now, Bernini—*he* could do drapery!

So we would set up the scene again, and perhaps once more after that, until we got it right, and could then move on to the next pose and the next shot. Nothing at the time struck me as unusual about this way of spending an afternoon. My father, John Cullen Murphy, was a cartoonist, and producing comic strips was the family business of many of the people we knew in our corner of Connecticut. He took pictures of himself to assist in the composition of panel after panel of the dramatic strips he drew—initially *Big Ben Bolt*, about an Ivy League–

4

educated heavyweight prizefighter, and then *Prince Valiant*, about a dashing knight in the days of King Arthur, the strip to which he devoted most of his career. Other cartoonists and illustrators took pictures, too. I showed my father a photograph, years later, of Maxfield Parrish adopting a stylized pose for a camera, back around 1905, thinking the picture would bestow the benediction of precedent. He professed no surprise—this is what illustrators have always done, his look seemed to say; think of what Leonardo might have achieved if he'd come after Edwin Land!—and simply observed of Parrish, "But he's not wearing any clothes." Indeed, in the photograph he wasn't. My father always wore clothes, selected from a jumbled wardrobe of raiment and accessories assembled over the years in the studio behind our house. The collection included holsters and scabbards, bowler hats and Viking helmets, trench coats and feather boas, kimonos and kilts and skirts, smoking jackets and ladies' silk loungewear, a Japanese admiral's fore-and-aft bicorne, an Eisenhower jacket, a pair of cowboy chaps, the robes of a Franciscan monk with a knotted white cincture, a bayonet from the Franco-Prussian War, a bishop's crosier, a toy rifle, two African spears, a maroon fez, and many varieties of shoes and boots.

For some reason, my father saved all the Polaroid pictures of himself, even as my younger sisters and brothers took over the photography. The fading squares with their deckled edges were held together by rubber bands and bunched according to some impenetrable taxonomy of his own devising. They filled cardboard boxes that were stored carefully in cupboards and closets, as if one day it might actually make sense to go through them in search of "Jealous Lover at a Fateful Breakfast" or "Death Throes of a Boastful Hun" or "Drunken Friar Telling a Ribald Joke," rather than just snapping another picture. Snapping another picture is what we always did. The Jealous Lover and Boastful Hun and Drunken Friar, the jousting knight and triumphant boxer and countless other characters, gradually grew older in the photographs at exactly the pace my father did. In other ways the studio seemed outside of time. A mingled smell

of Winsor & Newton oil paint and Middleton's Cherry Blend pipe tobacco was an atmospheric constant. Diffuse light came from a large picture window that faced to the north, as windows in studios typically do. The original camera lasted forty years, and was replaced only when film became impossible to obtain even on what I imagine must have become a lucrative black market sustained in the end by my father alone. Near his drawing table in the studio a grainy black-and-white television, its rabbit ears bent and taped and augmented with wire clothes hangers, would generally be turned on—to a baseball game in the summer and to a classic old movie in the winter. So you knew just from the sounds, the way a naturalist might, that the seasons had changed.

Reality broke in on occasion. A plumber or postman would knock, and in breastplate or cloche hat my father would write a check or sign for a package. A news bulletin would portentously interrupt *Roman Holiday* or *Sands of Iwo Jima*: Marilyn Monroe was dead! The Russians had put missiles in Cuba! My mother might arrive to announce a trip to the emergency room, a routine occurrence in a family with eight children. One afternoon, in October 1960, I was standing on the ladder taking pictures when Pittsburgh's Bill Mazeroski hit his famous ninth-inning home run off Ralph Terry of the Yankees in Game 7 of the World Series, handing the championship to the Pirates. The ladder shook and my father lost his fez. We took the picture again.

On some days an assistant would arrive with sheets of the stiff white paperboard on which comic strips were drawn, the panels blocked out and the lettering penciled, ready to be inked. Other cartoonists would stop in—scores of them lived nearby. There would be talk of new strips starting up and old strips getting new artists. The conversation might turn to the merits and defects of various kinds of pen nibs. Or how to create shadow effects by means of masking tape and toothbrush spatter. Or when the art supply shop was expecting a new shipment of sable brushes. Or what *The New Yorker* and *Esquire* and *The Saturday*

Evening Post were buying these days. Or who else had decided to move out from the city.

And then they would be gone and it was back to business: a couple more pictures left to take. I was drawn powerfully to this world of my father's, yet remember knowing even then that its days were numbered and that before long it would disappear. I wished there was some way to hold on to it forever, not then understanding that in fact there was.

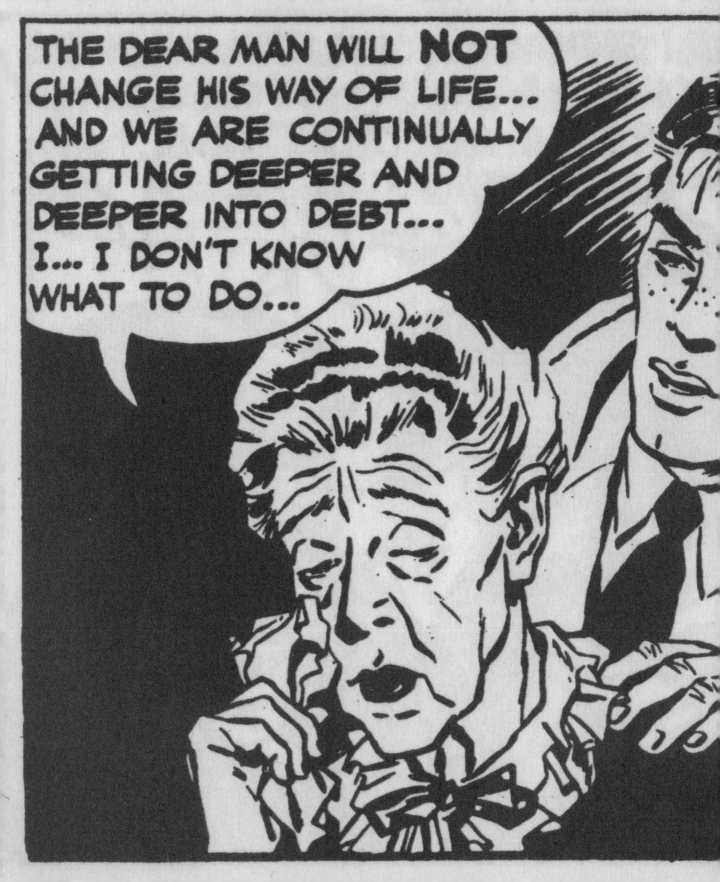

THE CONNECTICUT SCHOOL

JOHN CULLEN MURPHY

My father's drawing board, tilted to its customary steep diagonal, stands across the room from where I write. Above it hang some of his paintings, sketches, and comic strips, along with work by other cartoonists and illustrators who were among his friends. The surface of the drawing board is five feet long and four feet high, and a polished declivity on the cross brace marks where my father rested his right foot as he sat and drew. Every square inch of the oaken face is covered with flicks and curls of paint or ink, creating an inadvertent pattern as intricate as a Pollock. That surface was the accumulated product of almost sixty years, from the late 1940s until my father's death, in 2004.

If you had a sort of cinematic omniscience, you could connect each daub of ink and stroke of color to a moment of life in another world. I grew up in an unusual environment—not only as the child of a cartoonist and illustrator, but connected to a network of families where everyone's father was a cartoonist or illustrator. In time, some among the younger generation would be drawn into the business themselves, as I was, collaborating with my father on *Prince Valiant* for many years. The place was Fairfield County, Connecticut. In the high summer of the American Century, during the 1950s and '60s, it was where a populous

a moment of life in another world

Preceding pages: A panel from the inaugural year of *Big Ben Bolt*, 1951. Opposite: Watercolor sketch for an unpublished *Prince Valiant* story, 1991.

concentration of the country's comic strip artists, gag cartoonists, and magazine illustrators chose to make their home. The group must have numbered a hundred or more, and it constituted a tightly knit subculture.[1] Its members sometimes referred to themselves as the Connecticut School, with the good-natured self-mockery that betrays an element of seriousness. In the conventional telling, the milieu of Wilton and Westport, Greenwich and Darien, was the natural habitat of the suburban salarymen who made the trip every day to jobs on Wall Street or Madison Avenue. Westport was the setting of *The Man in the Gray Flannel Suit*. I was well aware of the men (and it was almost all men) lining the platform every morning at the century-old train station in my hometown of Cos Cob. But for me, those executives with their briefcases—a majority of the county's white-collar workforce—seemed like outlandish outliers. They weren't living the way normal people lived.

To my seven siblings and me, and others we knew, "normal" was something else entirely. Normal was coming home from school and finding a father who had done nothing but draw pictures all day while watching *Million Dollar Movie* on TV. He might not have changed his rumpled clothes since throwing something on after rolling out of bed—and, yes, that could be a piece of rope holding up his trousers. He may have played a round of golf or enjoyed a long lunch with some of his other artist friends, so when you visited his studio after school you would perhaps have to rouse him from a nap. Or, in the absence of children to do the job for him, he might be posing in front of the Polaroid, pneumatic plunger in hand, to snap a picture of himself from a distance.

Normal meant appreciating the difference between "plate" and "vellum" finishes on three-ply bristol board—the one smooth as glass, ideal for pen and ink; the other slightly textured, better suited for charcoal or crayon. Normal meant understanding that a Hunt No. 102 pen nib was good for ordinary lines but that a Gillott No. 170 was best for lettering. It meant thinking of "bigfoot" as primarily an aesthetic category—designating humorous cartoons rather than adventure strips—

and not a biological one. It meant being familiar with the terminology invented by Mort Walker, creator of *Beetle Bailey* and *Hi and Lois*—knowing, for instance, that the cartoon starbursts that convey intoxication are called "squeans" and the wavy lines that convey aroma are called "wafterons."

Normal was listening to conversations like this one at a local restaurant, between Curt Swan, who drew the *Superman* comic book, and Jerry Dumas, who with Mort Walker produced *Sam's Strip* and *Sam and Silo*:

DUMAS: Why does Superman have a cape?

SWAN: I don't know, Jerry.

DUMAS: Why does Superman's cape swirl around him even when he's standing in an office?

SWAN: I really don't know, Jerry.

DUMAS: When Superman undresses in a phone booth, how does he know his clothes will still be there when he gets back?

SWAN: I haven't the faintest idea, Jerry.

DUMAS: Can Superman fly when he's wearing his business suit on the outside, with the costume underneath?

SWAN: Pauline! Could you put a little brandy in this coffee?

•

At some point in the mid-1970s, Mort Walker and Jerry Dumas drew an aerial map of Fairfield County and wrote in the names of some of the cartoonists who lived there, quickly running out of room. Westport had a large cluster: Bud Sagendorf (*Popeye*), Leonard Starr (*On Stage* and *Little Orphan Annie*), Dick Wingert (*Hubert*), Stan Drake (*The Heart of Juliet Jones* and *Blondie*), Jack Tippit (*Amy*), John Prentice (*Rip Kirby*), and Mel Casson (*Mixed Singles* and *Boomer*). The great illustrator Bernie Fuchs was in Westport, too; imagine, my father would say, if Degas had worked for McCann Erickson and *Sports Illustrated*. Fuchs's career was all the more remarkable because an accident at an early age had cost

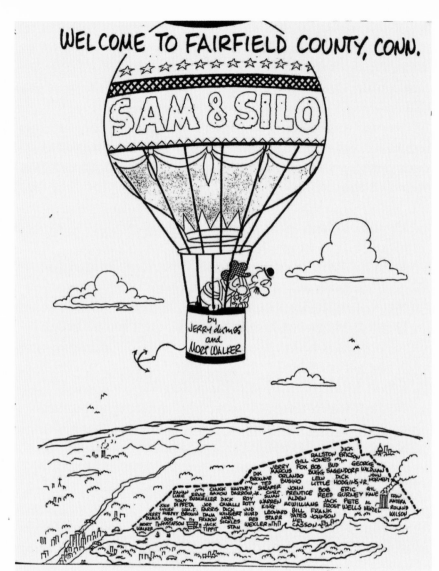

drew an aerial map of Fairfield County and wrote in the names

Pen-and-ink sketch by Mort Walker and Jerry Dumas, the team behind *Sam and Silo*. The eponymous characters float above a landscape of cartoonists.

him three fingers on his drawing hand. Dick Hodgins Jr. (*Henry*), Dik Browne (*Hi and Lois* and *Hägar the Horrible*), and Whitney Darrow Jr. (a *New Yorker* maintstay) lived in Wilton. Stamford was home to Ernie Bushmiller, the son of a vaudevillian, who drew *Nancy*, a strip so spare and elemental ("Dumb it down," Bushmiller would advise) that academic theorists can't let it alone. Online you can find a cache of correspondence between Bush-

miller and Samuel Beckett—it's a parody, but so true to life that it has entered reality through the back door.[2] Noel Sickles (*Scorchy Smith*, but also drawings and paintings that seemed to turn up everywhere) lived in New Canaan. So did Chuck Saxon, the John Cheever of gag cartoonists. Over a lifetime, Saxon's evocations of self-satisfied but oblivious suburban grandees yielded 92 covers and 725 cartoons for *The New Yorker*. Up in the Ridgefield area were the gag cartoonists Orlando Busino, Joe Farris, and Jerry Marcus. Frank Johnson (*Boner's Ark* and *Bringing Up Father*) was in Fairfield. Jim Flora, another illustrator, lived in an enclave tethered to coastal Rowayton. His edgy, angular confections— think of the album covers for any jazz artist in the 1950s and early '60s—epitomized the era's graphic sensibility of high-end hip. Also in Rowayton was Crockett Johnson (the comic strip *Barnaby* and the classic children's book *Harold and the Purple Crayon*). Greenwich was home to Mort Walker and Jerry Dumas, and also to Tony DiPreta (*Joe Palooka*), the political cartoonists Ranan Lurie and John Fischetti, and my father (*Big Ben Bolt* and *Prince Valiant*). An adjoining parcel of New York served as an exurban annex, with Johnny Hart (*B.C.*), Jack Davis (*Mad* magazine), Dave Breger (*Mister Breger*), Ted Shearer (*Quincy*), and Milton Caniff (*Steve Canyon* and *Terry and the Pirates*). This is just a sampling, and leaves out scores.

The surge into Fairfield County was mainly a product of the postwar years, and it had been driven by the age-old forces of money and geography. First, the artists and cartoonists needed to be close to New York City. That's where the magazines and book publishers and comic strip syndicates were mainly based, and in an age before scanners or fax machines, physical proximity was essential. The gag cartoonists had to make weekly rounds in midtown Manhattan, going door-to-door to sell their work—this at a time when dozens of national magazines still ran cartoons. As for the comic strip artists, they were always running behind and often needed to deliver finished work in person. A cartoonist boarding the train in Westport during the late-morning, off-peak lull, a thin rectangular parcel wrapped in brown paper under his arm,

would not have been surprised to meet someone he knew carrying a similar parcel boarding the train a few stops later, in Riverside or Greenwich. To anyone watching, the encounter might have seemed like a scene from John le Carré.

There are many ways of being close to Manhattan. You can actually live there, as some cartoonists continued to do, or you can live in the suburbs of New York, New Jersey, or Connecticut. This is where money came into play. Alone among the three states, Connecticut at the time had no income tax. Get yourself east of the state line and you would enjoy a tax holiday, with New York City only forty-five minutes away. Greenwich was the closest town in Connecticut to Manhattan; then came Stamford, Darien, and New Canaan. All were in the rectangular panhandle that Connecticut had somehow managed to keep away from grasping New York during the ferocious colonial disputes of the late seventeenth century—to the ultimate advantage of cartoonists and illustrators.

There was a third factor: Even before World War II, a few pioneers had begun to form a nucleus. In the first decades of the twentieth century, as comic strips and magazine illustration became big business, artists began migrating out of Manhattan to the comparatively rustic precincts of Westchester County, just north of the city. Hard as it is to believe for anyone who has seen its struggling downtown today, in the 1920s and '30s the town of New Rochelle was what Greenwich would become. The cartoonist Fontaine Fox, who drew *Toonerville Trolley*, lived in New Rochelle, as did Frederick Burr Opper, who drew *Happy Hooligan*, and Paul Terry, who established his Terrytoons animation studio there. Also living in New Rochelle were J. C. Leyendecker, best known for the painterly Arrow Collar Man, and Norman Rockwell, a household name even then. My father had the luck to grow up two doors down from Rockwell, model for him as a boy, and train with him as a journeyman illustrator. I have a pencil drawing that Rockwell once made to suggest the composition for a painting my father had in mind. When Leyendecker died, his longtime romantic partner, Charles Beach, and his sister, Mary Augusta, auctioned off the contents of his

a pencil drawing that Rockwell once made

Opposite, top: Outline by Norman Rockwell to suggest an arrangement of figures, 1937. Opposite, bottom: The painting by my father that followed, inspired by Ernest Hemingway's short story "The Killers."

16

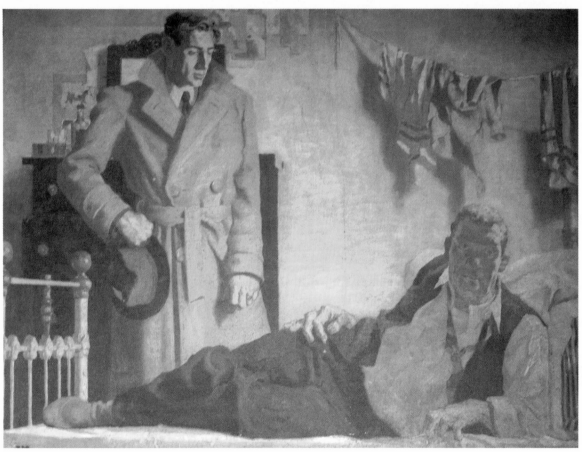

studio from the front lawn of the Leyendecker home. For a few dollars apiece my father picked up sheaves of oil sketches—small oddments of canvas on which Leyendecker had experimented with color and form before making a finished painting. A few pink noses and ears. A muddy work boot. A shirt cuff. A choirboy. A propaganda poster. Disembodied hands making stylized gestures—devoid of context, but so expressive in themselves that they seemed to say "Shall we dance?" or "After you!"

That was in 1951, and the drift of illustrators and cartoonists away from Manhattan and Westchester toward the promised land of Connecticut was already under way. The Famous Artists

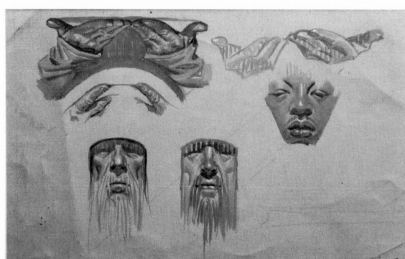

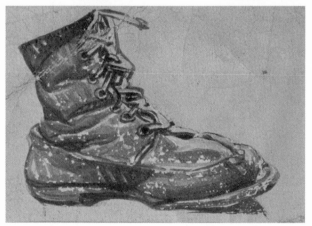

School, which offered correspondence courses for aspiring illustrators and cartoonists, had been spun off from the Society of Illustrators and had established itself in Westport, under Albert Dorne. A dozen well-known commercial artists were on its faculty. Families were growing, and property in Connecticut was cheap. The contemporary image of Fairfield County and nearby areas is hard to escape, but the region was a very different place before the era of arbitrage and hedge funds. To be sure, there were old estates along the waterfront and in the backcountry—onetime summer homes for wealthy New Yorkers—and artists and writers had been putting down roots in this hinterland for decades, drawn by the wooded hills and shaded dells that could make a nearby neighbor seem far away. In the late nineteenth century, impressionists like John Henry Twachtman and J. Alden Weir established what Childe Hassam called the Cos Cob School of painting. By the middle of the twentieth century, Arthur Miller was living in Roxbury. Shirley Jackson was in Westport, Maurice Sendak in Ridgefield, James Thurber in West Cornwall. But there were still working farms all over southwestern Connecticut, and towns like Greenwich and Stamford, Norwalk and Darien, had a big middle class of plumbers and teachers who could afford to buy houses near where they worked and had a firm hold on the levers of local power. Greenwich Avenue, now lined with Ralph Lauren and Gucci, back then more closely resembled a prosperous main street in Ohio or Michigan. Cartoonists and illustrators didn't earn fortunes, and didn't need to. For our Addams Family–style house in Cos Cob, purchased in 1953, my parents paid $22,500. It came with a cavernous barn that still smelled of horses. My father's weekly checks from King Features Syndicate would be left on the dining room table for my mother to deposit, so I know that his comic strip income in 1960 was about $25,000. This was for the boxing strip *Big Ben Bolt*, which appeared in three hundred newspapers—about average at the time—and was written by Elliot Caplin (who also wrote *The Heart of Juliet Jones*), the brother of the irascible Al Capp (who wrote and drew *Li'l Abner*). Only a very few strips, such as *Blondie*, *Beetle Bailey*, and *Peanuts*, ever hit the thousand-newspaper mark.

auctioned off the contents of his studio

Color studies by J. C. Leyendecker, oil on canvas, from among the many bought by my father at the yard sale after the illustrator's death.

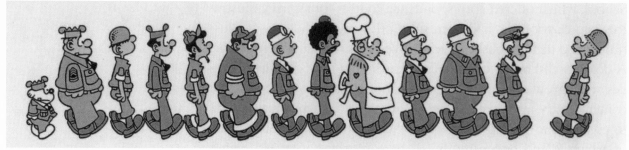

By the time I was old enough for childhood memories, Fair-
field County was fully stocked with cartoonists and illustrators.
What I know about the origins of the Connecticut School would
come gradually in the form of backfill. Most of the cartoonists
were military veterans, and many, like Dick Wingert, Bill Mauldin,
Gill Fox, and Bil Keane, had worked during the war for the mili-
tary newspapers *Yank* and *The Stars and Stripes.* Mort Walker had
gone to college after World War II, then came east from Mis-
souri and somehow landed a job at Dell as the editor of *1000 Jokes*
magazine, which paid the bills while he tried to sell gag cartoons
to the weeklies and monthlies. His boss at Dell was Chuck Saxon,
who was doing the exact same thing.[3] Dik Browne, after a year
studying art at Cooper Union, had gone to work for the *New York
Journal-American* as a copyboy. He remembered walking into the
newsroom for the first time, looking for a job. Bleary reporters
pecked at ancient Underwoods. Editors hurled obscenities. Smoke
rose in wafterons. The city editor took a cigar from his mouth and
appraised the gawky kid in front of him. "What do you want?" he
asked. Browne, taking in the surroundings, said, "I want it all."[4]
When Browne's talents as an artist became apparent, the *Journal-
American* sent him to do courtroom sketches. He covered the
Lucky Luciano trial, among others.[5] After serving in the war as
a cartoonist and mapmaker, Browne wound up at Johnstone and
Cushing, an advertising agency that specialized in cartoon-style
ad campaigns—the kind now enjoying a retro second life—and
became a hothouse for aspiring gag and comic strip cartoonists.
Milton Caniff worked there early in his career. So did Leonard
Starr, Stan Drake, and the comic book master Neal Adams. An-

other type of hothouse was the production departments—the "bullpens"—at the big newspapers like the *New York Journal-American* and the *Chicago Tribune*, and at the newspaper syndicates, such as King Features and the Newspaper Enterprise Association.

Even after launching a strip, many cartoonists continued to write gags for magazines. For some, that was an entire career. In the middle of every week the gag cartoonists would take an early train into Manhattan for "look day"—Tuesday for a favored few at *The New Yorker*, which wanted a first lick of the cream (and which paid per square inch of published work), and Wednesday for everyone else. Wednesday was also look day at *The Saturday Evening Post*, *Esquire*, *Sports Illustrated*, *Playboy*, *Argosy*, *Collier's*, *True*, and many other magazines, visited in descending order of largesse.[6] Cartoon editors would flip through portfolios of penciled roughs, maybe selecting one or two to think about. *The New Yorker*'s James Stevenson remembered that, besides what the cartoonists brought in, some two thousand unsolicited ideas for cartoons would arrive every week at the magazine, "mostly from doctors and people in prison."[7] These letters and drawings filled boxes that lined a hallway. After their morning rounds, the cartoonists

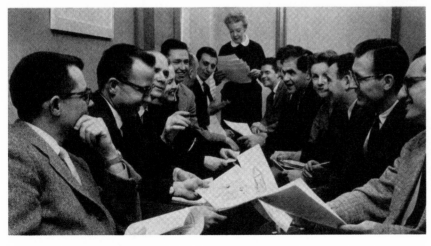

would meet for lunch at the Palm or the Blue Ribbon or the Pen & Pencil, continue their visitations in the afternoon, then meet for drinks at Costello's on Third Avenue, the bar where Ernest Hemingway, in a display of manhood, once broke John O'Hara's blackthorn stick over his own head.[8]

Some events cast a long shadow. Though I was only four when it happened, the death of Alex Raymond in an automobile accident, in September 1956, would always loom as an epochal moment—for cartoonists, perhaps the equivalent of the Buddy Holly plane crash.[9] Raymond was an acknowledged master—the artist behind *Flash Gordon*, *Jungle Jim*, *Rip Kirby*, and *Secret Agent X-9*, the last of these written for a time by Dashiell Hammett. Raymond's younger brother, Jim, was a prominent figure in the business, too—he had taken over *Blondie* from Chic Young. With his thin mustache and brushed-back hair, Raymond had the dashing appearance of a 1930s aviator—a young Howard Hughes. (The actor Matt Dillon comes from the same family; Alex was his great-uncle.) Raymond's work for *Flash Gordon* in particular was kinetic and rich, and matched by fast-moving plots in which Flash and his friends Dale Arden and Dr. Zarkov battle Ming the Merciless on the planet Mongo.

Stan Drake, who was with Raymond in the car, would sometimes talk about the accident, and I heard his account myself on one occasion. It has also been written about. Raymond and Drake hadn't known each other well, but Raymond had taken to stopping by Drake's Westport studio, in part to see how Drake was using Polaroids to help create realistic poses and nuanced expressions. The tech-

had the dashing appearance of a 1930s aviator

Below: Alex Raymond at the drawing board in his Stamford studio, 1946. Opposite: Milton Caniff working with models in the 1940s. The Dragon Lady (bottom) was a central character in *Terry and the Pirates*.

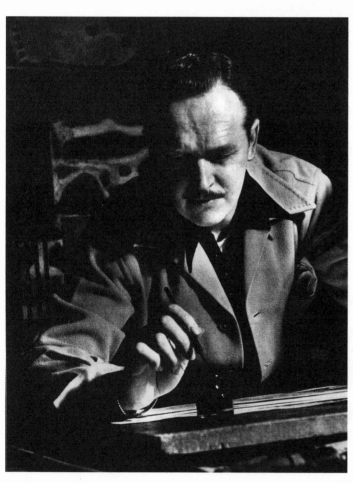

nique was new to Raymond. Like Milton Caniff and others, he had sometimes hired live models, but usually relied on a blend of art school training and pure instinct born of long experience—he had probably drawn a human figure in published comic strips seventy-five thousand times by then. Drake had just bought a white Corvette convertible, and Raymond, who owned a Bandini and a gullwing Mercedes, and raced cars for a hobby, one day asked if he could take the Corvette for a drive. He was at the wheel on a narrow road in Westport, top down, driving about twice the speed limit, but still going only about forty. Drake was in the passenger seat. A light, misting rain had begun to fall, but Raymond didn't want to put up the top. They came to a stop sign at the crest of a hill. As Drake would recount the story, Raymond suddenly said, "Oh!"—that was all—and the car shot forward and hung for a moment in the air. Drake remembered a pencil that had been on the dashboard seeming to float before his eyes. The car went off the road and smashed into a tree, killing Raymond instantly. No one knows exactly what caused the accident. Raymond was known to be reckless. Most likely his foot just slipped on a wet pedal and he hit the accelerator instead of the brake.

Jerry Dumas remembered Drake at a meeting of the National Cartoonists Society, weeks after the accident occurred, describing the terrible events moment by moment. The meeting was held at the Society of Illustrators, on East Sixty-third Street, and the upstairs room was packed. Chiseled portraits by Dean Cornwell and James Montgomery Flagg stared down from the walls. Drake had been thrown thirty-five feet from the car. His shoulder was broken. Portions of his ears had been torn and

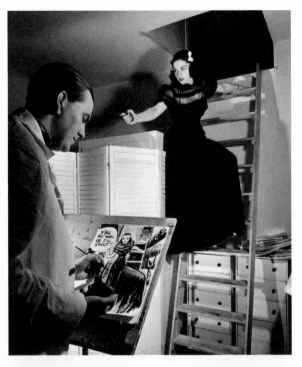

mended. When he spoke to his fellow cartoonists, he was still in bandages and wearing a sling. The accident replayed in Drake's head throughout his life. Five years afterward, he went back to the scene. Bits of metal and plastic were still embedded in the tree.

•

Children arrive in a world already made. Their slates are blank, but all the slates around have long been written on. It was simply a given that both of my parents were selfless and energetic. That they could laugh at themselves and crack a joke. That they were politically conservative and believed in God. That my mother was outgoing, disciplined, and persuasive. That my father was a soft touch, and patient beyond reason. That his mind was an overstuffed attic whose door was ajar. That he could draw and paint. That even simple directions on a scrap of paper would be embellished with drawings of houses and trees, cars and cows.

My father grew up in Chicago but was born in New York City. As if called by instinct to some distant spawning ground, his mother insisted on boarding the 20th Century Limited and returning to her native Manhattan whenever the time drew near for the birth of a child. He began drawing at a very early age—and also began carefully saving his work, as if for posterity, starting when he was about five. Given posterity's likely interest, he also began saving his tests and papers from school. My father signed his work carefully, first as "Jack," the name he was always known by, and sometimes as "J. C.," and only much later with the full "John Cullen Murphy." An artist of some kind is all he ever wanted to be if he couldn't be a baseball player, which he accepted early on he could never become. Once, late in his life, when asked by a fan to answer twenty questions about himself, he filled in the blank after a question about what had inspired him to do what he did with the simple response "Liking it." His family had an independent streak and a taste for the mildly unconventional, and encouraged him in his ambitions. His own father had been by turns a book publisher, a book salesman, and a literary agent whose most prominent client was the novelist and

carefully saving his work, as if for posterity

Counterclockwise from top left: "The Four Musketeers," by a six-year-old John Cullen Murphy, and a selection of other childhood preoccupations, rendered at ages six, seven, and ten.

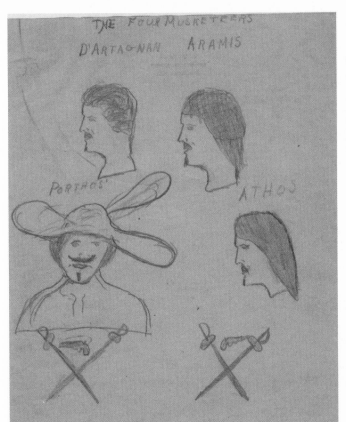

THE FOUR MUSKETEERS

D'ARTAGNAN ARAMIS

PORTHOS ATHOS

1926

J.C. MURPHY

J.C. MURPHY

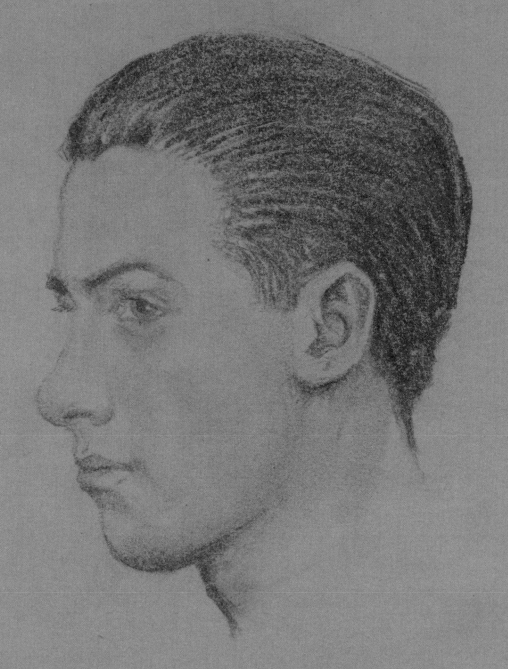

BOB
'37
FROM LIFE

poet Christopher Morley. His mother's family included artisans and craftsmen of various kinds. One of them was a coppersmith who produced elegant housewares and small sculptures in the mission style. My father enrolled in drawing classes at the Art Institute of Chicago when he was seven. A few years later, after the family moved back east, he attended the Phoenix Art Institute and the Art Students League, in New York.

One unexpected stroke of luck was that his neighbor in New Rochelle was Norman Rockwell, whose studio on Lord Kitchener Road was about a hundred feet from my father's back door. Rockwell had seen my father, then fourteen, with his unruly and very red hair, playing baseball at a field nearby—he looked like what we have come to think of as a Norman Rockwell character. Rockwell stopped by my father's house one afternoon to ask his mother if young Jack could pose for some illustrations. In the ensuing years my father found himself appearing in Rockwell paintings. At age fifteen he posed as David Copperfield for Rockwell's mural *The Land of Enchantment*, which is in the New Rochelle Public Library. As a cross-legged teenager he was on the cover of *The Saturday Evening Post* in September 1934, gazing at photographs of glamorous female movie stars. *Starstruck* is the title of the painting. A baseball glove sits by my father's side, and a dog nuzzles at his knee. Rockwell once explained that, to make a posing dog or cat behave, you need only "apply a slight degree of pressure to the base of the cranium where it joins the spine."[10] In this instance, my father remembered, Rockwell also needed to add a sedative to the dog's water.

Rockwell was an important figure in my father's life. He would assign my father short stories to illustrate, then critique the work and send him back to try again. He also taught him how to paint in oils. The sketch of Rockwell's that I have was for an oil painting by my father of Hemingway's story "The Killers." Eventually Rockwell arranged a scholarship for my father at the Art Students League, where one of his teachers was Franklin Booth, whose meticulous pen-and-ink magazine drawings were a mainstay of *Harper's* and *Scribner's*. Another teacher, even more

all he ever wanted to be

By age eighteen, caricatures and pencil portraits had become a staple. Opposite: My father's sketch of his older brother, Bob.

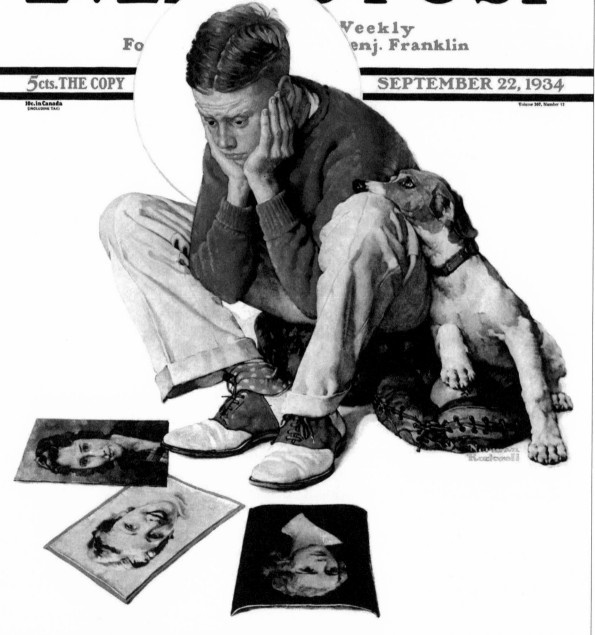

THE SATURDAY EVENING POST

Founded A.D. 1728 by Benj. Franklin

Weekly

5cts. THE COPY

10c. in Canada
(INCLUDING TAX)

SEPTEMBER 22, 1934

Volume 207, Number 12

influential, was George Bridgman, who had been Rockwell's anatomy instructor and ran a life-drawing class that Rockwell insisted my father attend. Bridgman had studied with Jean-Léon Gérôme in Paris in the 1880s. Gérôme had been trained by Paul Delaroche, who had been trained by Antoine-Jean Baron Gros, who had been trained by Jacques-Louis David, who had been trained by François Boucher, who had been trained by François Le Moyne—if you had time, my father could likely have pushed the laying on of hands back even further, through Raphael and Fra Angelico to some muralist at Pompeii. This sort of classical training was standard at the time—the cartoonist Chon Day had studied with Bridgman, as had Stan Drake, Bob Lubbers, Will Eisner, and a host of other cartoonists. So had Mark Rothko. The anatomical studies that resulted, done in chalk or charcoal, resembled exercises that might as easily have been done in 1550 or 1870 as in 1936. Bridgman entered the class promptly with an aroma of cigars, alcohol, and authority. When one student, who later became the director of the Whitney, resisted Bridgman's criticism of his work, saying, "I don't see it that way," Bridgman replied, "Consult an oculist."[11] I was always struck by how many cartoonists had built their careers on a traditional foundation, and how easily some of them could shift from comic mode to a quick pencil rendering of a nude or a tree that would have seemed at home in the Frick.

By the age of seventeen my father had sold his first painting—of a horse race—to the Manhattan restaurateur Toots Shor and was drawing program covers for sporting events at Madison Square Garden, mainly boxing matches. In high school, he also developed his talent as a caricaturist; historically, high school has been an environment where that skill is in high demand. Within a couple more years, right around the time a much older Hal Foster was giving up *Tarzan* and launching *Prince Valiant*, my father had developed the style that would lead to covers for *Sport*, *Liberty*, *Collier's*, *Holiday*, and other magazines. Becoming a cartoonist was not my father's original ambition—it was an opportunity that came his way by chance after the war. He

found himself appearing in Rockwell paintings

My father on a magazine cover at age fifteen. The title of the Rockwell illustration is *Starstruck*.

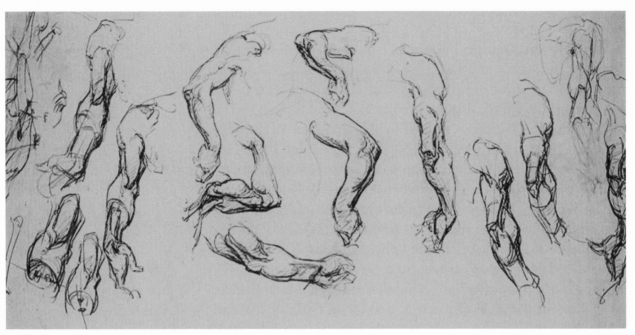

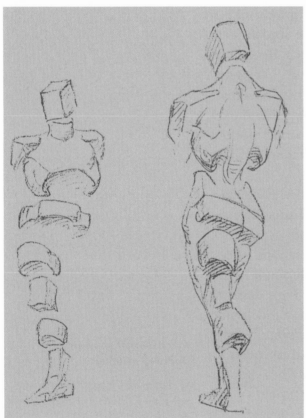

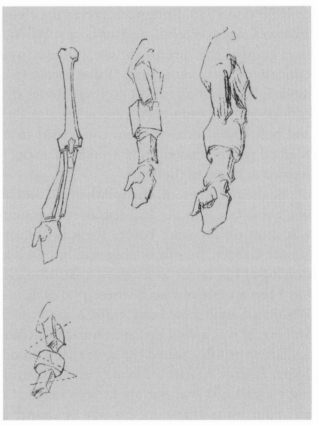

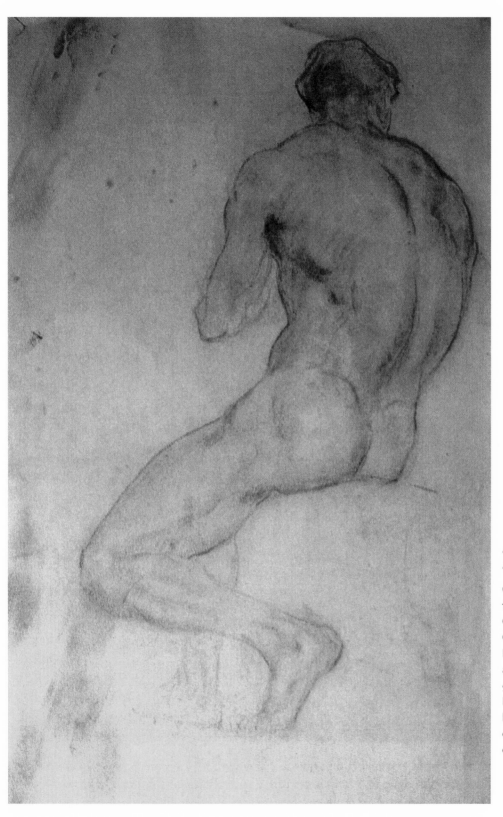

Opposite: Studies by
the life-drawing master
George Bridgman.
Classical training—and
Bridgman himself—left
a strong impression on
generations of artists.
Left: Pencil-on-newsprint
life study by my father,
done in Bridgman's
class, 1937.

was intent on a career as an illustrator of magazines and books. And he remained an illustrator all his life, both in the kind of comic strips he drew and in the vast number of sketches and paintings he produced privately. In this he was like many other cartoonists. Most of them cultivated some complementary side of themselves that was more than a hobby and had nothing to do with what they were primarily known for. Jerry Dumas was an essayist whose spare, elegant drawings appeared in *The New Yorker*. Dik Browne created pen-and-ink landscapes and fantastical scenes that might have been etchings made by an impish Rembrandt. Rube Goldberg was a sculptor. Noel Sickles moved on from *Scorchy Smith* to magazine illustration—his drawings accompanied the first publication of Ernest Hemingway's *The Old Man and the Sea*. Fred Lasswell, who wrote and drew *Barney Google and Snuffy Smith*, was an inventor— he came up with a method of producing comic strips in Braille and held a patent on a citrus-fruit harvester. Mell Lazarus, the creator of *Miss Peach* and *Momma*, was a novelist. Bill Brown, who wrote the comic strip *Boomer*, which was drawn by Mel Casson, had a sideline career on Broadway: he wrote *The Wiz*.

cultivated some complementary side of themselves

Below: A springtime comic strip landscape by Jerry Dumas, hand-tinted and used atop personal stationery. Opposite: A page by Dik Browne from Mort Walker's 1973 book *The Land of Lost Things*.

Stan Drake, whose parents had been close to Art Carney, tried his hand at acting. Carney told him it was no kind of life, but the actor in Drake came out when he posed himself for pictures.[12] Jerry Marcus, who drew gag cartoons for many magazines and also created the comic strip *Trudy*, dabbled as an

actor in movies and commercials for most of his life. If you watch *Exodus*, you can see him for an instant in the role of a British soldier crossing a street in the far distance behind Eva Marie Saint. When Marcus ran into her years later, on the set of another movie where he had another bit part, he asked her if she remembered him. She said no. He said, "We were in *Exodus* together."[13]

My father's fluidity with a pencil is one of my earliest memories of him, and a reliable and familiar constant ever after. There was a practiced thoughtlessness and an easy physicality to it that you also see in chefs and carpenters, barbers and tailors. He never sharpened a pencil mechanically. The tip was trimmed with a single-edged razor, the wood shaved off in thin wedges as the pencil turned in his fingers after each slice. When a half-inch shaft of graphite core had been exposed he then abraded the surface on a piece of fine sandpaper taped to the desk until the tip was properly sculpted. The effect he sought was not a symmetrically rounded cone, as a sharpener would produce, but something more like a scalpel, the graphite coming to a point, but with sides that were long and flattened. My brothers and sisters and I sharpen pencils like this even now.

As the pencil approached paper you could start to see his mind at work and the influence of Bridgman and his techniques, which were fundamentally architectural. He often began in an unexpected place—a nostril, a doorway—as if to put a stake in the ground. He then moved ahead lightly and loosely, the lines laid down in a way that at first seemed haphazard and chaotic until a sense of composition began to be discernible, like formless clouds gradually collecting into an image. He never used an eraser at this stage, but simply penciled over lighter lines with slightly darker ones as he grew more confident about what he wanted. His tendency was to move from the more general to the more particular, an approach that not only made sense when

drawing but also reflected the conceptual hierarchy his mind applied to everything. He warned against getting too detailed too quickly—his favorite example was Michelangelo's heartrending final *Pietà*, the one in Florence that the sculptor tried to destroy, with its polished arm and leg, expertly carved but hopelessly skewed in their overall proportions.[14] The whole composition had been doomed from the start. "The masses of the head, chest, and pelvis are unchanging," Bridgman had instructed. "Whatever their surface form or markings, they are as masses to be conceived as blocks."[15] Only when the basic structure was clear, and the blocks were in place, would my father move to the next level of concreteness, laying in the major shadows with the side of the pencil and then using the point to start the close work on prominent darker and sharper features—eyes, ears, hands, hooves, windows, branches. Time-lapse photography has captured the rapid, elegant arcs of a conductor's baton; I wish my father's graceful movements had been preserved the same way. His hand moved continually—settling in for a moment in one place, going back for a few strokes to another, coming again to where he'd just been—but there was nothing fussy or tentative about the motion. There was a sensation of inevitability: the picture starting to emerge had had no choice.

That was an illusion. For any cartoonist, the task of distilling some sort of invented reality into a series of blank spaces—one space for a single-panel cartoon, maybe three for a black-and-white daily strip, as many as nine for some of the color Sunday strips—took thought and preparation. For a humor strip or a gag cartoon, ideas were

Have you heard about the new "flat look" for women?

How do you stand on this?

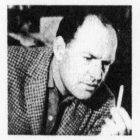

Heard you quit smoking . . .

. . . was it difficult?

Really, do you ever miss them?

Does your strip have a philosophical theme based upon man's concept of courage and human dignity? . . .

. . . You know, a message?

You have been referred to as a "sport car nut", is this true?

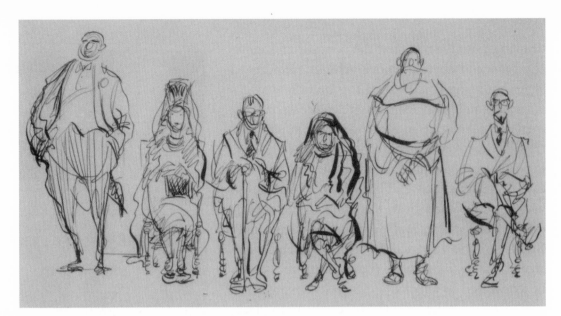

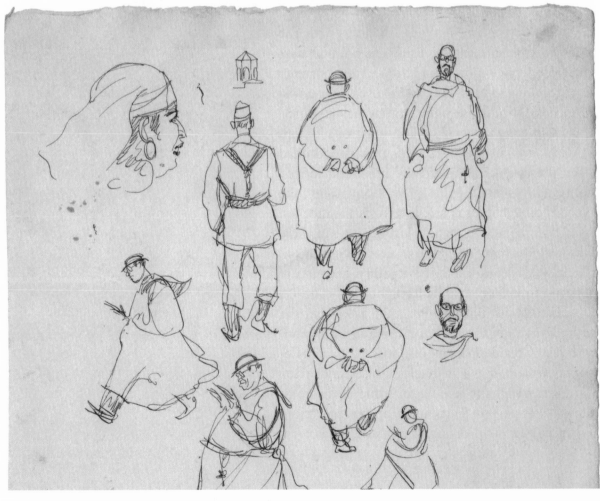

the engine, and the standard exchange rate was about one usable idea for every three or four you might come up with. Sometimes ideas struck suddenly—it often seemed that a cartoonist's mind was trained to see all situations first as material and only second as lived experience. "I can *use* that!" is the phrase you'd hear. One day, Mort Walker was at the grocery store, lost track of his wife, saw a stock clerk shelving cans, and heard himself asking, "What aisle are wives in?"[16] More often, ideas required "thinking," which to an untrained eye could look like dozing in a rocking chair or hitting golf balls with a putter on the carpet.

Realistic story strips such as my father drew—or strips like *Rip Kirby* and *Brenda Starr*—needed something different. They started with scripts plotted out months in advance, and involved an ever-changing variety of new characters and new locales. Preparation meant research and the snapping of all those pictures. My father's inventory of what he called "scrap" was organized alphabetically in a bank of filing cabinets. Once or twice a week he would sit with my mother in the evening, chatting amiably while riffling through a pile of newspapers and magazines, looking only at the photographs. When he came across an image that might someday be useful—a publicity still from *Lawrence of Arabia*, a family on muleback in the Grand Canyon, a fortification plan for the Tower of London, a prizefighter's cauliflower ear, an adman mixing cocktails, a killer being led to the electric chair, a child weeping over a broken doll—he would tear it out with a sharp flexing of the wrist that was scissorlike in its accuracy. With a clean incision he moved vertically down the page to his target, then executed full removal with a series of swift right angles. He would file the pictures away according to a classification scheme that Linnaeus or Roget would never have proposed but could not have improved on. *Ne'er-do-wells, General* would be further broken down into subcategories like *Swarthy, Femme Fatale, Irish, Armed, Seaborne, Cowardly.* The category *Combat* was followed by thick folders labeled *Swordplay, Arthurian, Jousts, Duels, WWII, Gladiators, Metaphorical.* There was a vast section on crime, another on sports, yet another

until a sense of composition began to be discernible

Sketches done by my father on the fly in the late 1940s while he was in an antechamber in Rome among people awaiting an audience with the pope (top) and on the streets of Madrid (bottom).

just on horses (*Racing, Rearing, Grazing, Frightened, Furious*). Romance was another big one: *Young Love, Unrequited, Dancing, Spats, Matchmaking, Heartbreak.* The fattest file of all was simply labeled *Faces*—a grab bag of people who might visually inspire a character: Auden, Arendt, Dirksen, Hepburn, Goldwater, Wharton, Acheson, Bacall, Keynes, Woolf. The scrap filled twenty-four file drawers.

This was the full extent of my father's organizational prowess. Like most other cartoonists he was a virtuoso at the drawing board, but his powers diminished with the square of the distance from its surface. There were some notable exceptions, Mort Walker being one, but cartoonists by and large were not shrewd businessmen, and their managerial sensibilities were frozen in a premodern condition. Their reverence for masking tape, which they would have considered to be a sixth basic element had they been ancient Greeks, was symptomatic: it was the stopgap remedy of choice, suitable for all basic domestic repairs and most bodily injuries. That our own household functioned at all was due entirely to my mother, Joan. If my father was the Prince Consort, devoted to his curious projects, my mother was Queen, Prime Minister, Lord Chief Justice, and Chancellor of the Exchequer rolled into one. Both of them in their different ways were intensely involved in the raising of eight children, somehow making each one feel like the center of attention. In the early-morning hours of Christmas, presents would be shifted suddenly from one pile to another to correct a numerical or volumetric inequality. But it was mainly my mother who dealt with the child-rearing logistics. She kept our mansard-roofed Victorian from falling apart too quickly, controlled the checkbook, bought the cars, managed the calendar, and posed stylishly in front of the Polaroid whenever the casting call came from the studio. She also served as the back-office vizier when it came to renewing or renegotiating the contracts that governed my father's work. When he returned from round one of any such meeting, there would be a quiet marital conference behind closed doors, punctuated by my mother's audible

whenever the casting call came from the studio

My mother, Joan, in the 1950s, performing for the Polaroid in her various recurring comic strip roles.

sighs and the occasional "Oh, Jack." Then she would devise a battle plan for round two.

That an American comic strip industry could exist at all was due to an unseen army of women who played the role of irrepressible Blondies coping with the mayhem caused by all those clueless Dagwoods and their bright ideas. My mother had come from a large family known for its stamina and strength of will. Her own mother was decisive and imperious; she needed canes because of crippling arthritis, and leveraged them to effect when it came to parking spaces, tables at restaurants, and special favors from total strangers. She once was waved through to the gangplank at the Cunard pier in Manhattan by thrusting a metal forearm crutch through the car window and saying, "Officer, I have canes." At home she used a crystal bell to summon help. It became a tradition to give her bells as gifts, making the wider family unwittingly complicit in its own servitude. My mother's father, the son of an Irish maid in New York, had lost both of his parents by the time he emerged from his teens. Tutoring himself in trigonometry and other skills—I have copies of his meticulous notebooks—he became an aviator with the army during the Pancho Villa campaign, in 1916, then built a global career in maritime insurance. In a basement workshop his tools hung obediently inside crime scene outlines of each shape that he had drawn on the wall. Nails and screws were carefully organized, the twenty or so jars neatly labeled and lined up in a row. This was the stock my mother came from. Her organizational capacities were prodigious, sometimes outstripping what lesser figures might regard as prudence.

Having to send all those children off to school with homemade lunches was the kind of challenge my mother was born to solve. One September morning, before the start of the school year, a Bendix freezer the size of a sarcophagus was delivered to our home and installed in

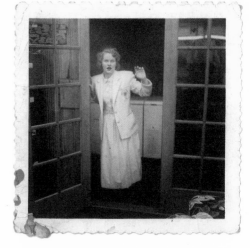

the basement. Later that day, my mother returned from the supermarket with a hundred or so loaves of Wonder Bread; large plastic pails filled with peanut butter, jelly, and mayonnaise; a hamper of egg salad; a butt of tuna fish; a hod of American cheese; and several yard-long tubes of sliced bologna. The age of artisanal sandwich-making was over. The era of efficient mass production had arrived. The family spent the day making the sandwiches we would consume for the entire year. As the hours went by, quality began to suffer. Episodes of industrial sabotage—peanut butter with bologna, tuna fish with jelly—afforded moments of amusement in the kitchen that would yield to horror in the classroom at a later date. The sandwiches were hauled down in bulk to the freezer, to be withdrawn as needed on school-day mornings. The Peasants' Revolt came around February, when freezer burn set in.[17]

•

For cartoonists in America, the 1950s were the Cretaceous revolution. Conditions on planet Earth had never been so propitious. There were more newspapers than ever before—about three hundred that appeared in the morning, fifteen hundred that appeared in the afternoon, and five hundred that appeared on Sunday.[18] Readership was at its peak. Those Sunday newspapers, with their thick comics sections, had a combined circulation of fifty million, which meant that more copies were being sold than there were households in America at the time. Postwar families were adding children to the population at a rate of four million a year.[19] A surge in affluence and advertising supported print publications of all kinds. The growing ease of global communications also meant that comic strips could migrate overseas, as a few had done in the 1930s and many more did now. Predators could be seen on the horizon but were not an immediate danger. Television, a natural threat, was in its infancy and was as yet only in black-and-white. Radio was big, but obviously not visual. Photography, another natural threat and already a mainstay of *Life*, *National Geographic*, and

a number of other publications, would not fully push aside illustration and reshape the entire magazine industry until the 1960s. The Internet, a threat the size of an asteroid, had been envisioned by the physicist Vannevar Bush in a famous *Atlantic Monthly* article, "As We May Think," in 1945, but it would not materialize for half a century.

To a child and to many adults, Hearst's Sunday comics supplement—syndicated as *Puck the Comic Weekly* to big-city newspapers—had all the magnificence of the Book of Kells. It was printed in color on a full newspaper broadsheet, about a foot and a third wide and a little under two feet high, and often ran to sixteen pages, for a total of about thirty-five square feet of comic strips. The color treatment that some strips required was demanding, and the printing quality of *Puck* was high—not a Taschen art book by any means, but sophisticated for a product that went to millions of people once a week, only to be thrown away within hours. Editors understood what sold—the news sections of the Sunday newspapers generally came wrapped in the comics section, not the other way around. Headlines about the hydrogen bomb or Eisenhower's heart attack were concealed by the colorful doings of a parallel world. The pages were so big that for anyone less than a full-size adult, the only proper way to read the comics was to open up the newspaper on the floor and get down on your hands and knees.

I have a copy of *Puck the Comic Weekly* from a Sunday in March 1962, when I was ten years old. It opens, as it always did, with *Blondie* (befuddled Dagwood versus headstrong Blondie) and *Beetle Bailey* (hot-tempered Sarge versus carefree Beetle). *Blondie* was drawn by Jim Raymond, and even a child could see that its introduction to the dynamics of marriage, though stuck in a time warp, was comprehensive and often canny. *Beetle Bailey* was a mandatory stop. Mort Walker's family was closely tied to my own by bonds of godparenthood and friendship. An exhilarating sense of secret knowledge came from reading a Walker strip in the Sunday comics that you may actually have seen on the drawing board nine weeks earlier. Even better was to see a

all the magnificence of the Book of Kells

Following pages: Examples of the broadsheet-size *Puck the Comic Weekly*, 1962, distributed as a Sunday supplement to Hearst newspapers nationwide.

PUCK
The Comic Weekly

CHARACTER · QUALITY · AMERICA FIRST · ACCURACY · ENTERPRISE

Seattle Post-Intelligencer

TV PREVUES

SECTION ONE

SUNDAY, MARCH 19, 1961

How to Get More Fun From Your Leisure Time

SEE TODAY'S AMERICAN WEEKLY

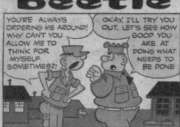

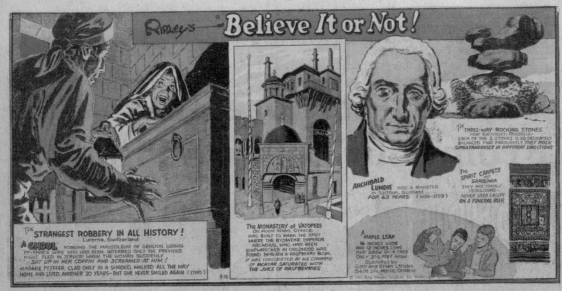

RIPLEY'S Believe It or Not!

THE STRANGEST ROBBERY IN ALL HISTORY!
Lucerne, Switzerland
A GHOUL ROBBING THE MAUSOLEUM OF GENERAL LUDWIG PFYFFER'S WIFE WHO HAD BEEN INTERRED ONLY THE PREVIOUS NIGHT, FLED IN TERROR WHEN THE WOMAN SUDDENLY SAT UP IN HER COFFIN AND SCREAMED AT HIM! MADAME PFYFFER, CLAD ONLY IN A SHROUD, WALKED ALL THE WAY HOME AND LIVED ANOTHER 20 YEARS—BUT SHE NEVER SMILED AGAIN (1780)

THE MONASTERY of VATOPEDI On Mount Athos, Greece, WAS BUILT TO MARK THE SPOT WHERE THE BYZANTINE EMPEROR ARCADIUS, WHO HAD BEEN SHIPWRECKED IN CHILDHOOD, WAS FOUND BENEATH A RASPBERRY BUSH. IT WAS CONSTRUCTED AT HIS COMMAND OF MORTAR SATURATED WITH THE JUICE OF RASPBERRIES

ARCHIBALD LUNDIE WAS A MINISTER in Saltoun, Scotland FOR 63 YEARS (1696-1759)

THE THREE-WAY ROCKING STONES near Salisbury, Rhodesia EACH OF THE 3 STONES IS SO DELICATELY BALANCED THAT FREQUENTLY THEY ROCK SIMULTANEOUSLY IN DIFFERENT DIRECTIONS

THE SPIRIT CARPETS of SARDINIA THEY ARE FAMILY HEIRLOOMS— NEVER USED EXCEPT ON A FUNERAL BIER

A MAPLE LEAF 16 INCHES WIDE AND 12 INCHES LONG THAT GREW ON A TREE ONLY 3½ FEET HIGH Submitted by Gary and Brian LATHAM Sault Ste. Marie, Ontario

BIG BEN BOLT
by JOHN CULLEN MURPHY

HURRY, MR. KENO. YOUR SURPRISE GUESTS ARE PROBABLY CHAFING AT THE BIT.

YEAH—THE BIT BEING THAT BEN'S GOING TO HANG ONE ON ME FOR PULLING THIS STUNT ON HIM!

COMING, MISS MACINTYRE.

LOOK—I GOT SOMETHING I WANT TO DO. YOU GO ON AND I'LL PICK YOU UP IN A MINUTE.

PLEASE HURRY, MR. KENO.

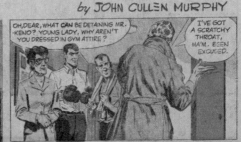

OH, DEAR, WHAT CAN BE DETAINING MR. KENO? YOUNG LADY, WHY AREN'T YOU DRESSED IN GYM ATTIRE?

I'VE GOT A SCRATCHY THROAT, MA'AM. BEEN EXCUSED!

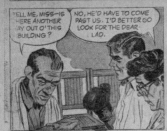

TELL ME, MISS—IS HERE ANOTHER WAY OUT O' THIS BUILDING?

NO, HE'D HAVE TO COME PAST US. I'D BETTER GO LOOK FOR THE DEAR LAD.

THE ONLY NICE PART ABOUT BEING CALLED A COWARD IS...

...YOU'RE ALIVE TO HEAR IT!

3-19

The PHANTOM
By Lee Falk and Wilson McCoy

WHERE ARE THOSE RUFFIANS? THEY TOOK EVERY CENT I HAD!

AND MY JEWELS— WHERE ARE THEY?

RELAX, MA'M. IT'S ALL OVER.

THERE THEY ARE, MA'M— DUMPED ALL OVER THE SHIP!

WHAT— HAPPENED TO THEM?

SOMEBODY HIT THEM.

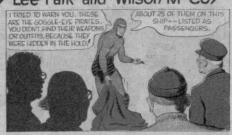

I TRIED TO WARN YOU. THESE ARE THE GOGGLE-EYE PIRATES. YOU DIDN'T FIND THEIR WEAPONS OR OUTFITS, BECAUSE THEY WERE HIDDEN IN THE HOLD!

ABOUT 25 OF THEM ON THIS SHIP— LISTED AS PASSENGERS.

THIS IS TOPS, THEIR LEADER. THEY ALL WEAR IDENTICAL COSTUMES. THE LOOT WAS TO BE FLOWN AWAY IN THAT COPTER.

—THEN THEY RETURN TO THEIR CABINS—SHOVE WEAPONS AND COSTUMES THRU THE PORTHOLES—AND YOU CAN NEVER IDENTIFY THEM—

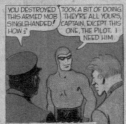

YOU DESTROYED THIS ARMED MOB SINGLEHANDED. HOW?

TOOK A BIT OF DOING. THEY'RE ALL YOURS, CAPTAIN, EXCEPT THIS ONE, THE PILOT. I NEED HIM.

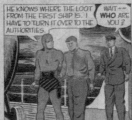

HE KNOWS WHERE THE LOOT FROM THE FIRST SHIP IS. I HAVE TO TURN IT OVER TO THE AUTHORITIES.

WAIT— WHO ARE YOU?

THE PASSENGER IN CABIN 14.

WILSON McCOY

Hi and Lois

BY MORT WALKER and DIK BROWNE

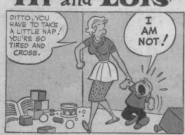

HENRY

by CARL ANDERSON

Hubert

by Dick Wingert

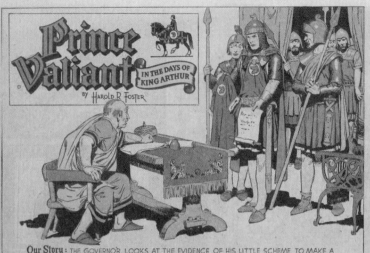

Prince Valiant
IN THE DAYS OF KING ARTHUR
BY HAROLD R FOSTER

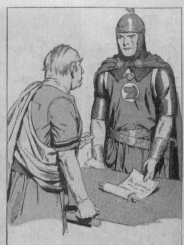

Our Story: THE GOVERNOR LOOKS AT THE EVIDENCE OF HIS LITTLE SCHEME TO MAKE A FAIR PROFIT. HAD HE KNOWN PRINCE VALIANT WOULD TURN OUT TO BE SUCH A FRIGHTENING PERSON, HE WOULD NOT HAVE TRIED IT. THEN HE REMEMBERS HE HAS A WHOLE GARRISON AT HIS COMMAND AND BECOMES ARROGANT.

HIS BLUSTER DIES AWAY UNDER THE STEADY GAZE. HE SENDS FOR ARN.

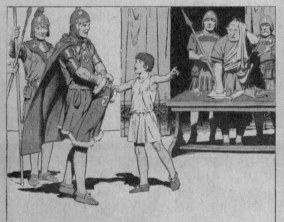

"GREETINGS, SIRE, THANKS FOR COMING, BUT WE MUST HURRY!" CRIES ARN BREATHLESSLY. "PAUL AND DIANE ARE PRISONERS ON THAT SHIP THAT JUST SAILED, BOUND FOR THE SLAVE MARKETS OF AFRICA! AND I KNOW WHERE OUR ABDUCTORS ARE!"

FROM HIS TOWER ROOM ARN HAD SEEN THE THREE FUGITIVES GO IN AND OUT OF A WATERFRONT WINE SHOP. THEY OFFER VERY LITTLE RESISTANCE.

ABOARD THE SLAVE SHIP PAUL AND DIANE, NOW BUT TWO SMALL BITS OF HUMAN MERCHANDISE, AWAIT THEIR FATE. SHE PATIENTLY, HE FIGHTING EVERY MINUTE.

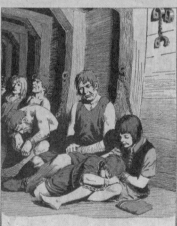

NOT A DAY PASSES THAT HE DOES NOT FEEL THE SLAVE-MASTER'S LASH. HE WILL NOT SURVIVE TO BE A SLAVE!

LEAGUE BY LEAGUE THE DISTANCE BETWEEN THE LUMBERING DHOW AND THE RESCUE SHIP GROWS SMALLER.

NEXT WEEK - The Swap

1298. 3 - 19 - 61

sketch and know it had no chance of being published: for himself and his friends, Walker roughed out a lot of ideas that he knew were born to blush unseen. (At a bar, Miss Buxley's date leans close and says, "I'd like to go where no man has gone before." She replies, "Too late.")[20] Collections of Walker's private stock have been published as books in Sweden.

My father's *Big Ben Bolt* was on page two, between *The Phantom*, with its atmosphere of mystery and menace, and *Ripley's Believe It or Not!*, to which we accorded a presumption of inerrancy. *Believe It or Not!* was where Charles Schulz's first published work appeared—in 1937, at age fourteen, he sent in a drawing of his omniverous hunting dog, and it was reproduced on the comics page.[21] Ben Bolt was a prizefighter, though an unusual one—he had been born in Europe to American parents, came to the United States after the war, was accepted at Harvard, and lived on Beacon Hill with his closest relatives, a proper if threadbare and dotty Brahmin couple named Aunt Martha and Uncle Thaddeus. By the time I began reading *Big Ben Bolt*, its hero had pretty much given up the ring and was a journalist and detective, usually getting into hot water in the company of his rough-and-tumble trainer, Spider Haines, who was based on the fabled trainer and cutman Whitey Bimstein.[22]

Then came *Hi and Lois* and *Hubert. Hi and Lois* could be read as the archetypal middle-American family strip, its gags derived from settings familiar to most people: school, kitchen, job, car. And it was a family strip in more ways than one: in the little-known backstory, Lois Flagston's maiden name was Bailey—she was the sister of Beetle. But the strip had a subversive streak embodied in the character Trixie, the toddler who cannot talk but conveys knowing commentary and some-times acid asides by way of thought balloons.

no chance of being published

Below: A young Charles Schulz makes his debut in *Ripley's Believe It or Not!*, 1937. Opposite: Pencil roughs by Mort Walker for *Beetle Bailey* strips that went no further.

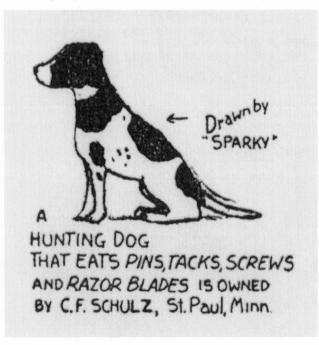

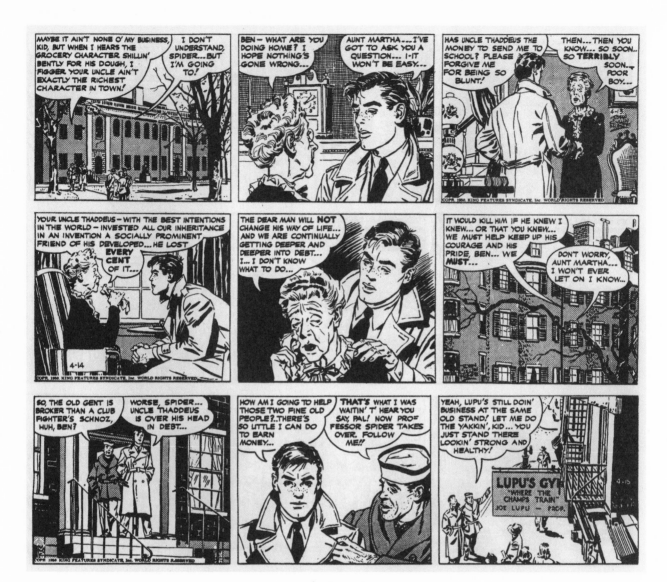

Ben Bolt was a prizefighter, though an unusual one

Above: The eponymous protagonist of *Big Ben Bolt* with Aunt Martha and Spider Haines on Beacon Hill, 1951. Opposite: The champ takes on the formidable Johnny Slaughter.

Trixie was like Snoopy—the wise fool. In one of her earliest appearances she is tossed a stuffed animal by her mother every time she screams with hunger. In the last panel Trixie looks at the animal and thinks, "Boy, if that was real there'd be nothing but bones left now." Dik Browne, who drew *Hi and Lois*, was a beloved figure, with that combination of ursine kindliness and ungainly affability that children find irresistible. He had a way of adding a quiet joke to everything he did. One afternoon he dashed off a sketch of my sister Cait, and before giving it to her,

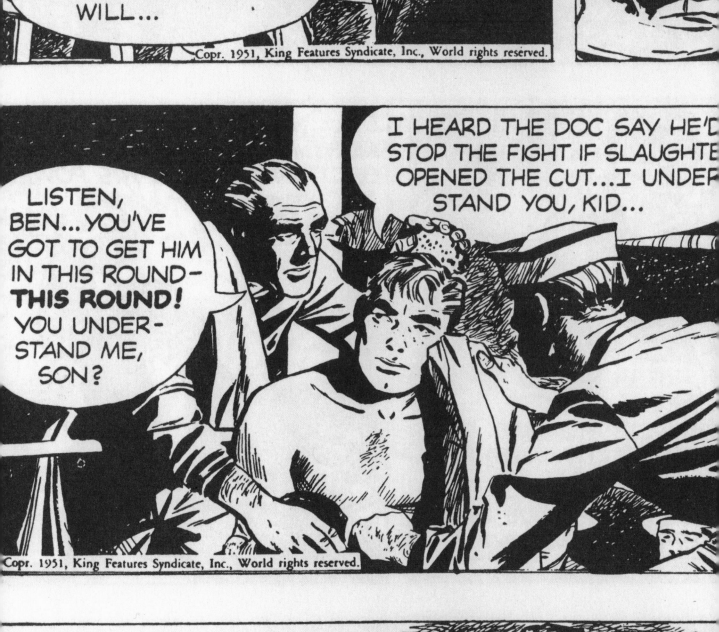

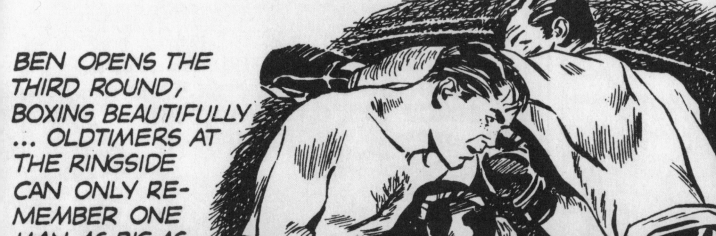

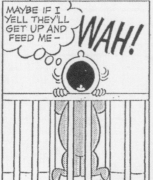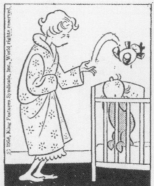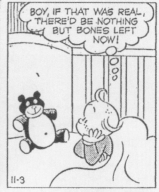

***knowing commentary and
sometimes acid asides***

Above: The silent but ever-thoughtful
Trixie, *Hi and Lois*, 1958. Right: Dik
Browne, who drew the strip, and his
wife, Joan, mid-1970s.

labeled it with a flourish, "Cait the Grait." Browne also presented
an alternative role model in terms of deportment. It used to be
said of the sportswriter and columnist Heywood Broun that he
looked like an unmade bed. Jerry Dumas considered Browne
an unmade Heywood Broun. Mort Walker once described him
as someone who appeared to be melting.[23] To a youngster curi-
ous about the scope of possibility that adulthood might tolerate,
Browne offered vast panoramas.

The next spread was all Disney comics: *Donald Duck*, *Uncle Remus*, *Mickey Mouse*, and the rest—never my favorites. Most of them seemed a cut below the other offerings, and on top of that my father had once heard from an army pal that Disney's behavior—he didn't elaborate—could leave something to be desired. This assessment cast a pall on our enthusiasm. The paternal verdict on famous figures—Generalissimo Franco, Nancy Mitford, Ty Cobb, Norman Mailer, Queen Marie of Romania, Orson Welles—amounted to an indispensable moral tip sheet, and weighed heavily.

But the Disney pages were followed by *They'll Do It Every Time*, *Flash Gordon*, *Mr. Abernathy*, and *The Heart of Juliet Jones*. The first of these, which captured moments of maddening behavior and familiar hypocrisy—the teenager who is Mr. How Can I Help? at school but avoids the household chores; the man who is ordered to the hospital for some rest, where interruptions make rest impossible—offered an introductory course in good-natured cynicism. It was drawn by an older man named Bob Dunn, who did magic tricks whenever children were around. *Juliet Jones* was not really a strip for a ten-year-old—it possessed a *Mad Men*–type sophistication, but possessed it in the actual moment, fifty years ago. Stan Drake's drawing was expert and stylish, and the plots ran heavily in the direction of romance and melodrama. It was essentially a soap opera. But *Juliet Jones* had earned a lot of loyalty in our family. When my father came down with pneumonia, in 1960, Drake stepped in and drew *Big Ben Bolt* for three weeks. I remember him coming to the hospital to deliver finished pages and pick up new scripts, and my father commenting through the oxygen tent on how beautiful the women in the strip were becoming.

Turn the page and there was *The Katzenjammer Kids*—a strip that dated back to 1897—and *The Little King*. The latter was virtually a pantomime, drawn in minimalist style by another childhood favorite, Otto Soglow. Soglow was unusually short, making his ordinary-size head seem unusually large. He knew he was odd-looking—Sarge's bulldog, Otto, in *Beetle Bailey*,

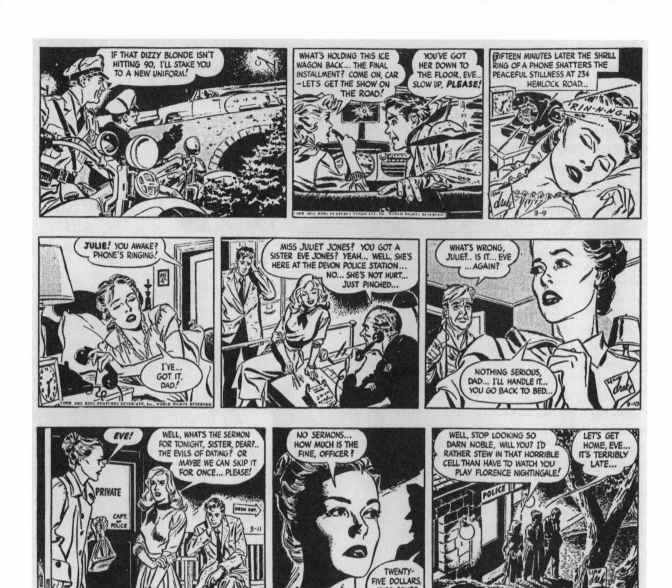

ran heavily in the direction of romance and melodrama

Panels from Stan Drake's stylish *The Heart of Juliet Jones*, 1953.

was named for him—and leveraged this to comic advantage by adopting a stance toward the world of unflappable dignity. In this he was not unlike the Little King himself. Soglow had trained initially with Robert Henri and John Sloan, and his early work has all the Ashcan grittiness you'd expect. But then he went off in another direction. A pantomime strip is an exercise in stage-craft, sometimes surreal, and at heart Soglow was an actor who understood precisely the effect that his own controlled manner

could have on other people. He worked for a time in a studio in New York that he shared with many others, and one afternoon some of Soglow's colleagues decided to poke fun at his size by removing his full-size drawing table when he was out for lunch and replacing it with a tiny rolltop desk meant for a child. When Soglow returned, he made no comment, but simply sat down at the desk and went back to work.[24]

On the next spread: *Popeye, Snuffy Smith,* and *Buz Sawyer.* Bud Sagendorf, who wrote and drew *Popeye,* was famous in our household because he worked only at night and slept till noon, which endowed this otherwise ordinary fellow with a patina of exoticism. Roy Crane, the man behind *Buz Sawyer,* had been something of a drifter who took art lessons by way of correspondence school and started out penciling roughs for H. T. Webster, the creator of the enduring character Caspar Milquetoast. But

Crane's tastes ran to adventure—embodied first in *Captain Easy,* about a swashbuckling soldier of fortune, and then in *Buz Sawyer,* about a globe-trotting oilman and trouble-shooter. Buz had tantalizing connections with the Pentagon and the CIA, and it was obvious even to a youngster that his pugnaciously anti-communist outlook was completely in synch with America's Cold War foreign policy. One episode in the 1960s even made reference, without demur, to the dropping of napalm in Vietnam. No one suspected that the State Department was sending Crane memos with detailed story ideas, which he sometimes used, and urging him, for instance, to "stress importance of Private Enterprise."[25]

Finally, at the end, on a full page, came Hal Foster's *Prince Valiant,* a masterpiece of drama and draftsmanship. To encounter *Prince Valiant* after all that had preceded it was like turning a corner and stumbling on

The Night Watch. Tall, trim, and confident, Foster cut a distinguished figure, the effect enhanced by a natural reserve. As with many laconic people, a sense of humor was revealed in his work rather than in his life. An undertone of lofty comedy ran through the tumultuous adventures of *Prince Valiant*, comedy of the bluff or coquettish kind that you'd find in Sir Walter Scott—the swaggering braggart getting his comeuppance, the lowly wench cleverly turning the tables, the besotted youth dithering in helplessness before his beloved's wiles. But you almost didn't need to read the strip to enjoy it. The pictures, in a style that had emerged from that great age of book illustration a hundred years ago, were richly detailed and dynamically composed. Every few months Foster would take two-thirds of a page and create a single glorious panel, about two feet square, as if to demonstrate the heights he could have reached if they'd just given him the whole newspaper. His stated rationale for these panels was more prosaic: the metabolism of any adventure slows down from time to time, and those are good moments for spectacle. As he once put it, "Every so often you have to bring on the elephants."

The strips in *Puck* were all from a single syndicate, King Features. Pick up a different newspaper with a different syndicate and you'd have a different lineup—*Peanuts* and *Ferd'nand* and *Tarzan*, say, or *Dick Tracy* and *Dondi* and *Moon Mullins*. In the early 1960s, newspapers had about a hundred and fifty comic strips or panel cartoons to pick from. This riot of enterprise was generally produced in a state of calm, by people laboring more or less alone. The particulars varied from place to place, but the story always began with a man sitting by himself at a drawing board for long stretches at a time. At our Cos Cob home, the studio stood at the back of the property, next to the barn. It was shielded from the house by a large apple tree. My father would leave the kitchen as his children were having breakfast. In one hand he carried any mail that had arrived the previous day, along with any scrap torn the night before from newspapers and magazines. In his other hand he carried a cup of milk to add to the tea or coffee he would make throughout the day.

a stance toward the world of unflappable dignity

Opposite, top: The cartoon character the Little King, from the strip of the same name. Opposite, bottom: Its diminutive creator, Otto Soglow, comes face-to-face with an embodiment of the monarch at a cartoonist event, in the 1930s.

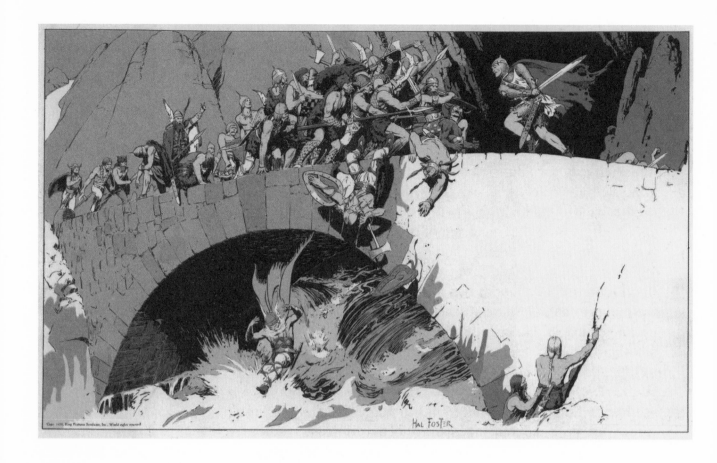

Copr. 1938. King Features Syndicate, Inc., World rights reserved

HAL FOSTER

as if to demonstrate the heights he
could have reached

On the bridge over Dundorn Glen, Prince Valiant and the Singing Sword keep a Viking horde at bay, 1938. One of Hal Foster's finest *Prince Valiant* panels.

If the house itself was loud and boisterous, the studio was a sanctuary. It was where many of the more serious family conversations took place—about squabbles, school, sickness, ambitions, love. When we were young, it was also the disciplinary destination of last resort. For most infractions, my mother served as police, forensic squad, prosecutor, defense attorney, and judge, and there was never any backlog in her court. The studio was reserved for capital crimes: "Go tell your father what you've done!" Never mind that, in reality, my father was the furthest thing from an Old Testament judge you could imagine; a look of disappointment was the mandatory maximum and was indeed punishment enough. But the command to go forth to the studio had an effect on those left behind. Tutored by movies, we expected to see

the lights flicker in the Big House as Old Sparky did its job in the death chamber out back. The miscreant, meanwhile, would have plea-bargained the sentence down to a cup of hot chocolate.

A bank of musty filing cabinets took up one wall of the studio. The other walls were hung with original strips drawn by friends and with old photographs from the war or of family and friends and of people my father knew in professional sports. One nook functioned as a costume shed. It was partly concealed by a mission-style rocker and a pair of wooden easels holding private work in progress. A tall photography lamp stood wherever it had last been rolled.

It took seventy-five of my father's steps, each lighter than the previous, to cover the distance from the kitchen door to the studio, and I remember noting, as I grew older, how the number of steps I needed—a hundred and fifty or so at the outset— gradually began to converge with the number that had come to symbolize maturity. Once inside he would flick on the light, file away the scrap, and sit down at the drawing board. Selecting a pencil, he freshened the point on sandpaper, and then started in.

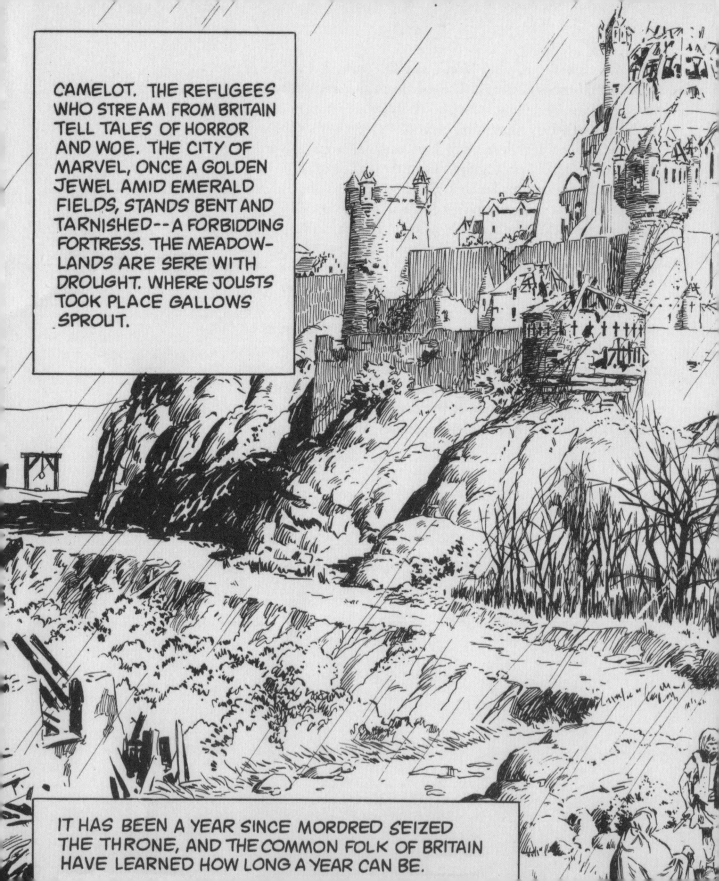

CAMELOT. THE REFUGEES WHO STREAM FROM BRITAIN TELL TALES OF HORROR AND WOE. THE CITY OF MARVEL, ONCE A GOLDEN JEWEL AMID EMERALD FIELDS, STANDS BENT AND TARNISHED--A FORBIDDING FORTRESS. THE MEADOWLANDS ARE SERE WITH DROUGHT. WHERE JOUSTS TOOK PLACE GALLOWS SPROUT.

IT HAS BEEN A YEAR SINCE MORDRED SEIZED THE THRONE, AND THE COMMON FOLK OF BRITAIN HAVE LEARNED HOW LONG A YEAR CAN BE.

HOME AWAY
FROM HOME

McFADDEN'S ROW OF FLATS

By the Author of "CHIMMIE FADDEN"
And the Originator of "HOGAN'S ALLEY."

TIM McFADDEN had given orders that politics were barred in the Row. What Tim says usually "goes" with the Flatters without argument or dissent—

always "want," indeed, before the arrival of the Yellow Kid. But that active young person proved a rebellious and turbulent element from the first. He had scarcely made acquaintance with all hands before he was playing Crusoe for campaign buttons and had soon won Marty Dunnigan's whole stack, wherewith the Kid decorated Mary Ellen until she was the envy of the Row.

From buttons to politics was a small and natural move, and, of course, the Kid made it. He was shortly in a terrific argument with Marty whither Bryan was running for "a Alderman what goes to Albany," or, as Marty thought, whether McKinley was using his pull to be appointed "Captain of de cops in de Oak Street Station."

Of course Tim McFadden was appealed to as an authority on that, as on all other subjects; and, seeing that the boys did not know enough about the subject to seriously disturb the peace of the Flatters, no matter how much they discussed, he repelled the law against talking politics.

"Kid," said Marty, "if we're to t'do de t'ing right, we must git de returns"

"What returns?" asked the Kid.

"Returns," Marty explained, "is de papers youse get stuck wid when youse dont sell de Jonal, See?"

"That kye av mob will be a Alderman himself, wid the great political larning he do be having!" exclaimed the proud Mrs. Dunnigan, who had overheard this.

"True of you," declared Mrs. Murphy, leaning out of her window. "'I do love political larning terrible awful, but it's that drying t'de t'roat! I has a t'irst on me like a fire engine. Let Marty hasten quickly t' Kel'y for a pint of beer, and come up in me room and join me, Mrs. Dunnigan, for I have the price."

When it was decided that returns should be brought to the Row by clothes line telephone, the troublesome question arose, Which candidate should be reported elected. It took all of Tim's diplomacy to avert a fight over this, until he hit upon the happy thought of having both elected, and gave orders to Louisette McEwatt to prepare banners and mottoes accordingly.

The Kid got early word of this, and broke away but in the neighborhood bottling on his straight tip.

With his money, such as it was, in his hand, he exclaimed: "I has boodle to burn and is looking for a dry."

The goat moved him further hunt for the fire by taking a tight meal of the Kid's earnings, whereupon Mrs. Murphy suggested putting the goat in soak with Kelly as security for beer all around.

"De whole wad wasn't de price of de beer," Marty explained, in time to save the goat's life. "Dey was Jeff Davises."

"What Jeff Davis, darlint?" Mrs. Murphy asked.

"Jeff Davis is boodle what's queer-green goods," Marty answered.

"Den de goat's stuffed wid sawdust," said the Kid, who never did have much idea of money.

"And I don't git no sealskin nor diamonds!" cried Mary Ellen, who had been promised those necessaries of life by the Kid.

"Not a bit like it!" squinched the particular Kid.

"I'll pull de whole tail outer dat parrot if it don't close its face!" yelled Mary Ellen.

"Goodness gracious, Mary Ellen, be a lady!" giggled Della Dunnigan, who wickedly winked at Mary Ellen's discomfort. "Be a lady, whatever you be, Mary Ellen! Even if youse hasn't a powder rag like I has, be a lady!"

The French cop from Oak street arrived in time to separate Della and Mary Ellen before much damage was done, and then he reproved Tim for breaking his own rule against politics.

"Let me discourse to you on the standing and situation of this status," Tim said to the French cop. "It's not politics as has made them two sweet girls fall against one another with rage, folly and contumely in their hearts. It's the Yellow Kid."

"And that's as true as Tim McFadden owns the Flats!" asserted Mrs. Murphy. "Hasn't the darlint childer a right, by way of diversion, t' have the political returns brought here widout you,

"Let me discourse to you on the standing and situation of this status," Tim said to the French cop, taking onto yourself I' put in your jaw. If you're looking for work, pinch the villain that stopped me can in its windy below and drunk all the beer but the froth."

This had the usual effect of driving the Fresh Cop of the block, and far the rest of the day and night peaceful revelry reigned in the neighborhood of McFadden's Row of Flats.

E. W. TOWNSEND.

RECEIVING THE RETURNS IN McFADDEN'S ROW ON ELECTION NIGHT.

Comic strips were not entirely an American invention. Hal Foster, when asked what the first comic strip was, used to point to the Bayeux Tapestry, created in the eleventh century—an embroidered cloth, 230 feet long, that tells the story of the Norman Conquest of England. Foster wrote and drew a strip about the Middle Ages, so of course he would say that. William Hogarth's eighteenth-century *A Rake's Progress* is essentially a comic strip. A little later came James Gillray in Britain and Honoré Daumier in France. Toulouse-Lautrec was in many ways a cartoonist.[1] Someone has probably made a claim for the Paleolithic cave paintings of Lascaux as examples of early comic strips. But whatever their forebears, newspaper comics as a mass-market phenomenon are American to the core. They began to proliferate in the late 1890s, when the powerhouse newspapers owned by Joseph Pulitzer and William Randolph Hearst began going head-to-head for circulation and advertising. Advances in color printing gave a home to strips like Richard F. Outcault's *Hogan's Alley* and Winsor McCay's *Little Nemo in Slumberland*. The medium was new, and comic strips colonized every categorical niche—humor, adventure, history, drama, fantasy, crime, nature, family, sports. It was like the dot-com boom, except there was no bust.

comic strips colonized every categorical niche

Preceding pages: The ruins of Camelot, detail from a *Prince Valiant* page by John Cullen Murphy, 1984. Opposite: R. F. Outcault's antic but observant cartoon character the Yellow Kid, *New York Journal*, 1896.

Within a few decades, strips like *Happy Hooligan*, *Krazy Kat*, *The Katzenjammer Kids*, *Tarzan*, *Flash Gordon*, *Gasoline Alley*, and *Little Orphan Annie* were syndicated nationally and familiar to everyone. Some cartoonists, such as Sidney Smith, the creator of *The Gumps*, became wealthy men. In 1922, Smith signed a contract with the *Chicago Tribune* that gave him a Rolls-Royce and paid him $100,000 a year. In 1935, during the worst of the Depression, the payment was increased to $150,000 a year. On the way home after signing that contract, Smith was killed in an automobile accident.[2]

Hearst maintained a personal interest in selecting comic strips right up until his death, in 1951, and his telegrams and communiqués—generally beginning with "Chief says" and signed by his secretary, Joseph Willicombe—reveal a micromanager's obsession with every last detail. Once, when considering

a micromanager's obsession with every last detail

William Randolph Hearst at age thirty-one. Portrait by Orrin Peck, 1894.

a new strip called *Dick's Adventures in Dreamland*, in 1945, Hearst sent his top comics editor a string of memos—asking, for instance, "Can we develop anything out of the idea of having Dick be the son of the keeper of the Liberty Statue in New York Harbor?"[3] The last two strips Hearst approved were the first one drawn by my father, *Big Ben Bolt*, and the first one created by Mort Walker, *Beetle Bailey*. In the family imagination, Hearst initials all the paperwork, mutters "Rosebud," and drops the snow globe.

Syndication was the engine of the comic strip business, and in our circle, references to "the syndicate" were as commonplace as references to "the Giants" or "the church." Depending on the circumstances, the references were hushed, respectful, angry, or resigned.

The hearings of the Kefauver Committee on organized crime had taken place in the early 1950s, and the notion of "working for the syndicate" had more than one connotation. In my father's case the syndicate was King Features, the biggest of them all. Other cartoonists were affiliated with United Feature, Universal Press, Field, the Newspaper Enterprise Association, Chicago Tribune–New York News, or one of several others. The syndicates had begun mainly as a way for newspapers to distribute comic strips and other features that the company itself had developed and could treat as its own private property; for the most part, cartoonists on staff had come up with the comic strip ideas and cartoonists on staff wrote the strips and drew them. But a variety of relationships eventually became possible. Some cartoonists had created their strips and owned them outright, and simply cut distribution deals with the syndicate bosses. Some strips were joint ventures between a cartoonist and a syndicate. Many cartoonists worked on contract, brought aboard by a syndicate to keep existing strips alive on a work-for-hire basis. A number of cartoonists were paid employees of a syndicate, doing whatever needed to be done and working out of the so-called bullpen in the syndicate's office. Whatever category you fell into, you needed a syndicate to market and sell your strip around the country and the world—effectively there was a single buyer for everyone's product. That's probably why my father knew the word *monopsony.*

How you felt about this state of affairs depended on where in the feudal order you stood. The syndicate certainly provided an essential and valuable service. If your strip was appearing in seven hundred newspapers and following the advance of American power on six continents, there wasn't much to worry about, though diplomatic relations with headquarters could still be tense. If your strip seemed to have achieved cult status mainly at small papers in college towns, then the future was precarious and you really could get rubbed out by the syndicate. When it came time to bring *Big Ben Bolt* to an end, in the late 1970s, the protagonist, Ben, was literally assassinated in the last episode—shot through the heart while accepting the Nobel Peace Prize.[4] (By

then my father was no longer drawing the strip; he did wonder if *Peanuts* would end with Snoopy being hit by a car.) Most strips occupied a middle ground in terms of readership. Landing a new paper—*The Dallas Morning News*! The *Orlando Sentinel*!—was always cause for rejoicing. Losing a paper was a call to action. Whom do we know in Spokane or Abilene or Youngstown? Can we get them and their friends to complain? A handful of letters and phone calls could persuade local editors to change their minds and maybe even run a sheepish note of apology on the editorial page.

The men who managed the syndicates ran the usual gamut from benevolent despots and nurturing mentors to hard-eyed managers and corporate strivers. Sylvan Byck, the comics editor at King Features for four decades, was revered. His roots went deep—James Montgomery Flagg, who painted the famous Uncle Sam ("I Want You!") army recruiting poster during World War I, had done a portrait of Byck as a young man—and he was old enough to remember when strips like *Gasoline Alley* and *The Gumps* were just getting off the ground. Byck was an editor at King by the late 1930s. Four decades later, he gave the green light to *Hägar the Horrible*. It was said that he looked at two thousand ideas for comic strips a year. It helped that Byck had started out as a cartoonist himself (he did political cartoons for *The Seattle Times*), though not of the first rank; like many managers in baseball, his true talent lay off the field. He had plenty of maxims for people wanting to start a comic strip, the most important of which was that "it is better to build around a character than around a job." When he signed up *Beetle Bailey*, Beetle was a college student, not an army private. It was the character he had liked.

Strips were sent to the syndicate under tight deadlines and by registered mail, and if a cartoonist was running late he'd have to get on the train and bring the strips in person to the offices on East Forty-fifth Street, in midtown Manhattan. Once, in an emergency, when I was ten or so, I was sent on this errand by myself like a bonded courier, the strips secured to my waist

"better to build around a character than around a job"

That was the advice of longtime comics editor Sylvan Byck (above, in an early portrait by James Montgomery Flagg) to would-be cartoonists thinking about new strips. Opposite: Bob Dunn, who drew *They'll Do It Every Time*, immortalizes a willing subject in New York, 1951.

with twine. I often joined my father on delivery trips to King, afterward going for lunch, perhaps with other cartoonists coming late with their work, at the Pen & Pencil or the Lambs Club. By the time I first met Byck, the sharp features captured by Flagg had settled comfortably into a softer blend of Jean-Paul Sartre and William Shawn, with a leavening dash of Mr. Toad. He smoked heavily and was tall enough to look a fifth grader in the eye. If my father and Byck needed to talk, I'd be sent on my own to the bullpen.

This would have been my destination anyway. Every syndicate had its bullpen, and fundamentally they were all the same. It was an open expanse divided haphazardly into work spaces by dull green wooden partitions and small panes of thick frosted glass—a sort of movie set that had been built for a pittance but would cost a fortune to re-create. Each space held a tilted drawing table and some array of flat working surfaces; a thin cumulus of variable smoke hung over the room, with here and there an angry thunderhead. Look up the biography of almost any cartoonist from the turn of the twentieth century through the 1970s and you'll find some version of the words "started out in the bullpen at . . ." Roy Crane started out in the bullpen at *The New York World*. Alex Raymond briefly helped his New Rochelle neighbor Russ Westover with *Tillie the Toiler* before joining the bullpen at King.[5] Milton Caniff started out in the bullpen at the Associated Press, where the drawing tables were lined up in a row alongside a

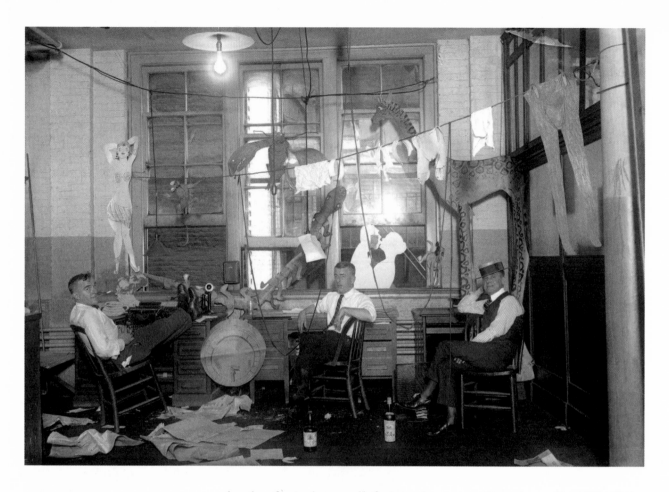

bank of windows, all facing the same direction; Caniff's alone was turned the opposite way, because he was left-handed.[6] The bullpen at King was home to perhaps twenty cartoonists, many of them people of enormous talent, and some, truthfully, workaday craftsmen who would unhappily never get a break or happily never seek one. A few of them had started drinking too early in life, or maybe it was just that day. It was an overwhelmingly friendly place whose occupants seemed to have nothing better to do than swivel around from their tables, light a pipe or cigar or cigarette, ask a question or two, curse the Giants and Dodgers for leaving town, compliment your mom and dad, and draw you a picture to take home as a souvenir.

There was no single bullpen job. The syndicate bullpens had originated as factories inside newspapers, when ideas for comic

a thin cumulus of variable smoke hung over the room

Above: The bullpen at the *New York American* a century ago—the kind of environment in which many cartoonists got their start. (Winsor McCay is the man in the boater.) Opposite: The use of Ben-Day dots, applied in the bullpen. *Big Ben Bolt,* 1963.

strips and other illustrated features were generated largely in-house. *Krazy Kat* and *Bringing Up Father* and *Popeye* had all been produced this way. And some of that tradition remained. Bob Dunn, who drew Jimmy Hatlo's *They'll Do It Every Time*, still worked out of the bullpen at King. He was an entertainer and a raconteur, and if you were a youngster he was likely to pull a quarter out of your ear and give it to you. I didn't know it at the time—and if I had, I would have been too awestruck for even the simplest conversation—but he was also the inventor of the knock-knock joke, and his book of these jokes sold two million copies in the 1930s.[7] That Dunn is less well-known today than Einstein or even Praxiteles is because he gave much of the credit to a pseudonymous collaborator, a man named Enoch Knox.

By the 1960s, the bullpens had mainly become something else. They were organizational brains and production clearinghouses. Hundreds of pieces of original artwork—referred to by the New Yorkers on the floor as "ott-woik"—arrived every day from distant cartoonists. A week of *Rip Kirby* dailies from John Prentice in Westport. A week of *Nancy* from Ernie Bushmiller in Stamford. A *Prince Valiant* Sunday page or two from Hal Foster in Redding. Comic strips on rectangles of bristol board, most of them about one foot high and two feet wide, lay around everywhere, sometimes with coffee rings on the margins. Many cartoonists did their own lettering, and specialists such as the superb Ben Oda did the lettering on a variety of strips, but the task could also fall to the bullpen. Spelling mistakes needed to be corrected in everyone's work. The men in the bullpen added shading where indicated by the cartoonists, cutting pieces of the overlay known as Ben-Day and carefully pasting it down. Ben-Day consisted of a uniform pattern of small dots that created

a sensation of intermediate texture but could be reproduced as a line shot—that is, just using black and white, like type itself—rather than requiring a halftone, as photographs did; these are the dots that give so many Roy Lichtenstein paintings their distinctive look. (Ben-Day came in acetate sheets, but a cartoonist new to the work might be told to go down to the storeroom for "a bucket of Ben-Day dots," and would return feeling foolish.)[8] Sometimes the drawings themselves needed attention from the bullpen—the ink may have smudged, or the cartoonist may have forgotten to finish an eye or a hand. Ultimately the comics editor took a look at everything. Then the strips went downstairs to be prepared for newspapers. The black-and-white daily strips were photographed onto copper plates and then engraved, producing molds that could be turned into printing plates. The color Sunday pages required many additional steps. But the process, from engraving all the way through printing, was largely mechanical, as it no longer is. Albrecht Dürer could easily have adapted to it.

He would also have been familiar with the occasional intervention of a censor. Comic strips raised nowhere near as many eyebrows as comic books did—during the 1950s, comic books were the object of fierce campaigns that included calls for prohibition. When he was finished looking into organized crime, Senator Estes Kefauver turned his attention to organized comics, and prominent cartoonists such as Milton Caniff and Walt Kelly gamely defended their profession—and tried to distinguish comic strips from the gamier comic books—at televised Senate hearings. Questioning Kelly, one senator cited a doctor who had testified to the effect that cartoonists might need psychiatric attention. Kelly replied, "We in the cartoon business sort of cherish the idea that we are all sort of screwball."[9]

Magazines laid down in-house standards for gag cartoons, and newspaper syndicates had their own thick codex of rules. Profanity was impermissible everywhere, of course, though you could resort to symbol swearing—#!*$%!&*#!—which was funnier anyway and led quickly down many promising rabbit holes (as when a character in Bill Amend's *FoxTrot* stubs his toe and

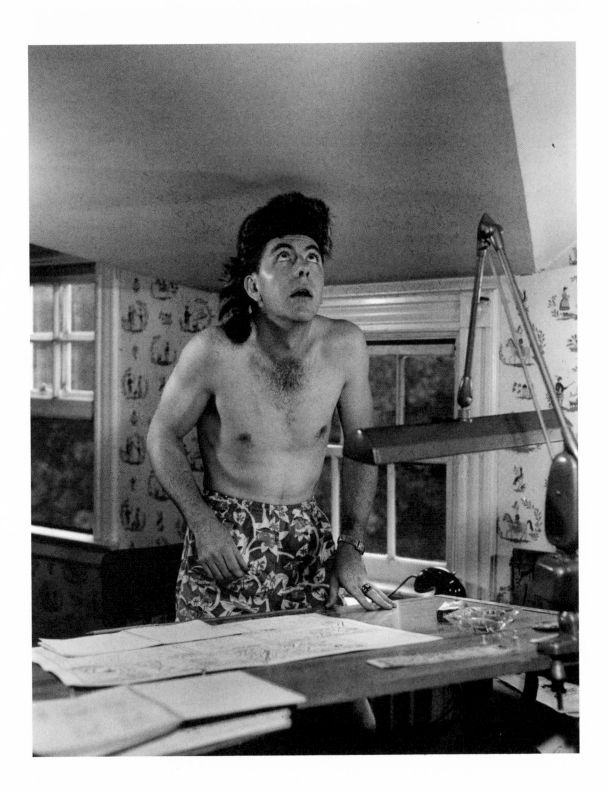

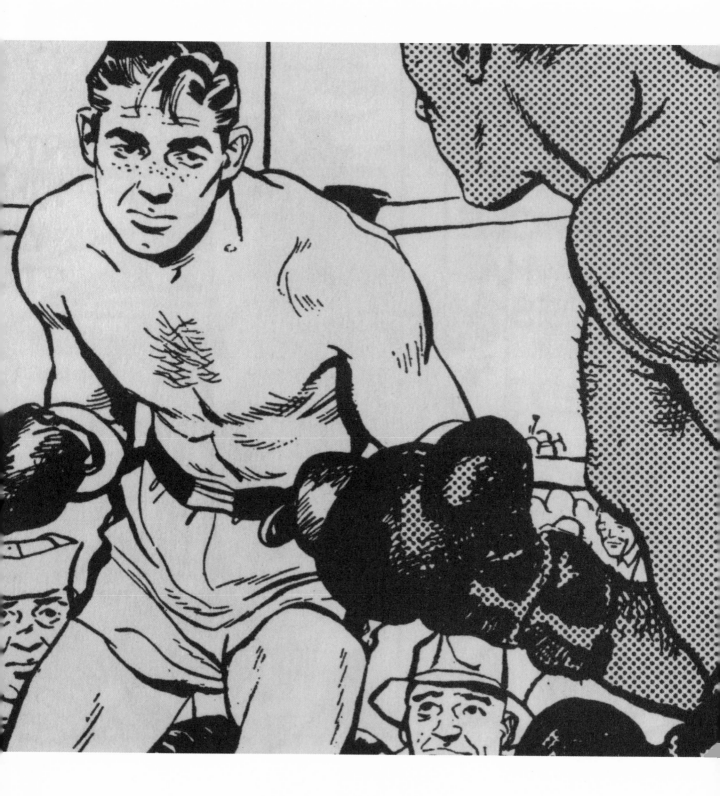

cries, "Asterisk! Dollar sign! Ampersand!").[10] You also had to be careful with politics. A *Li'l Abner* strip was suppressed in the late 1940s for its derogatory depiction of Congress. In its report on the incident, *Time* magazine quoted a spokesman for the Scripps Howard syndicate: "We don't think it is good editing or sound citizenship to picture the Senate as an assemblage of freaks and crooks."[11] Drinking could be shown, and even drunkenness, but there was a double standard: overindulging was permitted and even encouraged for some characters (Hägar the Horrible, Snuffy Smith, General Halftrack), but not for others (Hi and Lois Flagston, Dick Tracy, Prince Valiant). The human body came with many caveats. You could draw a woman in a bikini, but for some reason you couldn't show a navel, even on children, and for years the bullpen took an X-Acto knife to the offending squiggles, until Mort Walker began retaliating by drawing extra navels on his characters and gratuitously adding crates of navel oranges into the story line. (The bullpen kept removing them, but now started sending them all back to Walker, who saved them in a jar.)[12] The depiction of male nipples was also forbidden, which presented a challenge for strips about prizefighters, cavemen, or barbarians. Another red line, for some mysterious reason: showing dirty socks on a chair. Bud Sagendorf, a bullpen veteran who went on to draw *Popeye*, remembers having a list of "35 no's."[13] Race as a serious issue was virtually taboo until the 1960s, which is also when African American pioneers like Morrie Turner found syndicates for their work. (George Herriman, the creator of the classic strip *Krazy Kat*, which was syndicated from 1913 until his death in 1944, was of mixed heritage, but did not acknowledge the fact and allowed himself to be known as "the Greek.")[14] Religion had always been and remains a sensitive topic. Sagendorf once ran into a religious problem in *Popeye*, when he showed Olive Oyl foiling a vampire by spreading her arms wide and creating the shadow of a cross on the ground, the crucifix being a well-known deterrent. But her reference in a speech balloon to "a cross" was removed by the syndicate and replaced with the words "a dagger" (though it is common knowl-

syndicates had their own thick codex of rules

Big Ben Bolt, 1951. Male nipples were for some reason forbidden. The prizefighter Ben always entered the ring without some standard equipment.

edge that a dagger, unlike a cross, will not stop vampires).[15] Even if a strip sailed through the bullpen without attracting undue attention, as it generally would, it could still run into trouble down the line, at local newspapers. Miss Buxley, General Halftrack's lightly clad secretary in *Beetle Bailey*, was a frequent target of feminists, though Walker would always claim that his own target was really the old goat of a general. But Arab publications sometimes removed Miss Buxley in her entirety, leaving readers in Baghdad or Riyadh to guess at what the joke might have been.[16] The Mormon *Deseret News*, in Salt Lake City, used to remove images of alcohol and tobacco. Characters who might have been holding a martini glass or smoking a pipe would find that the objects had suddenly disappeared, their empty hands now frozen in a stylized pose, as if they had suddenly decided to play charades.[17]

●

As personalities, the cartoonists and illustrators were as different as individuals in any group of people can be. Some, like Milton Caniff or my father, were outgoing and courtly; either of them would have made a fine ambassador to a country where other diplomats performed the actual work. Some, like Walt Kelly, who did *Pogo*, performed frequently in public, but were also complicated and private; Kelly, of course, could be lacerating on the page or in front of Congress. Charles Schulz was famously shy. Al Capp, who as a boy had lost a leg in a streetcar accident, could be unpleasant in a way that turned increasingly bitter and corrosive. Yet his brother, Elliot Caplin, who wrote half a dozen comic strips and worked closely with my father for decades, was affable and urbane, and moved easily among people of all kinds. Taken as a whole there was a tilt toward the gregarious. The cartoonists all shared one thing—not so much a characteristic as a condition: The job was solitary. All it required was some heavy white paperboard, India ink, pencils and pens, a few brushes, a few kneaded erasers, and yourself.

Every cartoonist bore a hard callus on the distal interphalangeal joint of the middle finger of his drawing hand. Nothing about the craft had really changed since the Gilded Age, until the arrival of electric erasers and their dental whir. Many of the cartoonists had part-time help. My father employed an assistant—George Raymond, the younger brother of Alex and Jim—who did some penciling and lettering, posed for pictures, and eventually left to run the stationery department at Cartier. He came one day a week. Mort Walker ran what seemed to be a mini empire—a Titian's work-

a Titian's workshop of cartooning enterprise

Mort Walker, creator of many strips, outside the barn that became his studio, circa 1965.

shop of cartooning enterprise—and yet it consisted of only half a dozen people. In terms of economic scale, the *Beetle Bailey* and *Hi and Lois* industry ran a distant second to that of *Peanuts*, but Charles Schulz was in California, and by Connecticut School standards Walker's studio was close to agribusiness, and earned a measure of grousing as well as respect. Walker and Johnny Hart were longtime friends, but in his strip *B.C.*, Hart once included the word *mortgage* in an installment of the regular "Wiley's Dictionary" feature, defining it as "A device for measuring one's tolerance of people named Mort."

For the most part, "work" consisted of a man by himself in a room. Jimmy Hatlo used to keep a mirror taped to his desk—he maintained that it was to help him experiment with facial expressions, but it might also have been for the company. Studios came in many shapes and sizes, as places of worship do, and like places of worship they shared certain features. To begin with, there was a common smell. A *parfumier* would identify traces of wood and graphite particulate, from pencils being sharpened; notes of resin, paint, and linseed oil; the lingering residue of some form of tobacco; hints of spilled scotch.

"work" consisted of a man by himself in a room

Above: Milton Caniff, creator of *Terry and the Pirates*, as he saw (and drew) himself in the 1930s. Opposite: Hal Foster in his Connecticut studio, 1947, a *Prince Valiant* page on the drawing board.

The studio, in Redding, of *Prince Valiant*'s creator, Hal Foster, was a baronial room centered on a two-story leaded-glass window in Gothic style, befitting his subject matter. Foster was a Canadian by birth and an outdoorsman by upbringing. From that studio window he was said to shoot deer, though sadly not

with a longbow. Chuck Saxon worked in a cramped loft above his garage in New Canaan, his drawing board positioned under the slant of an eave. Flat cabinets held his originals, including hundreds of unused *New Yorker* covers, unsalable anywhere else. The studio received little natural light, which in Saxon's case didn't matter much; like Bud Sagendorf, Stan Drake, and a number of other cartoonists, he worked mostly at night.[18] Mort Walker eventually moved from Greenwich to Stamford, into a studio built by Gutzon Borglum, the man who designed and sculpted Mount Rushmore. An alabaster bas-relief of Beetle Bailey—joining four presidents, Rushmore-style—was set into the bar. Walker's studio had the grandeur of a royal lodge. But Dik Browne, in Wilton, worked out of his basement, surrounded by washtubs and laundry hanging on clotheslines; the one flourish was a painted mural of God from the Sistene Chapel—features altered to make him Browne-like—an outstretched arm pointing the way downstairs. A few cartoonists, such as Stan Drake and John Prentice, rented rooms above shops in the commercial areas of Westport or New Canaan. Most worked at home.

Brian Walker, Mort's son, remembers going to a friend's house after school one day and asking, "Where's your dad?" "He's at work," came the reply. "What do you mean?" "He's in New York." It was Brian's first inkling that having your father in the house all day was not the usual arrangement. My own father worked on the third floor of our mansard-roofed Victorian until the addition of a new child every eighteen months made the house too crowded. He went on the daytime game show *Tic-Tac-Dough* in 1958 and reigned on four consecutive days until he was unable to name the American-born British violinist who

THERE'S NOTHING TO EXPLAIN, SILO — SILAS MEAD MARRIED SOPHIE PIERCE IN 1825, AND THEY HAD 12 KIDS — THE KIDS HAD KIDS, AND THEIR KIDS HAD KIDS, AND NOBODY WANTED TO LEAVE THE FARM

the addition of a new child every eighteen months

Mort Walker and Jerry Dumas, *Sam and Silo*. Cartoonists frequently made veiled references to one another in their strips. The allusion here was to the Mead Avenue home of the ever-growing Murphy family.

had recently established a music festival in Gstaad. But he walked away with $7,000 and was able to build a studio at the rear of the property. Ever afterward, the answer to any unanswerable question in our home was "Yehudi Menuhin."

The need for some sort of link to Manhattan was a singular constant, but unlike the investment bankers and advertising executives who populated Fairfield County, cartoonists were free to live as they wished. And with planning, you could even escape the constraint of geography for a spell. For two years in the mid-1960s, our family relocated to Ireland. The move required my father to get many additional weeks ahead on the strip, providing a cushion in the event that artwork was lost in the mail. Against that inevitability, photostats had to be made in Dublin of every strip before the original was sent off. Communication was difficult, in a way that is now hard to imagine. Transatlantic jet service didn't begin until the late 1950s; almost no one flew routinely between Europe and America. From Ireland, overseas phone calls had to be booked in advance, like restaurant reservations, and cost about $30 a minute; an operator would call you when your three minutes were about to start. Ordinary messages were still sent by telegram, in a clipped, pay-by-the-character

style that text messaging would revive. For all that, open an Irish newspaper and the American comic strips were there.

In Ireland, my father was also able to sketch and paint in a way he had not done in years. From the perspective of his children, the most noteworthy work he produced was done in collaboration with the Bank of Ireland. A strike had closed the Irish banks for months, and we had finally run out of checks. How could we get cash? My father went to his drawing board and found a rectangular piece of stiff white paper. With pen and ink he wrote *Bank of Ireland* at the top in a large Gothic hand, and alongside those words he drew his own fanciful version of the bank's great seal. Underneath he wrote his name and address in elegant block letters, then drew several horizontal lines that ran the length of the paper. On the first of the lines he wrote, *Pay bearer.* On the second line he drew a £ sign. He filled in his name and an amount, endorsed the back, and gave the check to my mother, asking her to see if some shop would cash it—as the local newsagent did, without comment or demur. We cashed more and more of these checks as the strike wore on.

This, to us, was a breathtaking achievement. The character Harold in Crockett Johnson's famous children's book uses a purple crayon to draw his own reality wherever he goes. My father apparently possessed this very same power. Every cartoonist did, and the boundary between actual and invented could blur in unexpected ways. Sometimes life held a mirror up to art. In the 1930s, after Al Hirschfeld caricatured Groucho Marx by playing up those triangular tufts of hair, Groucho began teasing his hair to more closely resemble the caricature.[19] The larger lesson—a very practical one—was that you could create a life out of nothing: it could pretty much be your own invention. This was what everybody in the Connecticut School had done with their sometimes jerry-built careers, each in a different and unpredictable way. My mother was clearly in on the secret. The biblical Parable of the Talents—in which a master gives sums of money to his servants to do with as they please, then punishes the man who merely kept his share safe—was one she brought up often. At

holiday times, the only direction she gave when it came to family gifts was: "Make something." She didn't doubt for a second that those Bank of Ireland checks were somehow real. All of us in the family took a certain existential freedom for granted. It did not extend to values and manners, where standards were clear, but it applied to personal interests and ambitions, and to the very idea of risk. I can still scarcely believe that, during a visit to Rome when I was twelve, my parents allowed me to spend a day wandering the city by myself.

One defining reality about cartoonists was that although their characters—Beetle Bailey, Snoopy, Prince Valiant, the Phantom, Mandrake the Magician, Maggie and Jiggs—were known worldwide, they themselves passed through life more or less without notice. It was an odd kind of fame, now nearly unknown: "anonymous celebrity," as Brian Walker once called it.[20] If you happened to bump into a cartoonist, you'd come away thinking car salesman, golf pro, or village idiot before hitting on the truth. For that reason, cartoonists made great guests on *What's My Line?*, the TV show where contestants had to figure out someone's occupation by playing a form of twenty questions. Unlike actors or sports figures, no one ever stopped cartoonists on the street. Cartoonists didn't have a "gal" to protect them or "people" to speak for them. Life was interrupted mainly by mundane chores. For most of his life, Mort Walker did the family's grocery shopping at the supermarket on Saturday mornings. More than a few collectors have bought original comic strips and found notations such as *prescription ready* or *diapers, salami, Chesterfields* penciled in the margins.

The working environment of the studio was a private place that took on the idiosyncrasies of the occupant and then, over time, hardened around him like a carapace. There was always a lot of headgear strewn about. Mort Walker kept his old army helmet on a shelf, and on the wall hung a map of the United States with pins marking the locations of all the papers that published *Beetle Bailey*. Dik Browne sometimes wore a papier-mâché Viking helmet made by one of his sons (and he looked like Hägar

even without the helmet). Those who drew dramatic strips, like *Rip Kirby* or *Brenda Starr*, as opposed to the humorous big-foot strips like *Hägar* and *Snuffy Smith*, generally kept a lot of costumes around, along with filing cabinets full of scrap. The walls of almost every cartoonist's studio were hung with original work by other cartoonists and illustrators, sometimes even original classic panels by Winsor McCay or R. F. Outcault or George McManus. Or the work lay flat in studio drawers, a capsule history of the craft implicit in the strata. Most readers of the comics probably didn't give a moment's thought to "originals," and in the eyes of newspaper editors the product that mattered was the few square inches that each strip took up on the page, not the preliminary step of actual artwork, whose dimensions were many times larger. The syndicates did not pay much attention, either. The maintenance staff at King Features was once found to be using fifty-year-old *Krazy Kat* originals to absorb water dripping from a leak in the ceiling. But cartoonists and a few fans—today a much larger group—cherished these drawings. You could sometimes see light pencil work under the inking. You could see

HOW MANY TIMES HAVE I TOLD YOU NOT TO SIT IN THAT NEW CHAIR AND NOT TO SMOKE IN THIS ROOM? GET OUT OF HERE—

the fine points of technique: an unusual method of crosshatching or a surprising use of brush instead of pen. You might find small notes from the artist to the boys in the bullpen. A cartoonist's strips would accrue in dense stacks in the syndicate storeroom, each stack about the size of a catacomb niche. Walking down the narrow aisles among the dark shelves felt like visiting a mausoleum. And there were certainly grave robbers. Periodically, batches of original strips would be returned to the cartoonist; when he checked the numbered sequence, there always seemed to be a few missing. Sometimes scores were missing.

There's a well-known Ed Koren cartoon in which one of his fuzzy characters stands warily at the center of a throng of admirers. The caption reads, "We were all wondering where you get your ideas." That was not the most common question people asked of newspaper-strip cartoonists, which for at least seventy-five years has been "How far ahead do you have to work?" (About six weeks for the daily strip, nine weeks for the color Sunday.) "Where do you get your ideas?" was the second-most-common question.[21] The lightning-bolt method—a brilliant idea just pops

into your head—was known to occur, but was highly unreliable. The *New Yorker* cartoonist Mischa Richter came by our house in Cos Cob one day and his eye fell on a Victorian shaving stand in the corner of the living room—an ornate, marble-topped set of mahogany drawers on a tall base, surmounted by a face-high oval mirror. He had a sight gag within seconds: a man standing in front of this rococo confection and shaving with an electric razor.

Mostly the process was far more laborious. Johnny Hart could expound at length on the semi-scientific approach to daydreaming that he had devised—inducing a state of creative reverie that some might mistake for wasting time in a variety of ways, such as sleeping. James Stevenson began his *New Yorker* career as a gag writer—thinking up ideas and giving them to cartoonists like Peter Arno and Charles Addams to draw. This was an actual job and came with an actual office at the magazine; it also came with this injunction from the art editor: "You must not tell anybody at the office or anywhere else what you do."[22] When Stevenson was stuck, he would make two parallel lists of familiar nouns—*truck, mother, lightbulb, cat, office, taxi,* and many more—on a single sheet of paper and then free-associate as he matched a word in one column randomly with a word in the other.[23] Otto Soglow was famous for having generated a long-running series of cartoons in *The New Yorker*, starting in 1928, based on a single picture that showed one end of a ladder emerging from an open manhole in a city street. The only thing that changed was the gag, capturing the conversation down below. ("No, Joe, Jock's father was Payne Whitney," or "The trouble with you, Bill, is you got your head in the clouds.")[24] Dik Browne sometimes sat at his desk and drew a black dot in the middle of a sheet of paper, then stared at it in a spirit of open-ended receptivity. He knew that something about this technique generally produced results, though, not being a mystic or a psychiatrist, he could not say what it was. Mort Walker carried around a notebook and recorded things he saw and heard, but he also applied the insights of the industrial-efficiency experts. He and several of

"*Do you do much reading, Bill?*"
"*Sure. I'm an enthusiastic admirer of Borzoi Books.*"

"*You see, she's an extravert and I'm an introvert.*"

"*At one time in my life, Bill, I was a voluptuary.*"

his collaborators—over the years, a variable roster that included Jerry Dumas, Bob Gustafson (who had started out on *Tillie the Toiler*), and Ralston Jones (who drew *Mr. Abernathy*)—would gather every month in his studio, each person bringing twenty or thirty gags. The group would rate them 1 for good and 2 for not good enough, with gradations of like or dislike indicated by plus and minus signs.

When he started writing and drawing *Hägar*, Dik Browne adopted a version of this method with a close-knit group—mainly family members, but also including Ralston Jones—allowing the numbers to go deep into negative territory to capture a fuller degree of loathing.[25] He claimed that the record for dislike of one of his own suggested gags was minus 47. Browne could be eloquent when talking about the unusual sort of talent ("if that's the word for it") that cartoonists possessed, and the peculiar nature of the business. "Whatever value you have walks on two legs every day and gets a headache every night," he once said. "It's you. That's all. You're your own liability. You're your own treasury. You're self-contained."[26] But Browne had little appetite for delving into the sources of humor too deeply. Doing so, he would say, was like conducting an autopsy on the girl you love.[27]

Writers of realistic story strips, sometimes known as wrinkle strips, had a different challenge—coming up with some compelling new narrative every couple of months.[28] Hal Foster was an avid reader of Greek myths and Norse legends, and of short stories by O. Henry and Guy de Maupassant—these always got him thinking along productive lines. For other cartoonists, events in the news—a political brawl, a jewel heist, a coup d'état, a business calamity, a sensational murder, a spat in the world of fashion—could prompt an idea. You generally needed a mystery or a twist—a MacGuffin, to use Alfred Hitchcock's term—or you needed to build on some ongoing dynamic in the relationship among characters. And, over time, as readers became more educated and sophisticated, characterization in story strips became more and more important, which demanded visual nuance of a kind that was unprecedented. Syl-

van Byck at King Features was skeptical when Stan Drake, my father, and a number of other cartoonists started using photographs to help capture a wider range of emotion. Illustrators had been using cameras for years—Rockwell was famous for it, and before him Maxfield Parrish. From further back, many photographs survive of the great *Punch* cartoonist Edward Linley Sambourne posing for himself with dramatic abandon.[29]

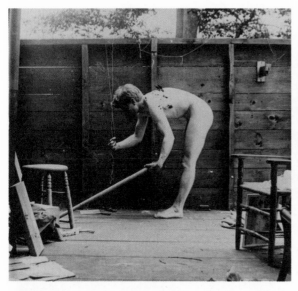

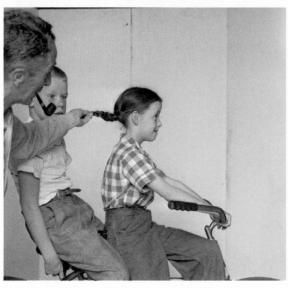
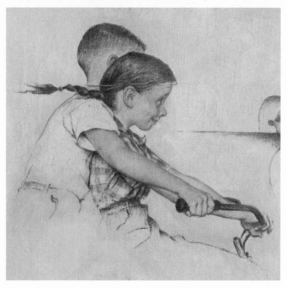

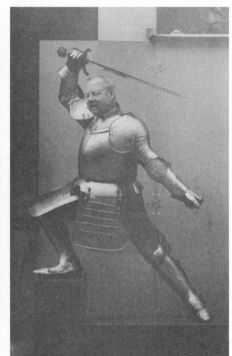

posing for himself with dramatic abandon

The cartoonist Edward Linley Sambourne (1844–1910) in a variety of roles destined for pen-and-ink treatment in the pages of *Punch*.

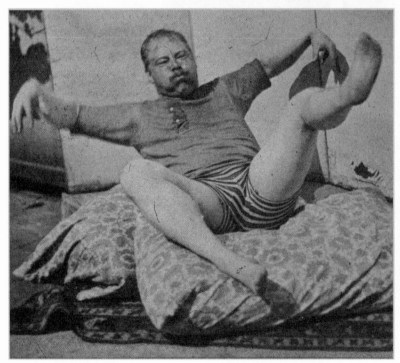

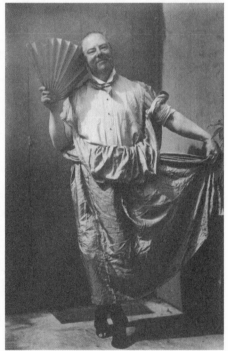

Byck wasn't skeptical about the photography; he was skeptical about the emotion. Byck was a wise and far-seeing editor, but when it came to story strips his roots lay in features from the 1920s and '30s, where action did the talking and facial expression consisted chiefly of mad, sad, bad, and glad. Many of the newer story-strip cartoonists had begun as illustrators, and in their souls would remain illustrators. They knew that a few deft lines could provide a more complex portrait of human feeling: doubtful triumph, reluctant malevolence, pleasurable melancholy. Byck worried that characters were starting to look too much like real people and wondered if readers would stand for it. He once brought the matter up with Drake, who replied, "I'm going to draw people the way they are."[30]

The cartoonists who did funny strips and gag cartoons were themselves not funny all the time. On the flip side, some of what they were quite serious about—for instance, the proposition that you can't be funny in pencil, only in ink; or that the funniest letter of the alphabet is *k*—could strike others as a joke. Mort Walker, shrewd and drily hilarious as a writer, was generally straightforward and midwestern in conversation, though he had his moments. When another cartoonist told him about an unfortunate experience he'd just had with the accounting firm Ernst & Ernst, Walker replied, "Well, Ernst is okay, but Ernst is a crook." Though his formal schooling ended after a single year at Cooper Union, Dik Browne was a man of parts. For one thing, he could draw cartoons while looking at you and talking. He once offered this definition of philosophy: "Looking for a black cat in a dark room where there is no cat." (As for religion, he said, "It's when you think you've found the cat.") Johnny Hart was a man who had found that the cat, and his occasional Christian evangelizing in *B.C.*, overlooked by the eyeshades in the bullpen, sometimes brought him trouble. (One Easter Sunday, for instance, he published a *B.C.* cartoon that showed a menorah being transformed into a cross.) Hart was known in particular for his subversive visual wordplay. He gave me the original of a strip that begins with the title character, B.C., looking at a sign that says "EXIT."

In the second panel he ponders what it's telling him to do. In the third panel he's walking away, and a big X has been painted across the syllable "IT." If Browne was Socrates and Hart was Noam Chomsky, Jerry Dumas played the role of Jean Baudrillard or Michel Foucault. His short-lived *Sam's Strip* was a self-referential homage to comic technique and the great strips of the past. Its characters knew they were in a strip, sometimes second-guessed their creator, and invited characters from other strips into their space. In one strip early on, Sam thumbs through a phone book looking for a new artist and writer. Nowadays we'd call this metatextual. Back then, it just meant not many pins in the map.

•

My brothers and sisters and I were always welcome in my father's studio, though a visit posed the obvious risk that some photographs would need to be taken and the next hour would be spent on a ladder with the camera. Or, worse, it might turn out that a panel my father was drawing called for a boy or a girl, and we would be pressed into service as models ourselves, arranged into a tableau by this demanding backyard auteur. ("That's not 'happy.' I want to see 'happy.' Let's do it again. *Happy!*") On one occasion, when I was eight or nine, I had to assume the guise of the son of a snake charmer, posing shirtless and wearing a turban fashioned of diapers. Every so often,

outsiders would be called in to play roles. My father was always on the lookout for local people who possessed what he called "an interesting face"—in many cases, a face that you yourself would never want to have—and was somehow able to persuade them to come back to the studio and stand in front of the camera. So you might stop by after school and find the new milkman under the tall floodlight holding a garbage can lid as a shield. ("'Courage.' I want to see *courage*!") Between them, *Big Ben Bolt* and *Prince Valiant* captured for posterity a sizable portion of Cos Cob society as it was in the 1950s, '60s, and '70s. But in the end my father was always his own best model. I once pointed out to him that some version of his face appeared on about half the men in a big *Prince Valiant* panel showing a wandering tribe of Goths. He said he figured they would all have been related anyway.

The studio was painted barn red, like the nearby barn itself, and I'll always think of it as a schoolhouse. A lot of education took place there. Writers can't really talk or listen when they're working. Artists can do both, and often want to. My father had never been to college, but he was widely read, and on many subjects deeply informed. His views on art and artists had long since taken firm shape. Among the Wyeths he preferred N.C. to Andrew, but was coming around to Jamie. Howard Pyle was a god. He admired Leyendecker, though greatly favoring the rough oil sketches over the final product. He was a Monet man, not a Renoir man. He admired the Renaissance masters and especially Leonardo working with black or red chalk, but observed that Leonardo couldn't draw a horse to save his life—"none of them could." Among the Dutch, he would take Frans Hals over Rembrandt any day, and when the Metropolitan in 1961 paid $2.3 million for Rembrandt's *Aristotle with a Bust of Homer*—at the time, the highest sum ever spent on a work of art at a public or private sale—he scoffed at the transaction and professed no intention of standing in line to see the painting, as thousands were doing. He would have stood in line indefinitely for Robert Henri, however, and he kept a postcard of Henri's *Bridget in Red* taped

to one of his easels. Whistler and John Singer Sargent could do no wrong. But Velázquez: "Now *there* was a master!" He loved the way the technique of Velázquez showed up in paintings by Sargent, and once explained what he meant by using Sargent's portrait of the Parisian gynecologist Samuel Jean Pozzi, whose red dressing gown was intended to recall a cardinal's robes, as an example. It was a brilliant impromptu lecture, and when at last he fell silent, the question I remember asking him was "What's a gynecologist?"

His taste in reading tilted toward biography and adventure. *Northwest Passage* and *Arundel*, by Kenneth Roberts, were particular favorites. He had read much of Alexandre Dumas—"*père et fils*," he would always stipulate. Not surprisingly, he loved illustrated books. His father had worked at Scribner's during that period a century ago when N. C. Wyeth illustrated a series of classics—*Treasure Island*, *Kidnapped*, *Robin Hood*—and he owned a complete set of these sacral texts. A special place in his affections was set aside for authors who could both write and draw. There were not all that many of them. The cowboy writer Will James was one. And of course James Thurber and Rudyard Kipling and Max Beerbohm. And again Pyle. He never took to John Updike as a novelist, but gave him credit for having wanted originally to become a cartoonist. My father had kept (of course) all the adventure books from his boyhood, their bindings frayed, which he pressed upon his children. Some of the books, like *The Jinx Ship* by Howard Pease, turned out to be remarkably good. Tom Swift should have been a thread of intergenerational continuity—my father had read Tom Swift, too, as a boy—but Tom's world had changed. My father once took *Tom Swift and His Atomic Earth Blaster* out of my hands, looked at it for a moment, and said, "I remember when it was *Tom Swift and His Motor-Boat*." If you had ever asked him for a summer reading list

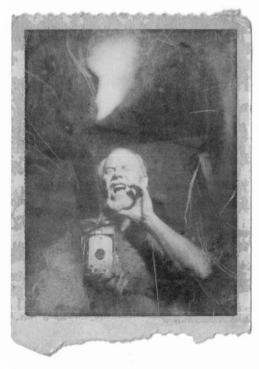

we would be pressed into service as models ourselves

Above: My father with his camera. Opposite and following page: Some of my brothers and sisters enduring various states of servitude as characters in *Prince Valiant* or *Big Ben Bolt*.

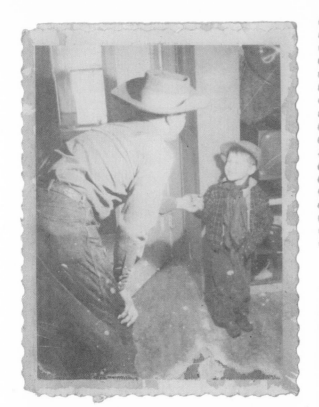
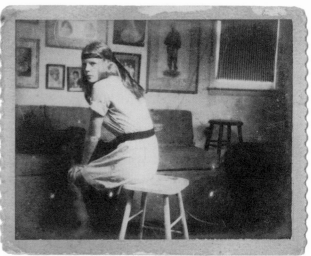
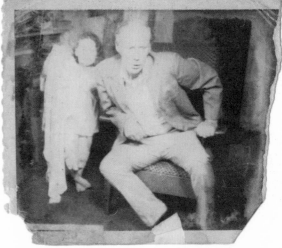
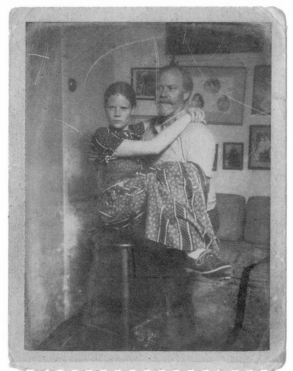
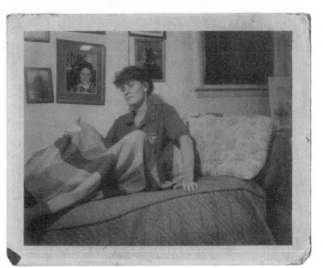

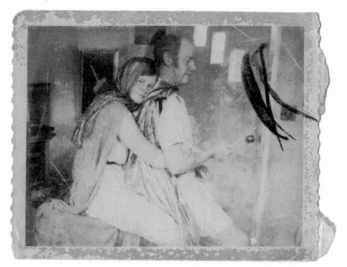

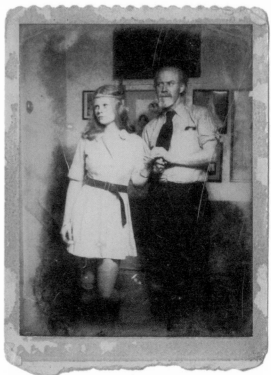

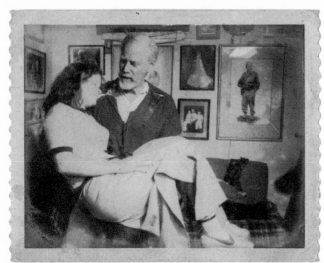

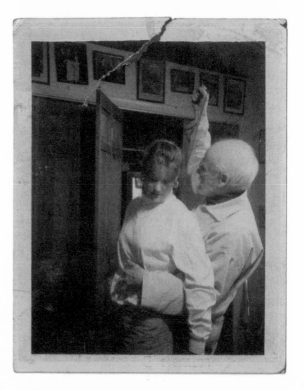

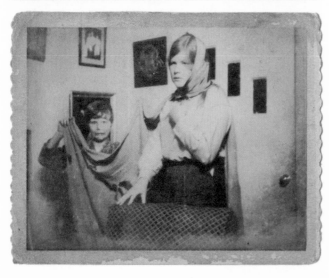

it would have been both outlandish and inspired. At the age of eleven, fed up with Dickens, I asked him for something different, and he gave me *The Autobiography of Benvenuto Cellini*, which turned out to be mildly intoxicating and the stimulus for a number of provocative conversations. ("What is 'the pox'?")

The drawing table in the studio was perpendicular to the picture window. Face-to-face with my father's table was a smaller one for whichever of us children was out there at the time. Both tables were tilted high, creating an A-frame effect and rendering the people behind them invisible to one another. But from the other side you could hear the scratch of a pen on paper and the splash of a brush in water. You could hear the plink of shavings from a pencil that was being sharpened as they dropped lightly into a pewter ashtray. During my grade school years, this was for me the place of choice on any fall or winter afternoon. It was here that my father taught me to draw and introduced me to basic techniques, such as how to create perspective ("Now you know something the ancient Egyptians didn't!") and how to treat the boundary between light and shadow when working in oil. He demonstrated how to transfer an image from tracing paper to a sheet of plain white board, blackening the reverse of the paper with graphite and a soft, cigarlike object known as a stump, and then putting the two sheets together and pressing down on the lines with a stylus. He explained why, when reproducing classical Roman script, the points of the *A*s and *V*s must slightly pierce the horizontal plane formed by the other letters; otherwise the *A*s and *V*s will seem too small. He elaborated on his view that unfinished works of art are generally more interesting than finished ones, and often better. George Romney's uncompleted self-portrait was a particular favorite, and he often completed his own paintings in the same casually unfinished way.

His regard for the craft of cartooning was high, even if in some ways it was not what he'd rather be doing. He'd *rather* be sketching people on the street or taking his paints and brushes aimlessly into the Irish or Southwestern countryside, but a comic strip paid the bills and freed him to paint only what he

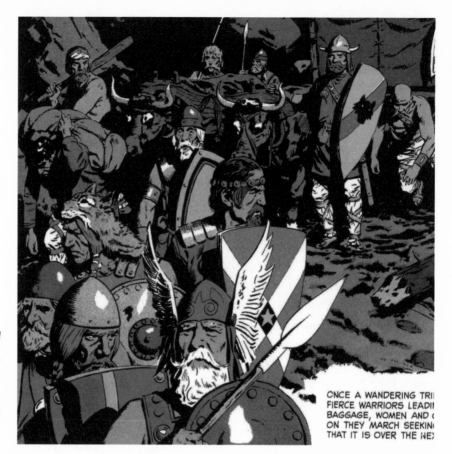

always his own best model

John Cullen Murphy, detail from *Prince Valiant*, 1971. The oxen possibly excepted, every figure displays some version of my father's face.

ONCE A WANDERING TRI[
FIERCE WARRIORS LEADI[
BAGGAGE, WOMEN AND [
ON THEY MARCH SEEKIN[
THAT IT IS OVER THE NE)

liked when he had some spare time. He loved the camaraderie of the cartooning tribe, everyone slightly off register and anxious for company. And, anyway, the kind of strips he drew offered great scope for creativity. He would lose himself in the task when creating one of those giant *Prince Valiant* panels, and he relished adding "John Cullen Murphy" to them as the final act. He was proud of that signature. It had evolved through childhood and young adulthood, and he finally settled on an official block-letter version that betrayed the influence of James Montgomery Flagg. Where Flagg had rendered each *M* in his name with three unconnected vertical strokes, my father rendered the *E* in his name with three unconnected horizontal strokes. He often cited the advice that Norman Rockwell had passed along: "Make it

large and legible. It's the only free billboard anyone will ever give you." Milton Caniff, he said, had once offered the same advice to Mort Walker. It had something of the status of a First Rule of Cartooning, and I remember looking at the funny pages the next Sunday and carefully noting that every cartoonist's signature was big and clear. "Maybe if you're Whistler," my father said, "you can get away with a butterfly."

In these hours at the studio, from behind his drawing table, my father would also backfill the story of his life. How he had been born feetfirst, "like Sinatra and the Kaiser." How his father would save the cardboard backing from his laundered shirts so he could have a firm white surface to draw on. How, in the 1920s, Gabby Hartnett of the Cubs had been a lodger in his family's Chicago apartment. How, in the late 1930s, when he sold his first professional painting, Toots Shor had pulled a fifty-dollar bill from his pocket to pay for it—an example of unthinking largesse that my father still found almost unimaginable. How the hardest thing to draw was hands. How if he couldn't have been an artist or a ballplayer he would like to have been "a minor nineteenth-century poet." How he had asked my mother to marry him after dating her for only a month.

He was drawn to family history not for the pedigree but for the perspective. One of his grandfathers had been born while Thomas Jefferson was still alive; he found that astonishing—that the cord of his known family could subtend almost the entire arc of America's national history. Family lore was also full of near misses: the genetic path to oneself could look very iffy in retrospect. His paternal grandmother, during the passage from Ireland as an infant, was nearly thrown overboard because she

he finally settled on an official block letter version

For any cartoonist, a signature was an advertisement. My father's had roots in an admiration for Flagg.

93

I have been very good,——the precise line I have described in it being this :

A B c c c c c D

By which it appears, that except at the curve, marked A. where I took a trip to *Navarre*,——and the indented curve B. which is the short airing when I was there with the Lady *Baussiere* and her

was thought to have typhoid. Her fever broke just in time. The lesson he took from all this was that "I" hangs on a long thread, but it is a thin one.

My father had plenty of advice to dispense, the most common theme being how to behave like a gentleman. Don't talk about money. The trouser cuff should rest on the instep. Don't tell all you know. Stand up when a woman enters the room—and if people think that's old-fashioned, so much the better. Be skeptical of good fortune—his response to happy personal news was generally "Well, it's better than a sharp stick in the eye." Though his formal education stopped at high school, like many cartoonists my father had a love of words and wordplay. His idea of a perfect name for a law firm was "Gold, Frankincense, and Murphy." If someone on the radio or television used the phrase "parting shot" he would invariably note that this was a bowdlerization of "Parthian shot," which referred to the ability of the ancient Parthians to shoot backward from their saddles while galloping forward. The way it wallows in baroque language made Laurence Sterne's *Tristram Shandy* a favorite book. (As an added bonus, Sterne sometimes broke into the text with graphic elements: "He

could have been a cartoonist.")[31] My father regarded puns as a serious business. After returning from a church fund-raiser, he pronounced the event "a fete worse than debt." Had he gone to the event just to be able to make the remark? He was partial to the rarely used positive terms hidden inside familiar negatives: *ept, ert, gainly, gruntled*. And he liked highfalutin words, not for the grandiloquence but for the humor. They could put a smile on a serious point, as when noting that our family was "not an eleemosynary institution." The word *sesquipedalian* occupied a place of honor—a visual pun, the physical embodiment of its very meaning.

His reservoirs of arcane knowledge, odd prejudice, and unexpected enmity were astonishing. He could talk with equal authority about the incidence of hemophilia among the Romanovs and the success of Fordham football teams from the 1930s, recalling the scores, game after game, season after season. His store of information about sports was immense. He both hated and loved the Polo Grounds; I remember being taken to a game there during the Giants' last season in New York, and being lifted in his arms to use the high tin trough that served as a urinal. When he saw someone with bad table manners, he would say, "You can always tell a Princeton man"—an insight passed down verbatim from his own father, and based on nothing whatsoever. He was well aware of the high marks being given to Jackie Kennedy as first lady, and concurred up to a point, but to him Grace Coolidge had set an impossibly high standard—she'd been plucky, outgoing, and a serious baseball fan. (At the other extreme, the standard for perfidy, on multiple fronts, was set by Lillian Hellman, who was "a louse"—the harshest term of disparagement he was comfortable using.) The challenge posed to royal succession by morganatic marriage was, for some unknown reason, a particular specialty of his, and if the names of certain historical figures happened to come up—Archduke Franz Ferdinand, to take the most prominent—he would put a hand to the side of his mouth, as if speaking confidentially, and say, "Of course, his marriage was morganatic." On more than one occa-

sion he warned against confusing the British Indian Army and the British Army in India. ("A frequent mistake.") His store of knowledge sometimes led to behavior that others considered eccentric, or even mad. There is a moment in *Dr. No* when Sean Connery, ascending some stairs for dinner with the eponymous villain, does a barely perceptible double take as he passes an oil painting on an easel. Watching the movie for the first time, in 1962, my father laughed loudly in surprise. Silent patrons, possibly including my mother, angled away uncomfortably. The painting, he later explained, was Goya's portrait of the Duke of Wellington. It had been stolen the year before from London's National Gallery.

Religion as a topic was hard to escape. Ours was a deeply Catholic household, but not an officiously didactic one, and religion was never thought of as something separate from a life lived in the world. For that reason, my father's religious reading consisted almost entirely of biographies—of people like Chesterton and Belloc, Joan of Arc, Cardinal Newman. Holding a place of particular honor was Evelyn Waugh's novelistic *Edmund Campion*, about a London bookseller's son who became a Jesuit and, in the violent religious climate under Elizabeth, was drawn and quartered on Tyburn Hill. It was a book he had first read during the war, and he could go on at length about Campion—not so much about the grim details of his execution (sadly) but about Campion as a poet and dramatist, Campion the beloved teacher during his exile in Prague, Campion the penniless man who had walked a thousand miles from northern France all the way to Rome to pursue his studies. What drew him was not theology but the example of Campion's gentle temperament and the fact that Waugh had written Campion's life as an adventure story. Walk to Rome—wouldn't that be something I'd like to do someday? he'd ask. And, by the way, wouldn't "Drawn and Quoted" be a good name for a cartoon feature?

As we talked in the studio, the black-and-white TV would be on softly, generally showing an old movie and usually featuring an actress unknown to me but invariably described as "a

great beauty in her day." In wintertime, dusk would come long before my father finished work, and as the sky darkened outside, the glass of the picture window gradually turned into a mirror. From my stool I now had an angled view of my father's hands at work—a picture to go with the ambient sound of pen and brush.

During those long hours in the studio there were frequent stories about his experiences in the war. Lenny Bruce used to say that there was only one "the Church," and for the Connecticut School of cartoonists there was only one "the war." Most of them had served overseas during the Second World War—my father for three years in the Pacific, on General Douglas Mac-Arthur's staff—and it was during the war that many of them had discovered or sharpened the talents they would deploy for a lifetime. In the 1950s, the war was not some distant Waterloo, but an event barely a decade past. Some cartoonists could still fit into their uniforms. Children wore old helmets and ammunition belts and even khaki spats when they played outside. The bowl in which my father dipped his brushes, now encrusted with ink and pigment, was a Japanese rice bowl, picked up in Tokyo during the occupation. A polished wooden box in a corner of the studio bore the name *Capt. John Cullen Murphy* in gilt letters that still shone, and it opened on hinges to reveal compartments for paints and brushes, pens and pencils, paper and canvas. The box retained a dry, musty smell, like that of mild sandalwood. To me it seemed to possess a talismanic quality, as if it had somehow made possible everything I saw around me. And in important ways, it had.

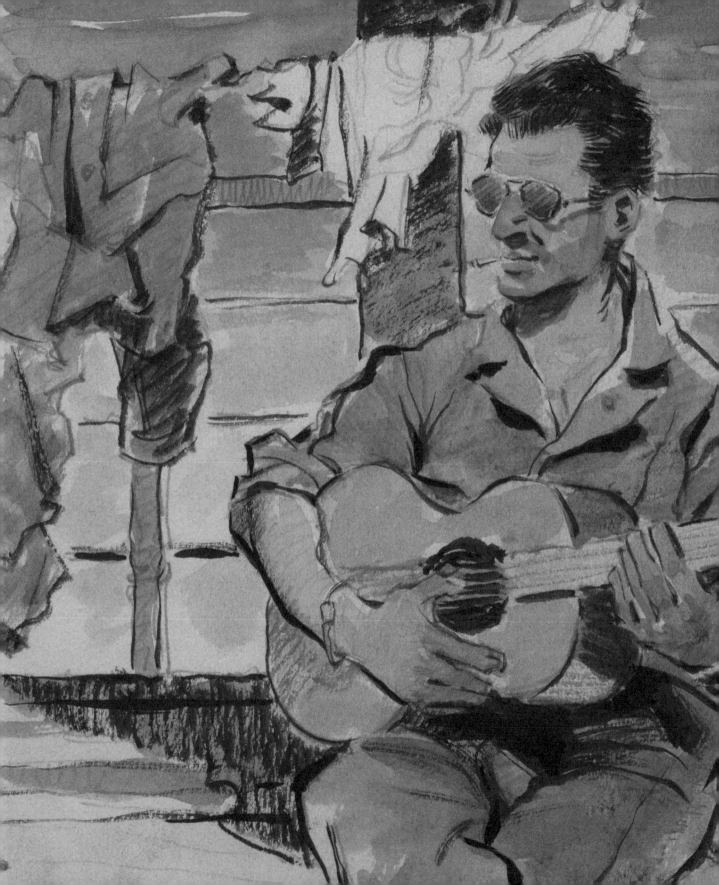

THE ART
OF WAR

Mt. Vesuvius stretches 4,000 ft into the sky and
is constantly overhung by soft pink clouds.
 Guide to Naples

For many members of the Connecticut School, indeed for most, the Second World War was the great common denominator. Cartoonists came from many backgrounds—there were college boys at one end and drifters at the other—but they had pretty much all been through the military during wartime. Some served stateside, and some even had duties that never called for them to leave Manhattan, but the largest group were veterans of the conflict in Europe or the Pacific. The words "the war" slipped into conversation almost as easily as "the syndicate." The references were generally to people they'd met or to ordinary life in the service and not to the grimmer things they may have seen and experienced. A number of cartoonists and illustrators, including my father, had just launched careers when the war began. Stan Drake had attended the Art Students League and was already drawing comic books, though he also had his mind on Hollywood. At one point he actually did a screen test for Paramount with Claudette Colbert—and then came Pearl Harbor.[1] Others discovered and developed a hidden artistic talent while serving in uniform. They published their work in military publications like *Yank*, *Leatherneck*, and *Stars and Stripes*, or sent it to newspapers and magazines back home. A few, such as Dave Breger,

the great common denominator

Preceding pages: From John Cullen Murphy's wartime notebooks, a shipmate on the passage from Oakland to the South Pacific, 1943. Opposite: Recollections of the Italian campaign, Mort Walker, 1945.

who created the strip *Private Breger* while serving as an army truck repairman, and who earned immortality (but not royalties) by inventing the name G.I. Joe for a strip that appeared in *Yank*, got syndication deals while the war raged on.[2] Like many cartoonists, Breger had started out drawing gags for magazines, publications that for the most part no longer exist—*The Saturday Evening Post*, *Collier's*, *This Week*, *Click*. He signed with King Features in 1943. By the time I met him, the strip was on civilian footing as *Mister Breger*, though the eponymous central character was still a loose, pudgy, bespectacled caricature of Breger himself. Bill Mauldin, who participated in the invasion of Italy, won fame—and a Pulitzer Prize in 1945—for his single-panel cartoon *Willie and Joe*. He may have been the only Pulitzer recipient in history who didn't know what a Pulitzer was, but he was grateful for the $500 that came with it. Mauldin's gritty, acerbic, antiauthoritarian style earned the enmity of his commanding officer, General George S. Patton, among others. One famous Mauldin cartoon shows two officers taking in a majestic landscape. The caption reads, "Beautiful view! Is there one for the enlisted men?" Patton once called Mauldin into his office to dress him down, but no one else in authority paid any attention, and Mauldin carried on as before.[3]

Having tasted the military's regimented and bureaucratic ways, the cartoonists went in a different direction for the rest of their lives. They were creatively self-employed and vaguely anarchic. I remember sitting in on a cartoonists' lunch that my father was hosting at our home, sometime in the early 1970s. He tended to be skeptical about conventional taglines for any historical era—"the Age of Reason" as a synonym for the Enlightenment would reliably trigger a discourse on the French Revolution—and at lunch he brought up the subject of the 1950s, which he'd heard some commentator on TV refer to as "a decade of conformity." There was a collective snort, followed by

lugged around art supplies and a camera in his Jeep

Above: A moment caught by Joseph Farris during the attack on the town of Bitche, in northern France, 1944. Opposite: Bomber pilot Charles Saxon, 1944.

a riot of shouted disproofs. Miles Davis! Nichols and May! The civil rights movement! Eero Saarinen! Abstract expressionism! *Lolita*! As cartoonists saw it, conformity was not a major feature of the landscape they inhabited, no matter what the train platform at Cos Cob might look like at 7:00 a.m. on a Wednesday. The people they knew were all living by their wits.

Mort Walker, Joe Farris, Dick Wingert, and Roy Doty had all been in Europe. Walker had served as an officer at an ordnance depot in Naples and then oversaw German prisoners of war. After Germany's surrender he was given the job of destroying U.S. Army equipment, such as wristwatches and binoculars, by running over it with tanks so that it didn't have to be shipped home. He began to realize, he would say, that "army humor writes itself."[4] Eighteen-year-old Joseph Farris, one day to be a *New Yorker* cartoonist, led a machine-gun squad in France and Germany, but lugged around art supplies and a camera in his Jeep, later publishing some of his letters and paintings in a book. "My drawings were, in a sense, my future," he acknowledged.[5] Chuck Saxon was a bomber pilot with the Army Air Corps who flew forty missions over Germany. Once, after returning from a mission, he complained to his copilot about a member of the crew who had been screaming in terror all during a heavy flak attack. He wondered who it had been. The copilot said, "That was you."[6] On the ground, Saxon spent much of his spare time drawing. His first contribution to *The New Yorker*, a small piece of spot art scarcely hinting at what would come, was published in 1943. Roy Doty was supposed to be sent to Europe with the Army Signal Corps, but the comic strip he'd been doing for the base newspaper at Robins Field, in Georgia, earned him a job at *Stars and Stripes*, in Paris. The exposure to European-style cartooning—minimalist, cerebral, often wordless—influenced his style from that

point on.[7] Dick Wingert found himself in the first U.S. infantry division dispatched to Britain. Eventually he was given a staff job in London at *Stars and Stripes*, where he created the comic strip *Hubert*, about an ordinary soldier. A chance wartime meeting in France with William Randolph Hearst led to the strip's stateside syndication, and Wingert would go on to draw a civilian version. Morrie Turner, one of the few African American cartoonists, and the first to get a syndicated strip, *Wee Pals*, flew with the Tuskegee Airmen; he took up cartooning only after the war, when he met Charles Schulz, who took an interest in his work and encouraged him to continue. Schulz himself was in France and Germany. He wasn't a notable artist during the war, but one famous incident—refusing to toss a grenade into a gun emplacement because he'd seen a little dog wander inside—offered a clue to the future.[8] Mel Casson, who would draw *Redeye* and *Boomer*, among other strips, was one of the most soft-spoken cartoonists in the group. At age seventeen, before the war began, he had signed a contract to draw cartoons for *The Saturday Evening Post*—the youngest cartoonist ever to do so. A few years later he enlisted. Casson rarely talked about it, but he had landed at Normandy and earned two Purple Hearts, two Bronze Stars, and the Croix de Guerre.[9]

For some reason—maybe because so many of them had served in the navy—a majority of cartoonists were veterans of the war in the Pacific. Elliot Caplin, who wrote *Big Ben Bolt*, *The Heart of Juliet Jones*, and several other strips, had won a Purple Heart while serving on a minesweeper—again, not something that came up a lot. Stan Drake, who would collaborate with Caplin on the beautifully illustrated *Juliet Jones* before drawing *Blondie* later in his career, was in the Pacific, too; he had only just started out as a cartoonist before the war, drawing for pulp magazines. John Prentice, who would take over *Rip Kirby* after Alex Raymond's death, enlisted early enough to have been bombed at Pearl Harbor; he served on destroyers during the campaigns for Guadalcanal, Iwo Jima, and Okinawa. Bil Keane of *The Family Circus*, an army man, spent three years in the Pacific theater and

drew a comic feature for *Pacific Stars and Stripes* called *At Ease with the Japanese*, a cartoon that made ample use of wartime racial stereotypes, and was very much a product of its time.[10] Alex Raymond, well established as a marquee comic strip artist, saw action as a marine aboard the escort carrier USS *Gilbert Islands*. His painting *Marines at Prayer* (1944) was widely circulated as a poster and hailed by the *United States Marine Corps Headquarters Bulletin* for "depicting in its impressive sincerity the worship and reverence that our fighting men carry to the very battle lines."[11]

And then there was a group that never left the United States—their talents were known when they enlisted, and the military, despite a reputation for ignoring common sense, put them to work doing what they actually knew how to do. Mexico-born Gus Arriola was an animator at MGM and had just signed a syndication deal for his strip *Gordo* when the war broke out, and he promptly signed up. Arriola spent the war in Hollywood, making animated training films for the First Motion Picture Unit. George Baker, also an animator, won a cartooning contest for servicemen and created the strip *The Sad Sack* for *Yank*. Dik Browne had been working in the art department of the flagship Hearst newspaper, the *New York Journal-American*, when he enlisted in 1942. He was put to work drawing maps and charts for the Corps of Engineers, and on the side he created a comic strip called *Ginny Jeep*, about a WAC, for the newspaper of the Third Air Force. (He also drew a comic book, featuring a character named Willie Gettit, to warn military personnel about the dangers of venereal disease.)[12] Bill Hoest, who would go on to create *The Lockhorns*, drew posters for the USO. Hank Ketcham, later famous for *Dennis the Menace*, had worked in animation before joining the navy; he served as a photographic specialist in Washington throughout the war, and on the side drew a comic strip called *Half Hitch*, about a sailor. Bob Montana created the character Archie before the war and launched the eponymous comic strip right after; in between, he worked in the Army Signal Corps,

to warn military personnel about the dangers of venereal disease

The character Willie Getit, created by Dik Browne for a wartime information campaign.

along with William Saroyan and Charles Addams. Zack Mosley, an aviator, created the strip *Smilin' Jack* in 1933; during the war Mosley never left the States, but he flew three hundred missions as a member of the West Palm Beach Civil Air Patrol.

Some cartoonists were too old to serve, or not fit enough. Their comic strip characters went to war instead. Roy Crane launched *Buz Sawyer* in 1943 and sent its hero to the South Pacific. From time to time, Crane wrote public-service pitches into the strip on behalf of the navy.[13] Milton Caniff failed his physical—he had phlebitis—but Terry Lee, the hero of Caniff's *Terry and the Pirates*, also went to the Pacific, flying with the U.S. Army Air Force. Caniff went even further, creating a spin-off strip called *Male Call*. It was built around a voluptuous Asian pinup girl named Miss Lace, and was set at a U.S. base in China. The strip ran for three years in *Stars and Stripes*, until the end of the war; the ever-vigilant censors for once stayed their hands, giving *Male Call* wide latitude to present sexually charged material that never would have been allowed back home. Caniff refused all compensation for this work.[14]

•

For most people, the visual image of World War II has been formed by photography. My own image was formed by the hundreds if not thousands of pencil drawings, pen-and-ink sketches, and watercolor paintings that my father produced while serving in the U.S. Army in the Pacific. The pictures were hung all over our house in Cos Cob: in stairwells, in hallways, in bathrooms. They figured prominently among the works displayed in my father's studio. They lay heavy in drawers and formed canopies in rafters. I grew up

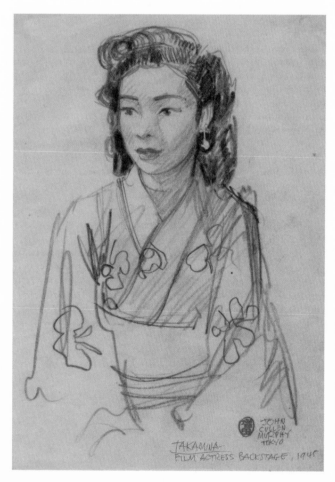

entered his life for no more than a few minutes

John Cullen Murphy, watercolor done in New Guinea (right) and pencil drawing done in occupied Japan (below), 1945.

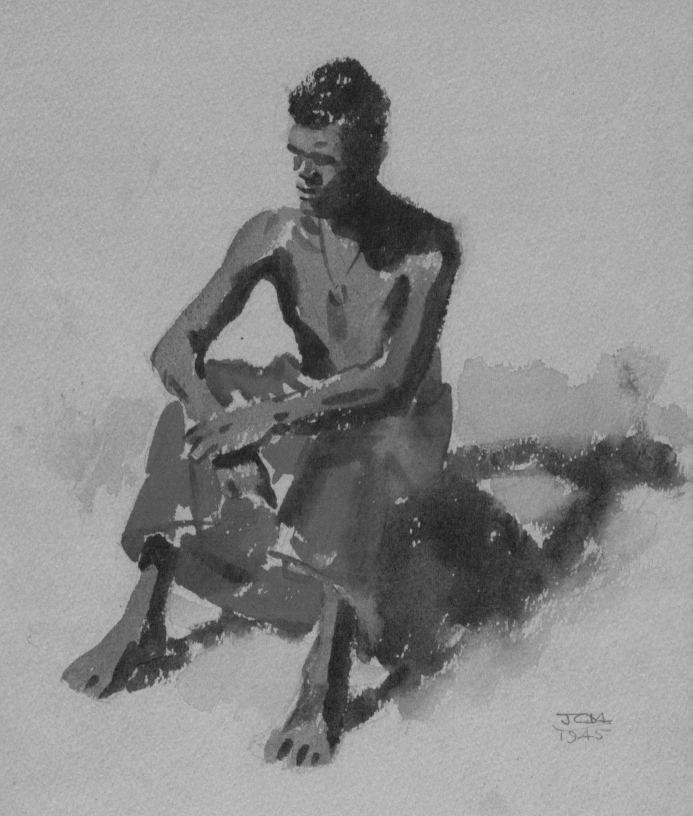

living and traveling with MacArthur's staff

John Cullen Murphy, street scene in postwar Tokyo, 1945. He sent paintings back to the U.S., hoping to interest newspapers. The *Chicago Tribune* published this one.

with these pictures of American soldiers and sailors whom my father knew well; of people from the Philippines and New Guinea and Japan who may have entered his life for no more than a few minutes; of landscapes in splendor and cities in ruin. Some of the pictures record matters of historical moment. Because he was for much of the war the aide-de-camp to a general who had escaped from Corregidor with Douglas MacArthur, and who was in command of American antiaircraft forces in the Pacific, my father spent a considerable amount of time living and traveling with MacArthur's staff. The work he produced during the war

was essentially private, done for himself and his friends and family, but it shaped him profoundly, just as wartime work shaped so many artists and cartoonists.

Growing up, my brothers and sisters and I thought of the Seventh Regiment, in New York, as the family's personal military contingent. Our martini glasses and pilsner glasses and brandy snifters, still in use, bore its regimental arms. My father's namesake (and mine), his uncle John Cullen Murphy, had lied about his age and, at sixteen, joined the Seventh when the United States entered the First World War. He promptly

shipped out, and within a few months of arrival, in the fall of 1917, was horribly wounded and gassed on the edge of a stream in northeastern France. He lived a long life, but never fully recovered. A generation later, after the onset of a second war in Europe, but before Pearl Harbor, my father and his older brother, Bob, both joined the regiment. Bob was destined for a general's star, his future likely ordained from the moment when, as a toddler, he was picked up and held by the white-suited military bandmaster John Philip Sousa, repaying the gesture by wetting his pants. The Seventh was a fabled unit whose origins went back to the New York State militia before the War of 1812. It had come to be known as the Silk Stocking regiment because of the social standing of many of its volunteers. Robert Gould Shaw, though a Bostonian, briefly served with the Seventh during the Civil War. It was the Seventh that broke the Hindenburg Line in 1918, suffering more casualties in a single day than any other regiment in American history.

The Seventh Regiment was headquartered at the armory that bears its name on Park Avenue at Sixty-eighth Street. Today the armory is mainly what is called an "event space," and is used for antique shows and book fairs and theatrical spectacles. During my childhood it was very much a military outpost, with regimental offices and grand public rooms dating back to the Gilded Age, with baronial woodwork and vast expanses of stained glass designed by Stanford White and Louis Comfort Tiffany. White-jacketed stewards staffed the elegant restaurant. My father enlisted in the Seventh in July 1940, drawn both by patriotism and, as he would be the first to admit, by the sheer aesthetic appeal of the regiment. There may also have been an Irishman's amusement at adding some coarse wool to those silk stockings.

If you viewed my father's wartime artwork in chronological order you'd get a stunning visual history of the conflict. The stack would be seven or eight feet high. The first drawings would be from 1940 and 1941, a period when America's entry into the war consuming Europe and Asia seemed highly probable, if not yet inevitable. The nation's state of readiness is suggested

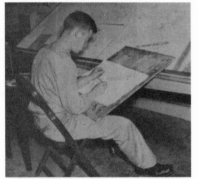

carried a pad, pencils, and a sketching pen at all times

Above: Grabbing time to draw at various billets from the U.S. to the Philippines, 1943–45. Opposite: In the doorway of his family home in New Rochelle, shortly after he enlisted.

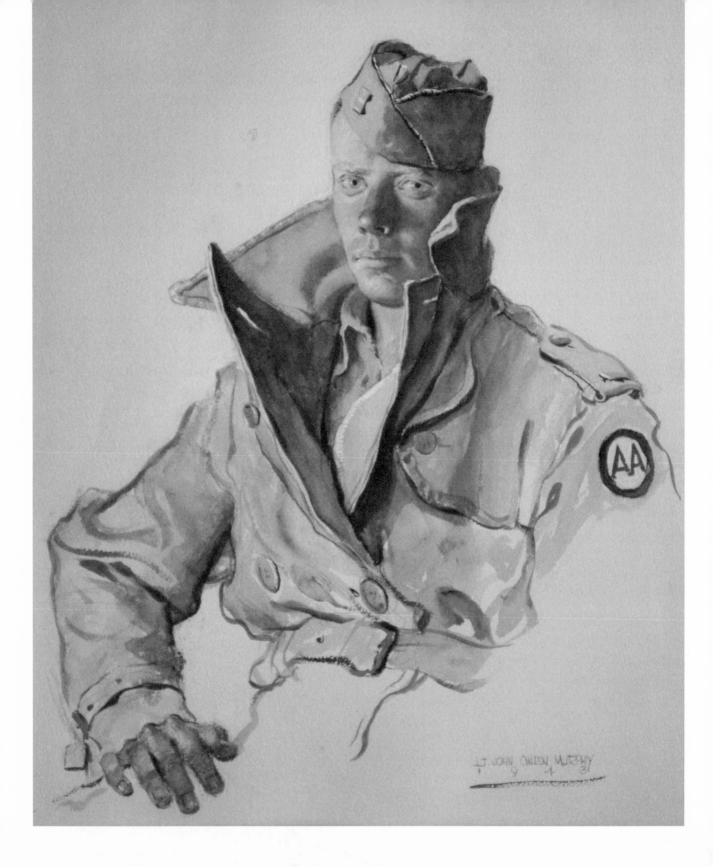

LT JOHN CULLEN MURPHY
1 9 4 3

by the uniforms, unchanged since World War I. Infantrymen still wore the old doughboy helmets. The Springfield rifles with which the soldiers trained were of turn-of-the-century design. When the Seventh Regiment was put into federal service, in February 1941, it became an antiaircraft unit; the antiaircraft guns it used for training, at Camp Stewart, in Georgia, were made of wood. A few real ones arrived in time for the great maneuvers that took place along the Eastern Seaboard from September to November 1941, with the First Army, led by General Hugh Drum, opposing the Third Army, led by General Patton. (Patton was ultimately declared the loser by army referees.) The Japanese attack on Pearl Harbor came one month later. My father remembered spending December 8, 1941, at Camp Stewart, painting a portrait of General Sanderford Jarman, the commander of the nation's Atlantic coastal defenses, who, even as he posed, was issuing orders and urgently redeploying troops up and down the East Coast.

My father was a first lieutenant when he shipped out from Oakland, California, in 1943. Before he left he had made a quick trip to see Norman Rockwell, now living in Vermont; he remembered that Rockwell at the time was experimenting with composition options for the painting *Freedom of Speech*, one of the famous Four Freedoms quartet. My father disembarked in Australia, where MacArthur, following the disastrous retreat from the Philippines, had established his general headquarters. In his sketchbooks my father made scores of shipboard drawings on the *Boschfontein*, a Dutch vessel that had been in an American port when the Germans overran the Netherlands, in 1940, and was promptly requisitioned by the U.S. Navy. The only other ship spotted during the three-week voyage to Australia was a schooner that happened to be the flagship of the Tongatapu navy.

In Brisbane, where the U.S. command was based, my father was sent to bomb-disposal school. Bomb disposal is a task to which my father would have been particularly ill-adapted. He survived the war because he was asked by a superior officer to

done for himself and his friends and family

Lieutenant John Cullen Murphy, self-portrait, 1943. The painting involved the use of a mirror, so the image is in reverse.

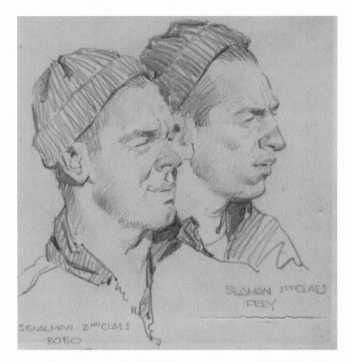

SEAMAN 1ST CLASS
FREY

SIGNALMAN 2ND CLASS
BOBO

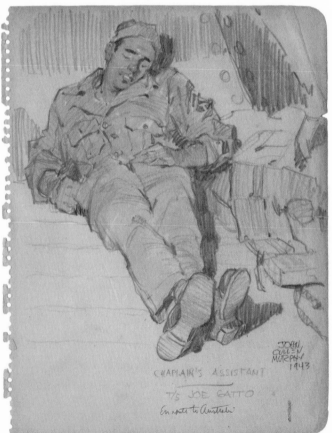

JOHN
CULLEN
MURPHY
1943

CHAPLAIN'S ASSISTANT

T/5 JOE GATTO

En route to Australia

scores of shipboard drawings

These and following pages: Sketches
and paintings done aboard the
Boschfontein during its three-week
transit of the Pacific, 1943.

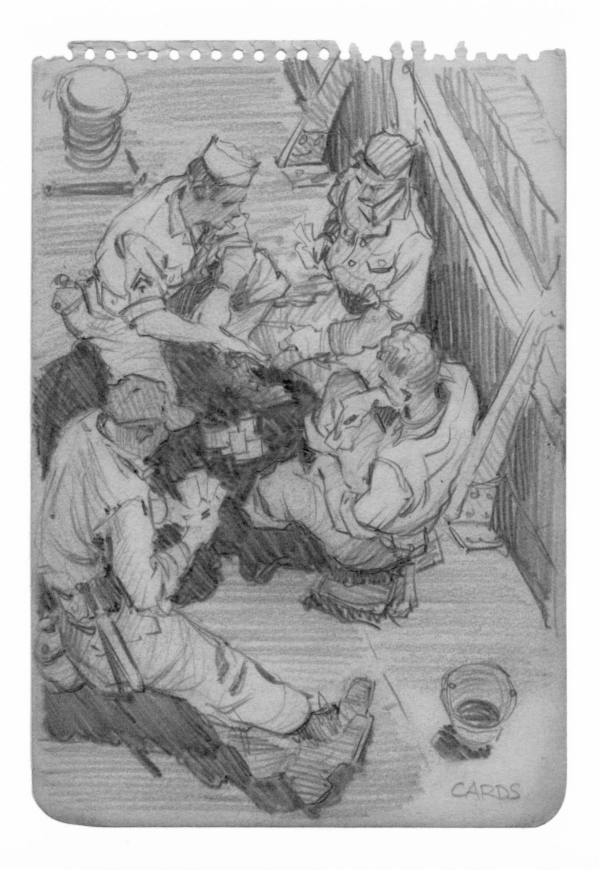

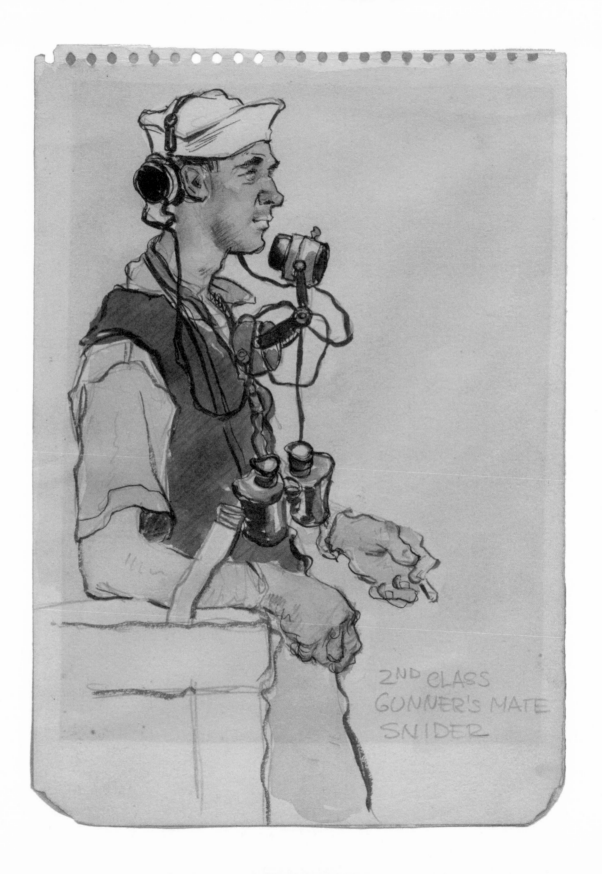

2ND CLASS
GUNNER'S MATE
SNIDER

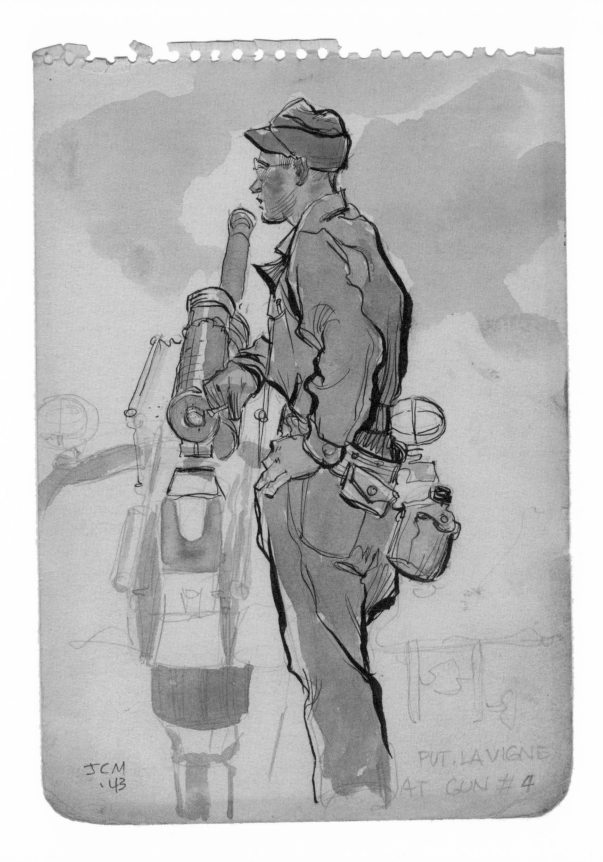

PVT. LA VIGNE
AT GUN #4

JCM
'43

draw a caricature of General William Marquat. The caricature, intended as a gift, was blunt—Marquat had a badly broken nose—and made a strong impression on its recipient. A few days later, Marquat, wanting an artist with such a sensibility in his own camp rather than someone else's, added my father to his staff and assigned him the task, in his spare time, of painting oil or watercolor portraits, usually from life, of seemingly every American (and Australian and British) general officer in the Pacific, as well as important political figures, such as the president of the Philippines. Marquat's broken nose was misleading: he was adept at soft diplomacy, and the portraits he commissioned greased favor throughout the war from all quarters of an often sluggish military machine. On the rare occasions when my father expressed skepticism or unease—he was eager to contribute to the war effort, which to him meant personal participation in actual combat—Marquat resorted to soft diplomacy again: Hadn't monarchs of yore (he suggested) used Holbein and Van Dyck to similar strategic ends? It was an unfair fight. Photographs of some of these portraits would eventually hang in my father's studio; it is no coincidence that his eight children all knew the name of the commander of the Eighth Army, General Robert Eichelberger, and could pronounce it at a very early age. It was as familiar and mellifluous as Yehudi. My father also produced during the course of the war several portraits of each member of

118

the MacArthur family: the general; his wife, Jean; and their son, Arthur.

After the debacle in the Philippines, the land war against the Japanese was resumed in New Guinea. My father's whereabouts reflected those of the general headquarters of the Allied forces in the southwest Pacific. He was based first in Port Moresby, then in Hollandia, then in Leyte, then in Manila, then in Tokyo. He carried a pad, pencils, and a sketching pen at all times. The rest of his supplies were stored in that varnished box we all knew so well; he'd had it made in Australia, and had waited to have his name formally lettered on the lid until his promotion to captain came through.

As I listened to my father on those darkening afternoons in the studio, it was odd to think that the box had been his physical companion during every wartime episode he mentioned—providing a kind of implicit corroboration. It sat on the floor, a mute witness, as he described how, returning with MacArthur to Manila, he watched as Allied troops burned piles of dead Japanese soldiers along the roadway. Or how, by chance, he'd first met Fray Angélico Chávez—known to me only as an old family friend and a quirky historian of New Mexico, whose roots in Santa Fe went back sixteen generations—because he'd been the chaplain in Uncle Bob's unit throughout the war. Or how MacArthur would stand on the veranda of his house in the Philippines, corncob pipe clenched in his teeth, and listen as white-frocked children sang to him, acknowledging them regally, but saying little or nothing. Or how, alone among the people my father painted, MacArthur's intelligence chief, General Charles Willoughby, made him redo his portrait from scratch. ("He was Prussia-born—Weidenbach was the name. The 'Willoughby' fooled no one.") Or how, wherever he was billeted, he would give "chalk talks" to the troops—drawing caricatures of the men (and, audaciously, the officers), giving himself a one-minute time limit for each one, a soldier with a watch standing by. Or how, back in New Rochelle, his mother would gather the paintings he sent home and bring them to

magazines and newspapers all over New York. And how the varnished box itself was once nearly lost in a swollen river in the jungles of Luzon.

•

There was actually another means of corroboration, though I didn't have any extended acquaintance with it until after my father's death. This came in the form of the daily diary he kept during the war and of the eight hundred or so letters he sent from the Pacific to his mother, who kept and preserved them.[15] All of this material sat on a shelf in the studio, gathering more dust than attention. Occasionally my father would copy a page from the diaries and send it to me when something in the news—the death of the journalist Teddy White or of the songwriter Irving Berlin, for instance; or the publication of Barbara Tuchman's biography of General Joseph Stilwell—sparked a memory of an encounter during the war. My mother sampled some of the letters over the years, perhaps wondering as she did so why none of her own children were such faithful correspondents. Not until my father was gone did I read the diaries and letters from start to finish.

It is a slightly unsettling feeling to be able to retrace the daily footsteps of someone you know and recognize, and with whom you were close, understanding that those steps were taken before you existed. The man I knew rings in every sentence—the deep religious faith, the love of sports and Broadway shows, and the precocious confidence in his own outlook and cultural tastes, coupled with a fundamentally good-natured trust and a Jimmy Stewart–ish naïveté. He goes to Mass and confession regularly. He cannot believe the luck that has landed him a billet at GHQ, where everyone he sees is some military grandee recognizable to any reader of *Time*. He talks about the people who walk in and out of his life, or sometimes, like the chaplain Father Chávez, become a permanent part of it. ("Seems like a very fine fellow, and really knows how to get along with the men. So many try to 'reform' the fellows, and

the eight hundred or so letters he sent from the Pacific

Opposite and following pages: The wartime correspondence, all to his mother, frequently contained cartoons and sketches.

Hi, Sarah-Jane!

I guess this'll reach you around Christmas-time, so Merry Christmas, everybody!

Too bad about Frank Graham — but maybe Tom'll have better luck. Any news from Walker as yet?

Glad to hear the good news about Harry Story and Al Mellon. They're both good boys.

Christmas-day I'll be in Los Angeles with some friends of Bill Spain's. We have the preceding day off too, so I should have a nice time.

Yesterday, Lt. Col. Vlack, the adjutant for AATC, called me and asked me

No.

John C. Murphy

(CENSOR'S STAMP)

MRS. ROBERT F. MURPHY
52 LORD KITCHENER RD.
NEW ROCHELLE, N.Y.
U.S.A.

LT. JOHN C. MURPHY
(Sender's name)
HQ., 6TH AAA GROUP
APO 922, % POSTMASTER
(Sender's address)
SAN FRANCISCO, CALIF
SEPT. 29., 1943
(Date)

Dear Mother,

Forgot to tell you in my letter yesterday that I saw "The Merry Widow" on the stage recently, and it was a well-produced show. Of course the music is beautiful: "Merry Widow Waltz," "Velia," "At Maxim's", and "Girls, Girls, Girls." I really loved it! I imagine you've seen it before, haven't you? I believe it's running on Broadway now with Jan Kiepura and Marta Eggerth, is it not?

I'm getting a great deal of fun out of reading "Punch." It's an English version of "the New Yorker," you might say. Or vice versa! I like it a lot.

Did Bob Berry ever visit you like you said he was going to? He's a nice fellow, isn't he? I'll bet when I get back home I'll be able to give a swell imitation of their jargon. Everything is "bloody" to them!

THE MAJORS HERE ARE VERY SHARP!

HERE'S A SKETCH I JUST MADE OF AN AUSSIE 1ST LOOIE!

The war news is really coming along O.K., isn't it?

S'all for now —

Love, Jack

V ··· MAIL

POST OFFICE DEPARTMENT PERMIT NO. 1

Somewhere in the Philippines —
4 March 1945 —

Dear Mother:

We're rapidly running out of typewriters and let me tell you that it'll be a mighty tough war to fight from now on!

Tomorrow I am moving to the Big Town. to stay. Should be interesting.

No letters came in today for Murphy.

Thought maybe you'd like to see a few sketches of what are common sights on the roads around here:

sweat
(honest)

wandering through Intramuros

One of scores of notebook sketches of Manila's ancient walled center city, virtually destroyed by fighting in 1945.

are not very subtle about it.") He describes wandering through Intramuros, the walled historic core of old Manila, now heavily damaged, and entering an old bookstore. He comes away with a folio edition of the *Divine Comedy*, bound in rich leather and illustrated by Gustave Doré—the same volume he'd later use to support his Polaroid. He yearns for mail from home. He offers opinions on books and movies and world events. Above all he draws and paints—hardly a day goes by without reference to something or someone he has captured in pencil or in pen and

ink, in watercolor or in oil. "I had an unforgettable experience today. Hearing that there was a mass at 6 o'clock this morning, I was up early and slowly wended my way through the mud to where the church was located. Time came for communion, and as I walked up the aisle, I took a look at what I thought was an American soldier. He was sitting right in front of me—and who should it be but the president of the Philippines, Sergio Osmeña. I recognized him instantly, for hadn't I painted his portrait?" The entries are always carefully dated, but, bowing to wartime censorship, the locations are rarely specified—it's always "somewhere in the Philippines," "somewhere in New Guinea." I understand only now why letters to me in later years were sometimes datelined "somewhere in Cos Cob," an inside joke that only the writer got.

He writes of his first meeting with the man who took him on as an aide-de-camp after seeing the caricature my father had done: "General Marquat is a short, balding man—puffy eyes, big jaw, a Jack Holt mustache. He turned to me and told me what he'd brought me down here for: 'I want you to do a little decorating around the office, Murphy.' Then he launched into the details of what I was to do. He wanted some paintings made of General MacArthur and also little caricatures to be hung around the different offices. Said he wanted a MacArthur painting for his office, and if Mrs. MacArthur wanted one, I would do one for her too." Or two or three of her, as it turned out. And at least six of the general. The work never stops. Here are some typical entries from 1944:

November 9—Delivered General Sutherland picture,
 and it went over big.
November 10—Did painting of Captain Clark.
 Delivered it. Very pleased.
November 12—Worked on oil portraits of Sergio
 Osmeña and General MacArthur.
November 14—Worked on landscapes. Mass at the
 cathedral.

MRS. DOUGLAS MACARTHUR

Brisbane, 1944
JOHN CULLEN MURPHY

November 15—Worked on portraits all day.

November 18—Mass in the morning. Hurrying to finish landscapes.

November 19—Up to Big House where Clark wants small watercolor of MacArthur.

November 21—Routine. Landscapes. Mass at the cathedral.

November 22—Same.

Mass. Paint. Mass. Paint. Mass. Paint. Mass. Paint. Substitute the pope for the Old Man, and the schedule might have been Michelangelo's.

Mass was not a joke to be taken lightly. Faith and family were the most important things in his life. A few years ago, finding myself in Brisbane, I sought out some of the places he knew—Lennon's Hotel, Gregory Terrace, Kangaroo Point. I attended Mass at St. Stephen's, with its dim Gothic interior and striking stained-glass windows—looking much the same as it did in 1944, a calming hint of incense suspended in the chill. It was easy to imagine myself as the twenty-five-year-old who wrote those diary entries and letters home. I have often wondered whether my father's faith was simple or profound, and at the same time also wondered whether those qualities are even at odds. It was specifically Catholic, very much so—the universality of ritual he encountered around the world was a source of comfort and awe. It was grounded in a workaday spirituality that sustained his equanimity but that you never actually saw. Unlike my mother, who was studious in her beliefs—she went to lectures by Jesuits; she read books by Teilhard de Chardin—my father didn't seem to work at religion intellectually, any more than a tree appears to work at photosynthesis. He had no beef with science or Darwin, but he did not accept that reason could explain everything. He did not go looking for proofs of the existence of God, agreeing with the godless that such proofs fell short. From his knowledge of color he knew that much of the spectrum was beyond our ken—why shouldn't the same hold for every other kind of hu-

"I want you to do a little decorating"

Opposite: A preliminary sketch—there would be dozens—for a portrait of Jean MacArthur, the general's wife, 1944. Above: Portraits of General Douglas MacArthur, both painted in 1944.

man perception? When people ridiculed the idea of an afterlife, his response was that life itself was just as improbable: if skeptics weren't already alive, they'd be the first ones scoffing at the idea that life could arise from lifeless matter.

In his wartime letters, he jokes about being in the afterlife business himself—the whole point of all those portraits is "providing immortality," though in the usual doomed and laughable human way. On one occasion a general named Robert Van Volkenburgh returns with the two portraits my father had painted (one for the general, one for his wife back home). This is mystifying. The general had been immensely satisfied—had thought the paintings "swell." Then my father realizes what the problem is: "Called into Marquat's office and was told to bring the two Van Volkenburgh portraits. V.V. was there too. He had grown his mustache back. The generals decided that I would paint mustaches on the portraits." Later: "Was told by Marquat that I'd be seeing Lt. Gen. Sutherland again soon, for he thought that his lower lip was a little too thick in the portrait." He is invited to lunch with General Eichelberger and General Clovis E. Byers, where the subject of my father's Eichelberger portrait comes up. "Eich thought it made him look tired—'I look as though I were in Burma again!' But Byers argued with him, saying that that was the rough, field-soldier type of picture he liked. We had quite a conversation and I said that if I could get hold of a brush I could lighten the lines under his eyes. Byers arranged this, and I fixed the picture." Only one of the sitters comes across as impossibly demanding and vain. "Willoughby talked about the portrait I had made of him, saying that he detested the photo I had used—said the picture made him look like a comic policeman 'in Red Bank, Iowa, or New-*ark*, New Jersey.' Has a peculiar accent. Then he got out some colored pencils and sketched out his ribbon layout—a most interesting set—most of them foreign—and how he rattled them off—Italian, French, Venezuelan, Bolivian, Ecuadoran!" Then back to Sutherland: "He took the painting to his rooms at Lennon's and studied himself in the mirror with the painting alongside. He wants me to come over while he sits

for me and have me study the picture and his face." He begins a portrait of Colonel Sidney Huff, MacArthur's aide-de-camp, who then asks for a portrait of his local mistress. "Showed me a photo of the girl he hoped to marry 'when I get my divorce.' Even gave me a lock of her hair and some threads from her suit." Afterward, as my father is walking down the street, General Sutherland's driver pulls over. "Said that the general wanted the hair in his portrait made grayer." His affection for his boss, and their sometimes joshing relationship, is evident: "Marquat tells everyone that I won't paint *his* portrait and only use him as an agent." The general understands how the world works in a way his aide-de-camp has yet to grasp. My father relays a bit of advice Marquat gave him after he once complained about all the time spent painting portraits of the brass: "It doesn't do a bit of harm to get to know these people."

The senior officers live at Lennon's Hotel, sometimes with their families. After he has completed several portraits of MacArthur, my father is invited to the hotel, in the company of Marquat, to paint portraits of the general's wife and son. Heading for the elevator, he passes Admiral William "Bull" Halsey Jr. On the top floor, Jean MacArthur opens the door. "General Marquat introduced me to her and she gave me her hand, then led us into the living room. There are a couple of photos of the General on tables, a watercolor of the launching of the *Bataan*"—a newly commissioned aircraft carrier—"and a small green bust of the General on a piano. We discussed poses, at length decided on one, and I began to draw. She discussed my painting of the General and was quite extravagant in her praise of it. Mrs. M. is rather a difficult subject—expression is constantly changing and she talks continuously. She is a very attractive woman of 46, but doesn't look her age. She talked of the bombing that they underwent on Bataan, and how she was made to crawl into a cave-like cellar for protection, did it once, but wouldn't do it again. 'I was more afraid of the cave than I was of the bombs.'" When the initial sketches are finished she takes the visitors into Arthur's bedroom, where an oil portrait of the general by the illustra-

tor McClelland Barclay is leaning against a wall. MacArthur had disliked it. "He much prefers yours," Mrs. MacArthur says. My father and Jean MacArthur would correspond throughout their lives.

"I'm constantly amazed by the things I see around here," my father writes from the Philippines. "There's so much that I want to draw and paint and keep a permanent record of." Finished work aside, the letters and diaries are filled with sketches that might have taken no more than a minute or two: Of a boy named Ramon who hangs around headquarters and becomes a kind of mascot. Of Filipino women, veiled in their mantillas, attending Mass. He captures the tropical landscape and the people in it. Over time his style becomes visibly more nimble and less mannered. The range of his facility seems to increase by the day. He creates a cartoon character for a poster campaign. He experiments with a humorous style to capture ordinary camp life. "I have finished four of those WAC drawings, and they look swell. Everyone gets a laugh out of them, for they are sort of cartoony. I hope to do about three more and then send them to the States. Watercolor and pen and ink over it. I like that style very much."

A trip across Luzon to find his older brother, Bob, nearly ends in disaster. "It was, of course, well nigh impossible to do anything, conditions being so terrible, but I do remember several pictures which I think I'll be able to put down from memory. Another misfortune which didn't help my sketching any was that while fording one of the rivers my box hit a rock, unloosing the catch, and spilling the contents right in the river." He saves what he can, but the episode is sobering because it is so hard to get supplies. He has already begun incorporating photography into his preparations—because he is moving around so much, and so are the people he wants to paint—but film is impossible to find; a supplier in Cincinnati eventually sends him some. But even rudimentary materials are scarce. Not long after the box episode he writes to his mother: "I'd sure like to see some Christmas presents. I wish you would send me another batch of oil paints. Here are the colors: ultramarine, viridian, alizarin,

cadmium red, cadmium yellow, yellow ochre, zinc yellow, zinc white, burnt sienna, burnt umber, venetian red, cobalt blue, and lots and lots of white, for that's what I use the most, and I don't have too much left. I still have a sufficient supply of canvas, but that'll have to be replenished soon too. And brushes! I'm really running short of them. What I need are bristle brushes from a quarter of an inch thick on up, and sable brushes from a quarter of an inch on down. Watercolor brushes are beginning to wear out too." On the letter itself you can see the tiny check marks my grandmother has placed above the names of the colors, probably after she has put each tube into her shopping bag. A few weeks later another letter comes: "Wonder if when you are near a book or art store you would get me a book on the chemistry of oil and watercolor paint. There is an excellent book, the name of which I forget, and it is written by Max Weber. This is a subject of which I know very little. Not only the chemistry angle but color itself, and it would help me greatly if, in my spare time, I could study a book of this nature."

his style becomes visibly more nimble

Above and following pages: Members of the U.S. Women's Army Corps in New Guinea and the Philippines, pen and ink with watercolor, 1944 and 1945.

People stop by frequently to look over my father's shoulder. There's a British lieutenant general who seems to know a lot about illustrators. "Talked about Frank Brangwyn, of all people. Remember the time we heard Dean Cornwell talk about Sir Frank, and how eccentric he was? He's the one who did a great deal to teach Dean, and he also painted the murals at Radio City." Cornwell had taught my father at the Art Students League. The British general stops by a few more times, and then, in a letter a few months later, my father reports that the man has been killed in action. Another chance meeting: "Yesterday, while I was working near a window, a G.I. poked his head in and watched me for awhile. I could tell by the way he looked that he was an artist too, and sure enough he used to work for Walt Disney. He's a Serbian and attended art schools in Belgrade and Zagreb. Lived in Hollywood and worked for Disney more to make a living than anything else, for he hates the work. And he hates Disney. As does everybody I've ever talked to who knows him. It seems that Walt is a very stingy sort of a Joe." On a

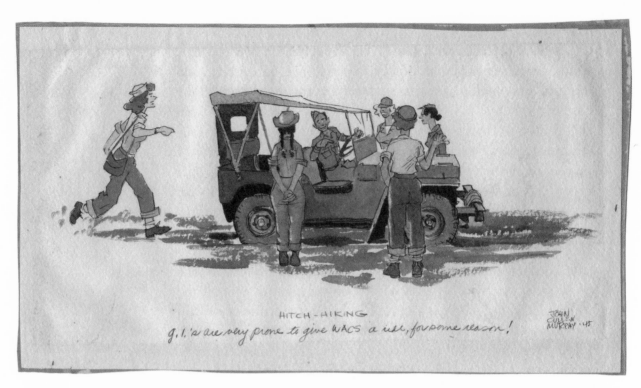

HITCH-HIKING

g.i.'s are very prone to give WACS a ride, for some reason!

JOHN
CULLEN
MURPHY · '45

WORK

JCM
New Guinea
'44

GOING TO WORK

JOHN
CULLEN
MURPHY
New Guinea '44

trip with Marquat up to New Guinea my father puts time aside to draw some of the local folk, whom he refers to as Fuzzy-Wuzzies. "As usual they were a little bit shy, but once they saw one of the paintings they of course all wanted to pose. I sat in the Jeep as I sketched, and about a dozen of them were all crowded around. I'll send them home to you. They would be excellent for any exhibition that I might have. Nice and loose, the way I like to do them."

Old issues of *Time* and *The New Yorker* become a lifeline, and my father is remarkably familiar with cultural developments back home. "Saw a fairly good movie tonight—that new Humphrey Bogart film taken from the Hemingway book *To Have and Have Not*. Typical Hemingway fare, and I don't get the idea of the title. This new gal, Lauren Bacall, is in it." A friend sends him Somerset Maugham's *The Razor's Edge*, though he doesn't care for the book. "Maugham seems to typify the modern writers in that he subtly pokes ridicule at the Church, morals, etc. Of course, it is beautifully written, as is to be expected of a writer of Maugham's caliber. That's the trouble with these guys—many of them are very clever and a lot of people are taken in by their crackpot ideas. A hundred years from now, the Church will still be going strong and Maugham will have been long forgotten." Back to the movies: "Last night I saw *Kismet* with Colman and Dietrich. Swell. I saw it in a very interesting setting—just heard about Cordell Hull resigning. I've traveled well over 8,000 miles recently, and am kind of tired. Still no mail." And again: "Last night I saw a memorable film, *None But the Lonely Heart*. Let's face it, Mum, Clifford Odets, who helped write and direct the picture, must be given a lot of the credit for this excellent production. Whether we like him or not"—his left-leaning sympathies would have gotten on their nerves—"we must admit that (like Orson Welles) he has a fine sense of the theater."

A New Rochelle neighbor and close family friend was the sportswriter Frank Graham. It was Graham who had made the introduction to Toots Shor, years earlier, and throughout the war Shor invited my grandmother to dinner parties at his restaurant.

My father is no stranger to this world; plenty of celebrities pass through the offices at GHQ, and he draws or paints most of them. "Well, there was a very famous visitor in the office today. And who was it but little Izzy Baline—better known to most citizens as Irving Berlin. He's here to put on his show *This Is the Army*. He is a little wizened up sort of guy, very homely as you know, and has a very squeaky voice." For all that, my father lives vicariously through his mother's accounts. He answers a letter in which she has recounted a dinner in New York that included the writers Frank Wallace and John Gunther, former mayor Jimmy Walker, the actor Bert Lahr, and the baseball players Carl Hubbell and Freddie Fitzsimmons.

> I was very glad that these latter two did not disillusion you like some of these stage stars (Beatrice Lillie, Helen Hayes) have in the past. Yes, Freddie is a handsome guy, and although I was generally rooting for the team he was playing against, I always admired him as a real fighter. Never have I seen a ballplayer who tried harder to win. Whether it was pitching (I'll never forget that funny wind-up of his, where he turned his back to the batter), fielding his position like no one else could, or hitting, he was always doing his best. And Carl Hubbell! I can't even talk about the Hub. You know how I feel about that guy. I would go so far as to say he is the only ballplayer in the history of baseball who has never been booed—and that goes for the days when he pitched against Brooklyn, too!

Although he is half a world away, my father stays informed about what's happening in the world of popular art. His mother sends him a clipping about Willard Mullin, the sports cartoonist for the *New York World-Telegram*, and later, to my father's astonishment, a good friend. He writes back, "I have always maintained, as you know, that Mullin is definitely out of the class of the run of the mill sports cartoonist and has something quite different to offer." Every month or so he sends his mother

a package of drawings and paintings, destined for *Life*, *Ladies' Home Journal*, *Collier's*, and *Liberty*. She plays the role of redoubtable agent, as if there's no reason global war against the Axis powers should prevent her boy from having a career on the side. He writes, "Not much news today except that I got what I think is an excellent idea for a cover for *The New Yorker*. The last couple of days I have been observing some U.S.O. girls around here, and the theatrical agents who are always with them. The girls are interesting in a Denys Wortman sort of fashion—all kinds of outlandish get-ups are worn by them—very theatrical—and of course the agents are all really characters." The reference to Wortman is typical. Wortman was a well-known cartoonist of the realist school and also a painter who trained with George

"what I think is an excellent idea for a cover"

A rough drawing in a letter home from New Guinea, 1944: on the same road, beautiful USO performers going one way in a Jeep, weary GIs going the other way on foot.

Bellows and Rockwell Kent. My father goes on to describe the *New Yorker* idea: "A bunch of infantrymen marching by a jungle road—and going in the opposite direction, a couple of jeeps filled with U.S.O. girls, the G.I.s all looking very interestedly. The whole idea will be the incongruity of the scene—deep in the jungle, muddy road, pretty girls, dirty infantrymen. What do you think?"

The future is continually on his mind—what he'll be doing when at last he comes home. "My work here is progressing very well, and I am busy as all get out. Just how busy 'get out' is I don't know, but I have been turning out a flock of watercolors. And I am learning to handle that medium. When the war is over, I will be able to turn to advantage all the things I have learned in the past year." But an even more distant future is also on his mind—he is aware of posterity, though in a joshing sort of way, as if to puncture vanity. He had been saving his drawings (and school papers) since about the age of

five. He very consciously regards his artwork and diaries and letters as a form of permanent witness. To his mother he writes, "I keep busy with all my letters, and then I have been keeping a running account of my doings, and that takes time too. Have been keeping this up since coming overseas. It'll be an interesting record someday." And a few months later he asks, "Are you still saving all my letters? I hope so, and I wish you would describe to me the manner in which you are keeping this scrapbook, how you have it fixed up, etc. There really must be a lot of material by this time."

That was in early 1945. There was more to come. It took a month for me to read the letters and diaries, and during that time my father materialized as if in some momentary fourth dimension. Every few pages there was a reference to something I'd heard about over the years, briefly or at length, during those afternoons in the studio. Or there was a glimpse of an explanation, by way of backstory, for some otherwise inexplicable opinion. It is an odd thing to say of someone else's reminiscences, covering a period when you weren't alive, but they brought back memories.

•

Not all of my father's work was completed on the spot. If a sketch was meant to be preliminary to a painting, he would generally make notes about the colors and then apply the paint back in his quarters. This was the case, for example, with his painting of the emotional ceremony at Manila's Malacañang Palace, in 1944, when General MacArthur turned civilian rule back over to President Osmeña, after three years of Japanese occupation. My father remembers making the original pencil sketch of the ceremony alongside the *Life* magazine photographer Carl Mydans, who was at the same time busily capturing the event on film. The ceremony was broadcast by radio, worldwide. Midway through, MacArthur broke down in tears.

Conditions in Tokyo in the aftermath of the war were grim. My father spent a year there, still on the headquarters staff. His

flags whipping tautly on the fenders

From the Tokyo sketchbook, 1945 and 1946. Below: Street encounters, with notations for a later painting. Opposite: MacArthur's limousine and waiting crowds outside the Dai-Ichi Mutual Life Insurance Building, which served as American military headquarters.

boss, General Marquat, was responsible for breaking up the zaibatsu, the powerful industrial and financial conglomerates. Demobilized Japanese soldiers, many of them homeless, wandered everywhere. The city had been virtually leveled—pounded and burned—by American bombing. Rubble stretched to the horizon in all directions. Squatters occupied every inch of the Ueno railway station, one large urban space that could still be inhabited. Among the relatively few other buildings left standing, besides the Imperial Palace and the National Diet Building (both of which MacArthur had directed not to be bombed), were the Imperial Hotel, where my father lived, and the Dai-Ichi Mutual Life Insurance Building, which MacArthur commandeered for his headquarters. Crowds of Japanese onlookers would gather every day at the Dai-Ichi Building to witness the arrival and departure of MacArthur and his limousine, flags whipping tautly on the fenders. Driving by Jeep or walking alone through every part of the city, my father captured all of this in his sketchbooks: Emaciated men, often maimed, clothed in tattered blankets, begging in the streets with rice bowls. Japanese diplomats, bespectacled and obsequious, arriving in morning suits for a meeting with the conqueror. Women wearing elegant kimonos, trying desperately amid the destruction to keep up appearances (as my father would have it) or to entice a customer (as he didn't wish to think). American servicemen interacting with a defeated people.

The U.S. embassy, like the Imperial Palace, had also been spared. That is where MacArthur held his famous meeting with Emperor Hirohito. In the general's recollection, Hirohito personally accepted responsibility for the war and offered himself up for retribution. Japanese his-

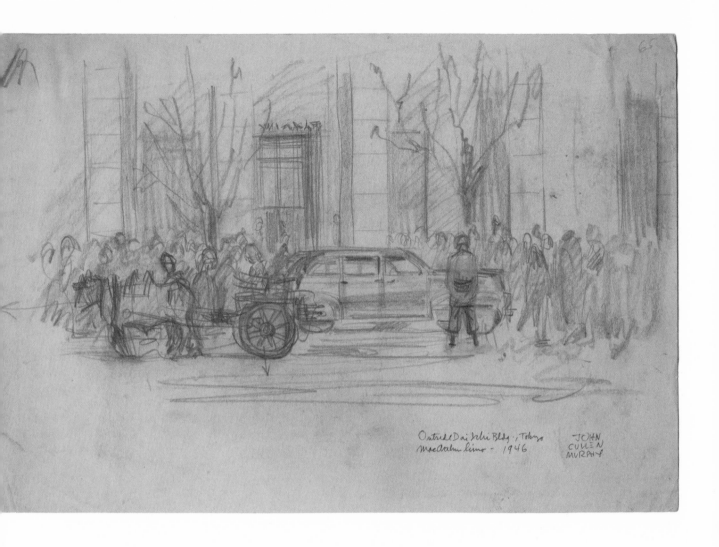

Outside Dai Ichi Bldg., Tokyo
MacArthur limo – 1946

JOHN
CULLEN
MURPHY

torians, perhaps not surprisingly, dispute this account. Shortly af-
ter the meeting concluded, my father was allowed into the room
to make sketches for a painting that for some reason he never fin-
ished. But his penciled roughs show the layout, the fireplace, the
furnishings. His careful notes indicate who sat where, the color
of the wallpaper, the type of fabric on the chairs and couches. As
for what actually occurred at the meeting, my father once fished
out from one of his old cardboard boxes (*Japan: Sundry*) a let-
ter from General Bonner Fellers, MacArthur's military secretary,
who was present in the room and relayed what MacArthur had

told him afterward: "I consider myself a liberal. It was painful to see this man humble himself before me."

In later years my father would become well acquainted with the ferocious criticism leveled at MacArthur—for his overweening self-regard, his conduct of the war, his insubordination, his delusions of grandeur, his political and constitutional tin ear. That hadn't been his experience, and in the face of any argument he always held up the shrewd rehabilitation of postwar Japan as an unmatchable weight on the plus side of the scales. There was no escaping MacArthur in our house. A watercolor portrait by my father that the general had signed was hung in the dining room. A watercolor sketch of his rolltop desk in the Philippines graced a hallway. My father once loaned me an old book

his famous meeting with Emperor Hirohito

Pencil drawing of a room at the U.S. embassy in Tokyo where MacArthur received the Japanese emperor, 1945.

of lectures by John Ruskin, bound in beautifully tooled leather, and a letter from Jean MacArthur on Waldorf Towers stationery dropped out of it, apparently employed as a bookmark. She must have been the last person in his life who always addressed him as "Captain Murphy." When Douglas MacArthur died, in 1964, my father took me to the Seventh Regiment, where the body lay in state. The casket was open, resting on a raised bier. I was twelve, and not tall enough to see fully inside. Above the casket's edge I was able to glimpse a single feature, that great aquiline nose, curling like a fin above the rim.

WITH THAT OBSTACLE BEHIND THEM THE WAY TURNS OUT TO BE CLEAR. SOON THE NARROW PASSAGEWAY BECOMES A LARGE CHAMBER, AND GALAN, RUSHING FORWARD, THRUSTS HIS TORCH INSIDE. *"DO YOU SEE ANYTHING?"* PRINCE VALIANT SHOUTS FROM BEHIND. *"YES,"* SAYS GALAN, *"WONDERFUL THINGS."*

IT IS THE TOMB OF BOUDICCA, THE WARRIO
A REBELLION AGAINST THE ROMANS. TH
COIL STILL GARBED IN SPLENDID RAIMEN
FRUITS OF PLUNDER GLIMMER IN THE
WRESTED FROM THREE ROMAN CITIES.
PAY CAMELOT'S BILLS FOR A CENTURY
SAYS BREATHLESSLY, *"WILL BE PLEAS*

WHO LED HER PEOPLE IN
SHE LIES, HER MORTAL
AND ALL AROUND THE
LIGHT: A TREASURE
BOOTY ENOUGH TO
KING ARTHUR," VAL
"

CONDUCT UNBECOMING

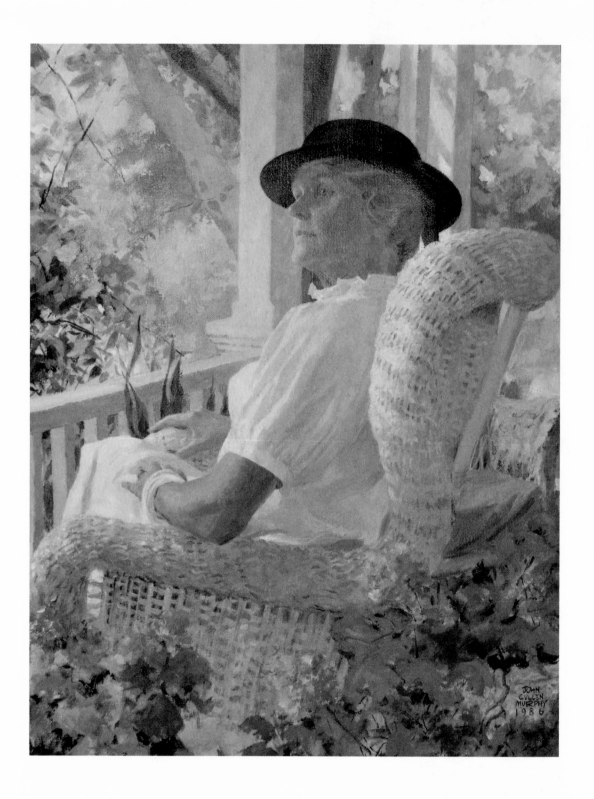

The war in Europe ended in May 1945. The war in the Pacific ended three months later. Most Americans in the armed forces would be home within the year. I have the telegram my father sent to his mother in the autumn of 1946, announcing that he had arrived in San Francisco after a long postwar assignment (sketching, painting, harrying the zaibatsu, attending Mass) in Occupied Japan.

The return to a peacetime economy brought many changes, and for cartoonists the changes were mostly good. Paper rationing came to an end, meaning that newspapers could bulk up. Manufacturers started making consumer and luxury goods again, creating a need for advertising that fattened and enriched publications of all kinds. More magazine pages translated into more pages for gag cartoons and illustration. Since the 1930s, advertising itself had been heavily dependent on comic strip–style presentation—"sequence/picture copy," in Madison Avenue's unlovely jargon—which provided a vast and lucrative additional outlet for what cartoonists knew how to do. New York had been drained of most of its young artistic talent when cartoonists and illustrators went off to war. They returned to an environment of pent-up demand. You had to work hard to not find work.

most of their waking hours were spent in an alternate universe

Preceding pages: John Cullen Murphy, *Prince Valiant*, 1991—Prince Valiant and his son Galan happen upon the tomb of Boudicca, who in ancient times led a revolt against Britain's Roman conquerors. Opposite: My father's portrait of my mother, 1980.

the world's premier hothouse of cartoon talent

Right: A signature self-portrait by Thomas Johnstone, a co-founder of the Johnstone and Cushing agency, where many cartoonists got their start, 1953. Opposite: A toothpaste advertisement drawn for the agency by Stan Drake, circa 1950.

The newspaper and syndicate bullpens had been a training ground for countless cartoonists before the war. The war itself was a training ground for many others. And for a decade after the war an ad agency called Johnstone and Cushing became the world's premier hothouse of cartoon talent.[1] Among members of the Connecticut School, a disproportionate number could claim an affiliation with Johnstone and Cushing at some point in their lives—not just the comic strip cartoonists but comic book artists and gag cartoonists as well, and even some of the illustrators. The company had started in the 1930s, just as the advertising business was beginning to rely on cartoon art for its graphics. Thomas Johnstone had been a theater impresario—the force behind the Marx Brothers hit *I'll Say She Is!*—and a syndication executive before venturing into the world of Madison Avenue. Jack Cushing was the wealthy son of the inventor of the tracer bullet.

Johnstone and Cushing wasn't so much an ad agency as an outsourcing clearinghouse of cartoon talent to which ad agencies could turn. If Campbell's Soup or Birds Eye Foods wanted something cartoon-like for its next campaign, the executives at BBDO or Young & Rubicam would farm the job out to John-

stone and Cushing, which had a large and constantly revolving roster of cartoonists on staff or on call. Some, like Milton Caniff, Otto Soglow, Albert Dorne, and Noel Sickles, had worked at Johnstone and Cushing before the war. Scores of others flooded in afterward—Dik Browne, Stan Drake, Ralston Jones, Leonard Starr, Austin Briggs, John Prentice, Neal Adams, Gill Fox. The pay was better than other work could provide, and a lot more regular, and the agency was the ideal place to dip your pen while developing projects on the side, which everyone was doing. It also held out the promise of society—of collegiality—in a field that was by nature solitary. And the agency sometimes allowed cartoonists to sign their work, which had obvious benefits. This wasn't just free advertising—the big billboard Norman Rockwell talked about. It was advertising that piggybacked on other advertising, national in scope.

The agency's office, on East Forty-fourth Street, had the feel of a clubhouse loft. It was arranged in classic bullpen style—an open expanse jammed with drawing tables—but far more idiosyncratic. Cartoonists drew on the walls. A baby's tiny footprints seemed to track across the ceiling.[2] When jobs came in, the cartoonists would bid for the work by submitting samples. The job could be creating a product-based comic strip—like *Little Alby* (to sell Grape-Nuts) and *Mr. Coffee Nerves* (for a non-caffeinated coffee substitute called Postum)—that would run in the comics

pages right alongside the real comic strips. It could be designing new characters to personify a brand. Some of the advertising was of the kind that loudly cries out "1950s" and today is either recalled with derision or replicated with ironic affection. (Husband to wife: "Our guests will love the many uses of Philadelphia-brand cream cheese!" Wife to husband: "And it's so easy!") Stan Drake created this kind of ad for Ipana toothpaste. The beautifully drawn and lissome young woman who touts its virtues while wrapped in a bath towel already hints at a different path ahead for Drake.[3] A portion of Johnstone and Cushing's work wasn't advertising at all, at least not directly. Month after month, the company created and supplied the comics pages that ran in *Boys' Life*, the Boy Scout magazine.

Dik Browne, who went to work for Johnstone and Cushing right after leaving the army, took on every kind of work there was. He drew *The Tracy Twins* for *Boys' Life*. He created a strip called *The Peter Paul Playhouse* for the maker of Mounds candy bars. And he came up with the Chiquita Banana brand icon and redesigned the Campbell's Soup twins. His work on *The Tracy Twins*—very legibly signed "Dik Browne"—is what got the attention of Mort Walker, who in 1954 took him on for *Hi and Lois*.[4] Even after that strip was successfully launched, Browne worked for years on various Johnstone and Cushing projects. He drew *The Tracy Twins* until the early 1970s.

The Johnstone and Cushing alumni could look forward to a wealth of possibilities. In the ten years after the end of the war, scores of new comic strips began syndication—*Steve Canyon, Pogo, Rusty Riley, Peanuts, Beetle Bailey, Dennis the Menace, Hi and Lois, On Stage, Miss Peach, B.C.* At the same time, younger cartoonists stepped in to continue strips that had been going for decades, and whose creators had retired or died. My father got into the business more or less by accident. He was working successfully as a magazine illustrator and had done movie posters for MGM. He was well known for his depiction of sports in general and of boxing in particular. When Elliot Caplin, then a staff writer at King Features, had an idea for a strip about a prize-

got into the business more or less by accident

John Cullen Murphy, brush-and-ink sketches, 1939. Magazine illustration was my father's ambition, and horses would get his lifelong professional attention—racing, jumping, jousting, dressage.

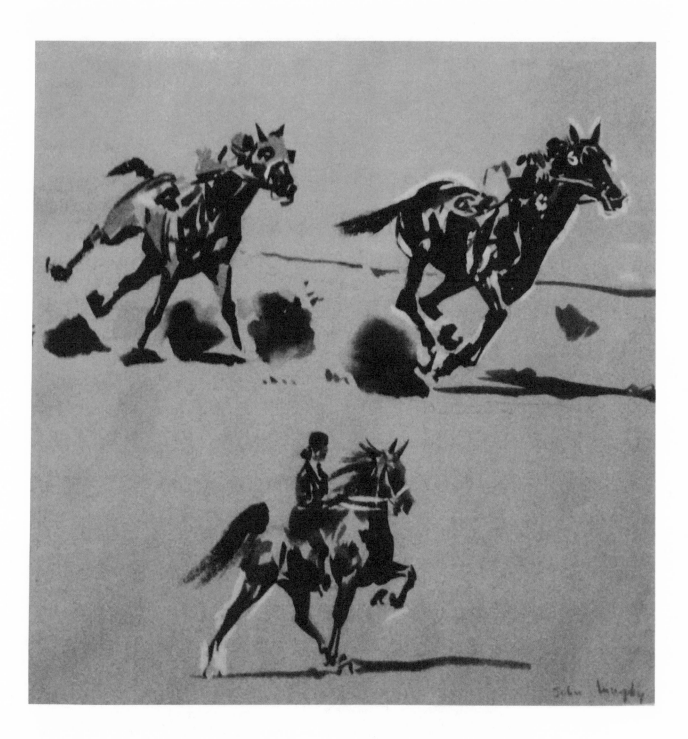

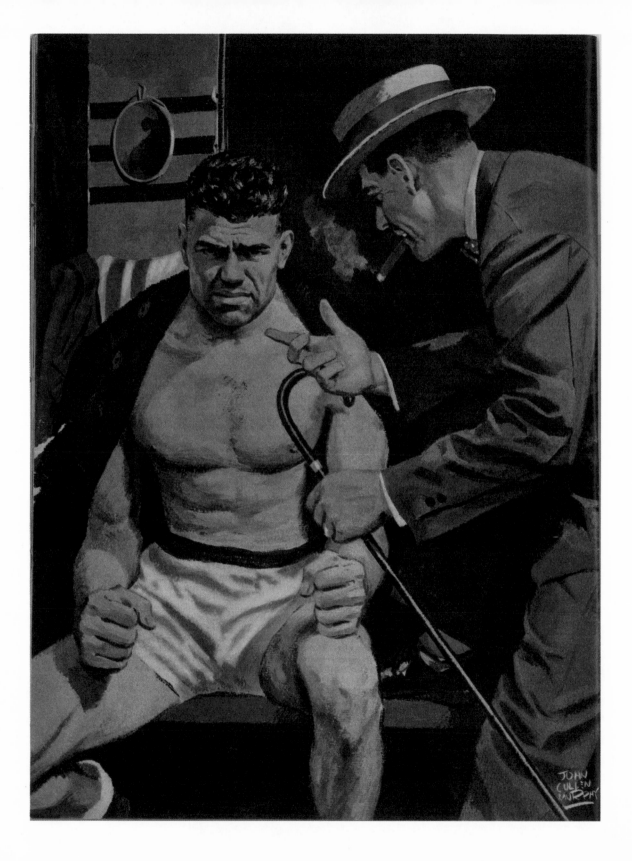

fighter, he came to my father and asked him to draw two weeks' worth of continuities. Sylvan Byck sent the samples to William Randolph Hearst, who gave *Big Ben Bolt* the green light. My father launched the strip in 1950. He married Joan Byrne, my mother, the following year. She seems to have understood that he was both an odd duck and getting serious when he took her on a date to Stillman's Gym, the premier training ground for boxers, and then sent her a telegram that concluded with the words "Love, Whitey Bimstein." Her family, I suspect, never fully grasped that my father's work was steady, or even that it was work. He was thirty-two; she was twenty-three. Eight children arrived over the next fourteen years. The faith my parents had in each other, and in the future, transformed what should have seemed precarious into something that always felt like bedrock.

Just about everyone was starting a family after the war. Low taxes, open land, cheap housing, and proximity to New York City made Fairfield County a natural place for cartoonists to settle. At the same time, it was a world away. In 1950, more than three thousand households in the county still used privies. The median price of a house was about $13,000.[5] Interstate 95, which today seems an immemorial fixture—ageless and forever crumbling, like the Pyramids—did not yet exist. I remember when it pushed through Cos Cob, in 1958, taking a couple of Colonial-era salt-box houses with it. When the highway hit Westport, in 1960, it earned a *New Yorker* cover by Arthur Getz. Greenwich Avenue now resembles an easterly version of Rodeo Drive. Back then it was an ordinary Main Street with an Italian barber, an Irish bar, a Chinese laundry, a German funeral home, and a threadbare hotel called the Pickwick Arms, which was meant to be English and whose ambience was certainly Dickensian. The town was provincial, voting in the 1940s to reject a proposal to put the United Nations headquarters there. Opponents stirred xenophobic sentiment by paying a man five dollars to walk up and down Greenwich Avenue in a fez.[6]

In the late 1940s, suburban development was just starting in Fairfield County. One of the earliest subdivisions in Green-

well known for his depiction of sports in general and of boxing in particular

Opposite: The heavyweight champion Jack Dempsey, painted by my father for *Sport* magazine, 1949. Below: One of his earlier paintings, of an earlier champion, John L. Sullivan.

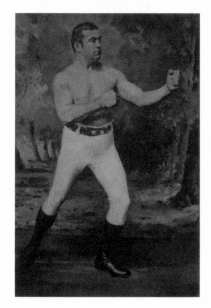

wich was Havemeyer Park, built by the boxer Gene Tunney—two-bedroom Cape Cods on streets named for Nimitz, Halsey, Marshall, and MacArthur. The most common car was the Ford Country Squire station wagon, now a coveted throwback, but once as common as Toyota Corollas are today. When it came to raising children, the great fears were either apocalyptic or, from a modern perspective, trivial. Air-raid sirens would sound every few weeks, and schoolchildren would practice taking shelter under desks as protection against a nuclear attack. I remember seeing a replica bomb shelter on display for several months in a supermarket parking lot, and for some years in Fairfield County it was the vogue among the affluent to have a bomb shelter dug into their property somewhere. At the other extreme was the hysteria over comic books, which were said to be sapping the moral fiber of America's youth, and over blasting caps, which seemed to have been strewn everywhere as new homes and highways spread across the land. In contrast, no one was much con-

cerned about cigarettes, alcohol, drugs, or premarital sex, and few foresaw that teenagers would find those backyard bomb shelters ideal for all four.

The onset of the American Century was in many ways unplanned and inadvertent. It was marked by a certain innocence that at times rose to the level of blindness. Up to a point, comic strips are inherently conservative and take on the characteristics of what's around them. The first generations of cartoonists had drawn heavily from big-city life, the immigrant experience, and the Jazz Age. The postwar cartoonists were part of the great suburban migration by a more educated and professional population. Their preoccupations reflected that fact. Hi and Lois Flagston bought a house in a place called Mammoth Acres, the kind of development described by a King Features ad for the strip as "the new home for millions of young moderns."[7] *Peanuts*, *Dennis the Menace*, and *The Family Circus* were inherently suburban. It wasn't just comic strips that held a mirror up to this expanding world. So did gag cartoons. So did *New Yorker* covers. *The Tunnel of Love*, a novel by Peter De Vries, held up a double mirror—it revolved around two characters, a gag cartoonist and a cartoon editor, living in Westport. *The New Yorker*'s longtime art director and cartoon editor, Jim Geraghty, happened to live in Westport, as did twenty or so of the magazine's cartoonists and illustrators. Geraghty organized them into a bowling league. Over a span of half a century, artists in Westport produced nearly eight hundred of the magazine's covers, more than forty of which were of Westport itself.[8] For decades after the war, with a handful of exceptions, the cartoonists were also white and male. Dalia Messick, who created *Brenda Starr* in 1940, took an androgynous route professionally as Dale Messick. Not until the success of Cathy Guisewite's *Cathy* (1976) and Lynn Johnston's *For Better or For Worse* (1979) would women become a force.

•

When cartoonists broke free of the studio, it was like a release from school. Socializing could be intense. Once a month there

a towering jumble of acrobatic nudes

Above: Rube Goldberg's drawing of the statue he designed for the Reuben Award. Opposite, top: Self-portrait by Goldberg, dashed off at a cartoonists' event, 1963. Opposite, bottom: At a Reuben Award dinner in the 1960s, cartoonists create a living Rube Goldberg machine.

would be a meeting of the National Cartoonists Society at the Lambs Club, in New York City, with 150 people or more in attendance. The NCS was created right after the war, in 1946, and indirectly had been an outgrowth of the war itself. A group of cartoonists too old or hobbled to serve in the military had spent the war years doing shows at military bases and hospitals around the country for the USO—a version of the chalk talks that my father was doing at the same time for his fellow servicemen in the Pacific. Then, at the prodding of a flamboyant New York agent named Toni Mendez, a Columbia University dropout and former Rockette, they began taking an even more elaborate show on the road, with music and entertainers. It was an easy next step to form a club—mainly because, as the cartoonist C. D. Russell, who drew *Pete the Tramp*, pointed out during a long flight from one show to the next, undertakers, garbagemen, lumberjacks, and everyone else seemed to have a club. "No—leave us alone; we're doing fine," Rube Goldberg objected before eventually giving in.[9] Goldberg, as he likely feared he would, became the founding president. The society would name its most prestigious award for him, and he designed the Reuben statuette, a towering jumble of acrobatic nudes topped by an inkpot. Mendez was officially designated the society's "troubleshooter." The illustrator Russell Patterson was elected first vice president. Otto Soglow was elected second vice president. (The job of the second vice president was defined as being "to follow the first vice president around.") It was a perfect sort of club, bestowing an aura of vague organizational sanctity and high-minded purposelessness on people who would be gathering to no good end anyway. In time, the NCS would develop a liturgical calendar, with its important feast days (the annual Reuben Awards dinner, the annual Sports Night, the annual golf tournament) and many smaller events scattered throughout Ordinary Time.

The founders never suspected that, having constituted themselves into an executive branch, they would be needing a judicial branch as well. But they soon did. The problem arose from a nasty dispute that had begun in the 1930s involving Ham Fisher,

the creator of *Joe Palooka*, and Al Capp, the creator of *Li'l Abner*. In his day, Fisher was one of the most successful cartoonists in the business, with a strip about a good-natured heavyweight prizefighter that appeared in nine hundred newspapers, inspired movies and eventually a TV show, and endowed the language with an enduring name for an amiable lunkhead.[10] Capp had worked for Fisher as an assistant before heading out on his own. How these two hot-tempered and unyielding men ever functioned together remains a mystery; part of the explanation may have been that Fisher's extravagant lifestyle kept him away from the studio much of the time. When *Li'l Abner* was launched, in 1934, Fisher was livid—the title character, he alleged, was based

on a character of his own invention. Not so, said Capp. Yes, there had been a similar character in *Joe Palooka*, but Capp had created and drawn that character himself during one of Fisher's long absences. In the small, rarefied field of comic strip forensics, the competing claims continue to be picked over as if this were the Alger Hiss case. The preponderance of opinion sides with Capp. In any event, Fisher threatened a lawsuit, and Capp retaliated by goading him in a variety of ways, once naming a horse in *Li'l Abner* "Ham's Nose-Bob" right after Fisher underwent a rhinoplasty. Attempts at peacemaking by other cartoonists proved unavailing, and the feud deepened.

Then it went catastrophically public when Capp, in 1950, wrote an article for *The Atlantic Monthly* titled "I Remember Monster," about his years working for "a certain treasure-trove of lousiness." Fisher went unnamed, but everyone knew whom Capp was referring to. "From my study of this one li'l man," Capp wrote, "I have been able to create an entire gallery of horrors. For instance, when I must create a character who is the ultimate in cheapness, I don't, like less fortunate cartoonists, have to rack my brain wondering what real, bottom-of-the-barrel cheapness is like."[11] Fisher retaliated by anonymously sending photostats of what he alleged were pornographic *Li'l Abner* cartoons with suggestive marginalia to a New York State commission that was investigating comics. The source was clear to everyone.[12] Fisher had been a founding member of the NCS and was one of the most prominent cartoonists in the business; word of what he'd done made headlines. Now the question arose: How should the NCS respond? In 1955, after a meeting of its hastily formed ethics committee, Fisher was expelled from the society on grounds of "conduct unbecoming a cartoonist."

There would be more to this unhappy story. Fisher committed suicide in his studio soon after his expulsion; Capp would later cite the suicide as one of his proudest accomplishments.[13] But what lingered in the air, acquiring a life of its own long after the precipitating event, was that phrase "conduct unbecoming a cartoonist." Without knowing the origin, I would

hear the phrase used jokingly by cartoonists to describe some recent escapade or peccadillo by one of their number—anything from taking one mulligan too many to serving a watered-down drink. "Conduct unbecoming" was a resonant phrase, by its nature subject to enormous elasticity depending on what followed it. Plug in the words "an officer and a gentleman," as you might hear in the movies, and it acquired the grave majesty of a military court-martial. Plug in the words "a wabbit," as Elmer Fudd would sometimes do, and it came across very differently. What the phrase meant when you plugged in "a cartoonist" was anyone's guess. Was it a high standard? A low one? How does anyone *expect* cartoonists to behave? In a way, it didn't matter—the phrase could be applied to almost any kind of behavior and would always come across as a joke. Whatever the red line was, Ham Fisher had certainly crossed it. He remains the only person ever expelled from the NCS for "conduct unbecoming."

The society was ostensibly a nationwide organization—and is very much one today—but in the 1950s and '60s, Fairfield County carried enormous weight, matched only by New York City. The Manhattan contingent, with their distinctive accents, included people like Bill Gallo of the *Daily News* and Al Jaffee of *Mad* magazine. And Rube Goldberg himself. And Harry Hershfield (*Abie the Agent*), well into his eighties, always natty in a tweed suit. By then a columnist and toastmaster, Hershfield would tell you if you asked, and often if you didn't, how he used to run into Mark Twain on lower Fifth Avenue, a story that was actually true. He described himself philosophically as "an optimistic futilist."

Cocktail and dinner parties at one cartoonist's home or another were a major outlet—parties not of the Noël Coward variety, but squean-heavy gatherings of twelve or twenty, where Manhattans and old-fashioneds flowed like Perrier and teenagers waited until the adults went off to dinner, then drained what remained in the glasses. A song by Sinatra or the sight of beef bourguignon on a menu instantly brings these gatherings to mind. Cigarettes by the score would be laid out for the guests—a job for the youngest children in the family. The ciga-

rette display was standard at the time for a successful hostess, as my mother was. (She was also prudent, staying alert to the latest in medical thinking and, on doctor's orders, switching to menthol cigarettes during pregnancy.) Drinking was important. It cut short some careers and, as assistants stepped in, allowed others to get a start. It was both glue and solvent. And it went well with golf, which was almost universal among cartoonists, as was an inability to play it very well. The names of the cartoonists' home courses evoke an entire world. If the cartoonists had christened weekends the way the Jacobins christened months, time would tick by in a succession of euphonious fairways: Silvermine, Greenwich, Burning Tree, Millbrook, Tamarack, Rockrimmon, Stanwich.

It occurred to me only later that, for cartoonists, recreation didn't represent an escape from ordinary reality; it was one of the few times that their reality was the same as everyone else's. Most of their waking hours were spent in an alternate universe with its own swirl of consequential events. How would the Phantom and his trained wolf deal with the looming threat of a missile base in the Deep Woods? Would Steve Canyon ever marry Summer Olson? Had he been foolish to volunteer for service in Vietnam? Could Prince Valiant defend Camelot, or would it fall into the malign clutches of the usurper Mordred? Would Juliet Jones have her suspicions borne out: that she and her sister, Eve, were being two-timed by that lout Tal Chesney? What about Brenda Starr's love interest, the mysterious Basil St. John: Would he ever run short of the black-orchid serum that kept him alive? What new quasi-legal assignment did the dashing and cerebral Rip Kirby have in store for Desmond, his safe-cracking valet? What if Ben Bolt lost his heavyweight title to that brutal Aryan bruiser, or whoever the next challenger was? Could he possibly win it back? And what should he do about the sad little orphan boy who appeared out of nowhere? Even more important: Would I have to pose for the orphan boy's pictures?

When you broke it down, the world of the Connecticut School sorted itself into circles overlapping circles—you could see it as a

almost universal among cartoonists, as was an inability to play it very well

Golf outings went awry in unpredictable ways—medical, meteorological—and were memorialized by the participants after the fact. The sketches here, from the 1970s, are by Dik Browne (top) and Dick Cavalli (bottom). The man with the twisted leg is my father.

cluster of affiliated subgroups with a high degree of interconnection.[14] Sometimes the subgroups had a name. Jerry Marcus, Orlando Busino, and Joe Farris were the nucleus of a group based in Ridgefield known as the Fairfield County Irregulars.[15] They met every week for pizza. For a period of decades my father was part of a group of twelve who called themselves the Men Who Are Thursday. They got together for lunch on Thursday every other week. Jerry Dumas was part of it, as was *The New Yorker*'s Chuck Saxon. The illustrators Jim Flora, Bob Jones, and David Shaw were members, along with the sculptor Reuben Nakian, the screenwriter Herman Raucher, and the novelist Gerald Green. The gathering moved from house to house around the county, and the host would usually add a guest or two, people who lived nearby: maybe Dick Cavalli, who drew *Winthrop*, or Roy Doty, whose illustrations appeared everywhere; maybe the fabled art director Howard Munce, of Young & Rubicam, or the cartoonist Leonard Starr, who created *On Stage* and later revived *Little Orphan Annie*. I was invited to sit in on several of these luncheons, shyness overcome by what had by now become a paternal injunction: "It doesn't do a bit of harm to get to know these people."

One discussion began with a reference to Russell Lynes and his famous "highbrow-middlebrow-lowbrow" classification scheme from the late 1940s; it quickly moved to a consideration of unwashed salad bowls, like the one being passed around—according to Lynes, a cultural signifier of a highbrow. What happens, someone asked, when a highbrow signifier goes mainstream—isn't there an endless circularity involved, where highbrow becomes middlebrow and where lowbrow can in fact become highbrow? "Mark my words," my father said at one point, "Norman Rockwell will be highbrow someday!" He dreaded the moment, which he knew was inevitable, when *The New York Times* would endow Rockwell with a nimbus of artistic sanctity, and when those who had sneered would suddenly bow. It would be, he said, like the about-face on the war by American communists after Hitler broke the Molotov-Ribbentrop Pact. ("And don't get me started on Lillian Hellman.")

A year or so later, at another such lunch, the conversation tackled the theme of who or what is overrated. The first response (from Reuben Nakian, as I recall) was a resounding, "Well, Bach, of course." Western civilization was soon in tatters: *Hamlet*. Fallingwater. Thomas Jefferson. *Moby-Dick*. France. Brooks Brothers. *Death of a Salesman*. Robert E. Lee. Renoir (my father's contribution). And underrated? A. E. Housman (of course!). Jones Beach. Lucas Cranach the Elder. The Albert Memorial. Pencils. Nebraska. Omar Bradley. John Sloan. Grace Coolidge (my father again). It all seems silly, but to the teenager in the corner, these exchanges might as well have been Plato's *Symposium*.

For gag cartoonists, look day was as much a social occasion as a professional one. There were conflicting stories about how Wednesday had come to be the day when cartoonists went from magazine to magazine in Manhattan, selling their work. Had it evolved this way because the Cartoonists Guild of America always held its monthly meetings on a Wednesday, at the old Knickerbocker Hotel?[16] Or was it because Marione Nickles of *The Saturday Evening Post*, which bought more cartoons than any other magazine, had decided that this was the day she liked coming to New York? Nickles came by train from Philadelphia, where the *Post* was based, arriving in the Manhattan office at around 10:30. Heading in much earlier, cartoonists converged from north and east, also by train. At any one time you might find twenty of them in some dingy room—in essence a holding cell—at the *Post* or *Collier's* or *Sports Illustrated* or *True*, waiting to show their roughs. The *Post* would be particularly crowded— the cartoonist Mort Gerberg compared it to the Sargasso Sea: "You *expected* to get stuck there, sometimes for two hours." As the wait went on, cartoonists might begin mooing, like penned cattle.[17] During the peak years, in the 1950s, as many as a hundred cartoonists would be prowling Manhattan every Wednesday, clumping and dispersing all over midtown throughout the day.[18] Riding home to Westport and the other Connecticut townships, in the bar car of what was then the New Haven Railroad, they would try to sell the leftovers to Bill Yates, who had

followed Mort Walker as the editor of *1000 Jokes* magazine.[19] Yates, himself a gag cartoonist, would eventually start his own strip, *Professor Phumble*. He succeeded Sylvan Byck as the comics editor at King Features.

•

Collectively, the cartoonists possessed a great convening power, to a degree that is hard to imagine in a present-day world with so many media distractions. The Hearst newspapers once conducted an experiment, sending out Sunday editions with a section missing to a thousand randomly selected subscribers. One week the main news section would be left out, then the magazine supplement, then the color comics. Only forty-five out of a thousand people complained about the missing news section; 880 complained about the missing comics. Comics had universal cachet, reached everybody, and opened doors. One night, when I was five or six, I went with my father on a surprise trip to the old Madison Square Garden. Rin Tin Tin—not even a reader—was waiting to meet us.

For cartoonists, the biggest gathering of the year was the NCS awards night, when the coveted Reuben was bestowed. The second-biggest gathering was Sports Night, usually held at the Commodore. When the hotel first opened, in 1919, its glass-ceilinged lobby was advertised as the largest room in the world. Sports Night took place in the ballroom, and the great sports figures of the day would be out in force for drinks and dinner. Politicians showed up, too. Once, reaching across the dais to shake hands with Theodore Sorensen, who was running for the Senate, I knocked a glass of scotch into his lap. Had I been a cartoonist, and the act deliberate, I suppose it would have been considered conduct unbecoming (but maybe not). The bonds between cartoonists and athletes were strong, forged by people like Willard Mullin and

*massive liver-spotted hands resting
atop the curve of a cane*

Above, a ticket to one of the biggest annual events on the cartoonists' calendar. Opposite: My father and Dempsey that same year.

Bill Gallo in an era when every newspaper had a sports cartoonist, and sometimes two or three.

To autograph-hunting kids, the experience of Sports Night was like setting out to trap squirrels and coming home with the Bronx Zoo. Jack Dempsey was almost always present, massive liver-spotted hands resting atop the curve of a cane. His handwriting was delicate and beautiful, like a nun's. Casey Stengel was often in attendance. When I was ten or so—he was in his seventies, and managing the woeful Mets—I introduced myself to Stengel. He said, "Murphy, Murphy. I know a Murphy in San Diego." A brief pause and an angled squint. "Are you him?" One night our dinner companions were Bobby Thomson and Ralph Branca, united for life by the "shot heard 'round the world"—Thomson's home run off Branca in 1951, which won the National League pennant for the Giants—and by now companionable in their public shtick. Dinner with Yogi Berra was more of an ordeal. The gregarious malaprop artist of our expectations turned out to be a man of amiable monosyllables. "See much of Whitey Ford?" "Nah, not too much." "How's Yoo-Hoo doing?" "Good. Real good." Only when my father in despera-

164

tion began to draw his portrait on a napkin did Yogi liven up. That broke the ice, as it had in New Guinea, and Yogi relaxed ("Hey, that's pretty good!"), permitting himself an exuberant disyllable.

After dinner the cartoonists would summon the immortals— Gene Tunney, Yogi Berra, Frank Gifford, Y. A. Tittle, Rocky Graziano—onto the stage, one by one, and draw caricatures on the spot within a mandated minute, clock ticking, then give away the drawings. It had the feeling of a contest: the ability to draw fast and well, under pressure and with an economy of line, was a highly prized skill. The cartoonists were past masters at cap-

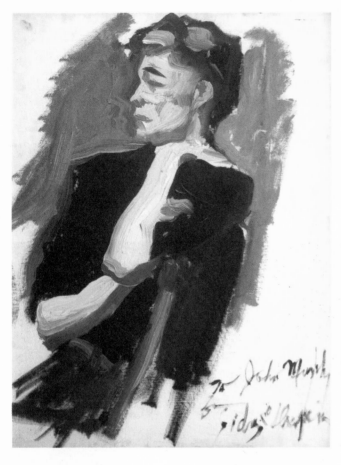

turing themselves—their very first models, and always the most accommodating—and in idle moments would sketch one another on whatever lay close to hand. I have a large rendering of my father, on newsprint torn from a pad, that Chuck Saxon drew in about thirty seconds as I looked on, and another by the illustrator Harry Devlin, drawn on a Reuben Awards program as he quietly observed my father from across the table. In his studio my father kept a painting done by the portraitist Sidney Dickinson, a friend and teacher. Walking down Madison Avenue one day, paint box in hand, Dickinson had noticed through a shopwindow a worn but stylish woman lounging theatrically in a chair. It was like that moment in Moscow when Tolstoy (the story goes) saw a woman's bare arm through a window and conceived the character Anna Karenina.[20] Dickinson stopped on the sidewalk, unfolded a spindly easel, and painted for no more than five or ten minutes, capturing attitude and pose with louche slatherings of color. The next day he gave the painting to my father.

Satchel Paige was the speaker at Sports Night one year, and in the end a big success. I learned only later that it had been a close call. Suffering an attack of nerves, he had been discovered in his room minutes before showtime, wearing nothing but green boxer shorts and swigging from a bottle of bourbon. Another year we entered the ballroom to find that a boxing ring had been set up in the middle. The onetime middleweight champion Rocky Graziano was a guest that evening, and in his honor, we were told, there would be an exhibition match. Into the ring stepped Irwin Hasen, who drew *Dondi*. Hasen, then about fifty, was pudgy and short. He shadowboxed gamely for the crowd.

unfolded a spindly easel, and painted for no more than five or ten minutes

Above: Sidney Dickinson's oil sketch, done on a sidewalk, 1964. For cartoonists, speed was part of the performance. Opposite and following pages: Portraits of my father by Don Orehek, Harry Devlin, Chuck Saxon, and Gary Gianni.

Jack
from
Chuck

Then the spotlight shifted to his opponent. The man was if anything even shorter. He wore purple satin boxing trunks that were several sizes too large and came up to his rib cage. He was about seventy years old. Pale skin sagged on a sunken chest. His knees were as knobby as a camel's. With a serene and stately countenance, Otto Soglow parted the ropes and put up his fists.

The sight of Soglow at that moment is indelible, and captures something of the muted us-against-the-world attitude that lurked just below the surface in the sensibility of cartoonists. The attitude was not entirely serious, but neither was it empty of seriousness. It came across in Walt Kelly's testimony before the Senate, when he noted that cartoonists were screwballs. Not only that, Kelly went on, but he resented the insinuation that they might not be: "This is another thing we fight for!"[21] Dik Browne would often note that cartoonists generally got themselves into trouble when they tried to sway minds: "More cartoonists have come a cropper by pushing a political slant than any other single thing. Wasn't it Samuel Goldwyn who said, 'Messages are for Western Union'?"[22] Despite some notable exceptions—such as Al Capp's *Li'l Abner*, Walt Kelly's *Pogo*, and, later, Garry Trudeau's *Doonesbury*—most comic strips were sparing when it came to stirring public debate. But there was a stubborn streak and an anarchic streak that invited controversy anyway. For all his cautionary talk about messages, Browne was not above sending one. I have a strip he gave me in which a monk appears with a flickering torch. When Hägar asks him what he's holding, the monk says it's the lamp of learning, which will guide humanity toward peace and progress. Hägar replies, "Great. Can you hold it a little closer while I finish this sword?" Charles Schulz (in 1968) and Mort Walker (in 1970) introduced African American characters into their strips—Franklin Armstrong, a schoolmate of the other children in *Peanuts*, and Jackson Flap, a goateed lieutenant in *Beetle Bailey*. Both cartoonists took some heat. Schulz remembered hearing from a Southern newspaper editor who said that the character Franklin was fine, just fine, but did he have to attend the same school as the other kids? *Beetle* was briefly

parted the ropes and put up his fists

The main event, Sports Night, 1968. *Dondi*'s Irwin Hasen takes on *The Little King*'s Otto Soglow.

THE MAIN EVENT: "KING OTTO" VS. "BIG FRENCHY"

KING OTTO (SOGLOW) DEFIANT, DETERMINED, STALKS
BIG FRENCHY (IRWIN HASEN) AND THE FIGHT OF THE
CENTURY IS ON! ZAP! ZOK! POW! BAM! OOF! KERPLUNK!
ZANK! CRASH! UNTIL (LOWER RIGHT) THIS WAS ALL
THAT WAS LEFT OF BIG FRENCHY. LONG LIVE THE KING!

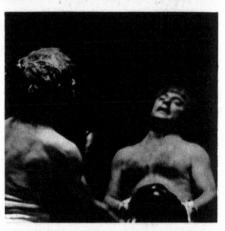

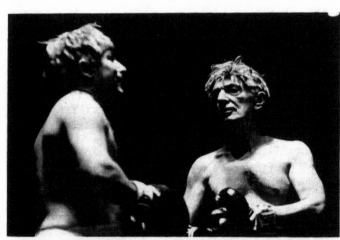

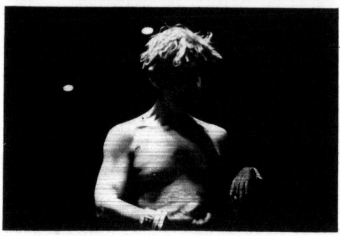

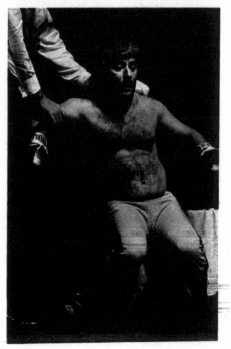

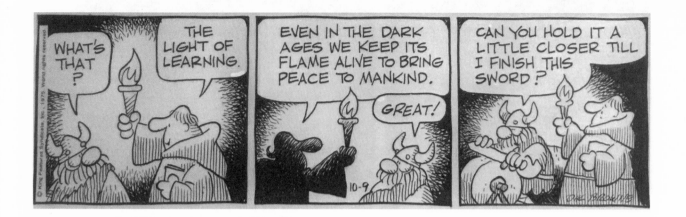

WHAT'S THAT?

THE LIGHT OF LEARNING.

EVEN IN THE DARK AGES WE KEEP ITS FLAME ALIVE TO BRING PEACE TO MANKIND.

GREAT!

10-9

CAN YOU HOLD IT A LITTLE CLOSER TILL I FINISH THIS SWORD?

for all his cautionary talk about messages

Dik Browne couldn't resist sending one. *Hägar the Horrible*, 1975.

dropped from *Stars and Stripes* when Lieutenant Flap made his debut, until objections from a U.S. senator, William Proxmire, caused the military to reconsider. In its depiction of clueless officers, wise idiots, and gold-bricking enlisted men, *Beetle Bailey* was by its nature antiauthoritarian, and it had been dropped once before by *Stars and Stripes*, in the 1950s. The chief result was an outcry that gained a hundred additional newspapers for the strip and earned a quick reinstatement. Years later, post-Flap, Walker would be awarded the Pentagon's Decoration for Distinguished Civilian Service, and on another occasion, also in Washington, would receive a salute in the reviewing stand as troops marched by at sunset.

There was a famous moment at Johnstone and Cushing—one that seemed to loom larger with each retelling—when Browne was seen running through the bullpen in a bloody shirt, pursued by an editor who was brandishing a bullwhip and screaming at him never to submit such lousy work again. It was all a setup, to welcome a new cartoonist to the floor.[23] At some point, just about every cartoonist endured the lash of rebuke or the sting of rejection, maybe even Chon Day, the amiable creator of the deceptively gentle *Brother Sebastian*. That may be among the reasons why they were quick to come to one another's assistance—stepping in to meet deadlines, for instance, when one of the group was sidelined by illness or accident. Bob Lubbers, who worked on

Tarzan and *The Saint*, among other strips, did all the drawing on *Juliet Jones* while Stan Drake recovered from the accident that had killed Alex Raymond. When Drake took over *Big Ben Bolt* for a month as my father battled pneumonia, I remember being surprised that one cartoonist could so closely mimic the style of another, even to the point of crossing genres. This was a chameleonlike talent that many cartoonists had. Drake himself, an acknowledged master of the dramatic strip, would go on to draw *Blondie*, a classic bigfoot feature, complaining all the while about how much harder it was. He claimed that Dagwood alone had four hundred facial expressions, and he didn't even want to talk about the hand gestures.[24] When cartoonists gathered to mark significant birthdays and anniversaries, they generally brought drawings or paintings in the style of the person being celebrated. You could infer the creators by certain deliberate quirks of identity. At a party for my father I remember Leonard Starr, who drew *Little Orphan Annie*, bringing a sketch that showed Prince Valiant with those vacant Annie eyes. Fred Lasswell, who did *Snuffy Smith*, had Prince Valiant smoking a corncob pipe. Mort Walker had Prince Valiant's helmet coming down over his eyes, like Beetle's. But each person's breadth of mimicry was plain.

In the early 1960s, Browne fell on an icy sidewalk and shattered his drawing arm—an accident that left the arm functional but looking as if it had been repaired with masking tape. Henceforward it swung from his shoulder like soggy laundry on a swaying line. His golf swing looked like something that Rube Goldberg had contrived, a twisted elbow angling precisely down the fairway as if to indicate where the ball, in the end, would not be going. After the accident, Browne's Johnstone and Cushing colleague Gill Fox drew *The Tracy Twins* until Browne recovered. When Browne was sidelined again for some reason, decades later, the gag cartoonist Orlando Busino drew *Hägar the Horrible* for several weeks. All of this was done quietly, without fanfare, and indeed under the table. No cartoonist wanted others, meaning primarily the syndicate, to know that he was getting help—or, perhaps more to the point, to entertain a suspicion that his spe-

cial genius could so easily be replaced. But cartoonists could tell. If Stan Drake had ever been made to draw *Nancy*, he would have tried dutifully to copy Ernie Bushmiller's style—but Nancy herself would somehow have acquired an erotic charge. Jerry Dumas remembered calling Busino to tell him what a wonderful job he was doing on *Hägar*, only to have Busino categorically deny any involvement. Dumas countered that he knew his work down to the smallest pen stroke—and that, indeed, he had recognized a certain distinctive method of inking the letter *G*—at which point Busino gave in and admitted the truth.[25]

From time to time, museum curators determine that only the left hand in a certain painting was really by Rubens, or only the eyes and nose in another truly by Tintoretto. Among collectors of comic art, the category of ghosted strips involves similar feats of connoisseurship. Is this one of the *Gordo* strips drawn by Hank Ketcham when Gus Arriola got hurt? Could that be one of the *Popeye*s done by Hy Eisman after Bud Sagendorf took ill? Would-be Berensons are everywhere.

•

Dik Browne wasn't a churchgoer, but he exemplified a quality for which the only apt word is "grace." Physically, he seemed to have very bad luck. When Jerry Dumas told me the story about Orlando Busino drawing *Hägar*, he didn't bother to fix a date that was any more specific than "during one of Dik's medical crises," as if nothing more needed to be said. But Browne had been blessed with an extraordinarily good nature. He was an odd-looking man, especially when he was younger. I have a picture of him and a dozen cartoonist friends, including my father, taken at Mort Walker's fortieth-birthday party, in 1963. Most of the cartoonists have that early-'60s Clark Kent–ish look—the black-frame glasses, the carefully parted hair, the square jaw. They could pass for one of those insurance salesmen in a matchbook ad—maybe even done by Johnstone and Cushing—who says, "Think of the security, Bob—and that low monthly payment!" Browne has been stuck in the middle of the group, an

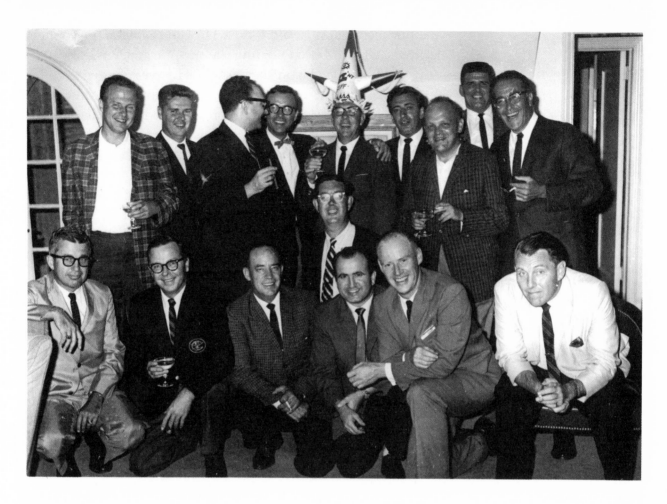

all-too-obvious outlier. He wears a suit, but it doesn't really help. His head is oddly narrow, as if squeezed in a vise. His jug ears resemble those of the Yellow Kid. The neck is already wattled and fleshy. Browne would eventually grow a beard, which some assumed was to link himself visually to Hägar the Horrible, but in fact he stopped shaving after one of his sons told him that he "had more chins than a Chinese phone book." He was inattentive when it came to his deportment, and his wife, Joan, could often be heard casually saying "XYZ" when he returned from the bathroom, which Dik understood to mean "examine your zipper." Once, during a party at our house, as hors d'oeuvres were being passed around, Browne took a handful of crackers

that early-'60s Clark Kent–ish look

Mort Walker's fortieth-birthday party, 1963. Walker wears the hat. Jerry Dumas is standing fourth from left. My father is in the front, second from the right. Dik Browne is the man in the middle.

and put them in his jacket pocket. He said to one of my younger brothers, who had been holding the tray, "You never know. Poverty could be just around the corner." His eyesight began to fail prematurely, and he would cite his poor vision when suggesting that he'd long been under the impression he looked like Ronald Colman. Self-pity was absent from his demeanor. In a few short moments he could draw a landscape that would transport you to Elysium, where perhaps in his own mind he lived. A child could not approach Browne without departing in possession of a joke and a picture. If an adult wrote to him wanting an original drawing, he would send something off and simply request in return a donation to the Milt Gross Fund, named for a renowned cartoonist of the 1920s and '30s, which had been set up to assist those who had fallen on hard times.

Browne worked for decades with Mort Walker on *Hi and Lois*. Walker was in many ways Browne's opposite—trim, tidy, well organized. He was both buttoned-down and buttoned-up. You could infer something about his capacity for control from the way he drew. Unlike, say, Jerry Dumas, whose pen stroke would snag unless he always moved the pen away from himself in a single direction—meaning that he constantly needed to turn the paper in circles—Walker kept the paper stationary and drew methodical strokes in all directions without incident: top to bottom, bottom to top, left to right, right to left. They got the same results, Dumas would say, but Walker made less noise. Walker actually knew how to run things. His expanding web of comic enterprises—besides *Beetle Bailey* and *Hi and Lois* there was also *Boner's Ark*, *Sam and Silo*, *Gamin and Patches*, and *The Evermores*, plus an assortment of comic books and hardcover books and merchandise—came to be known as King Features East. The regular ideas meeting for the various strips was held one morning a month, yielding gags to power the enterprise for the next four weeks. There was a clear division of labor: penciling, lettering, inking. Walker's work space was an expansive and immaculate domain—located initially in a second-floor loft of the barn behind his Greenwich home, then in the house next door,

then in the cavernous Gutzon Borglum studio in Stamford with its medieval hooded fireplace and a granite atrium, three stories high. Walker somehow seemed to be first with everything: the first to build a pool, the first to buy a color TV, the first to acquire a second house just to work in. He was also among the first to collect the original work of other cartoonists in a serious way,

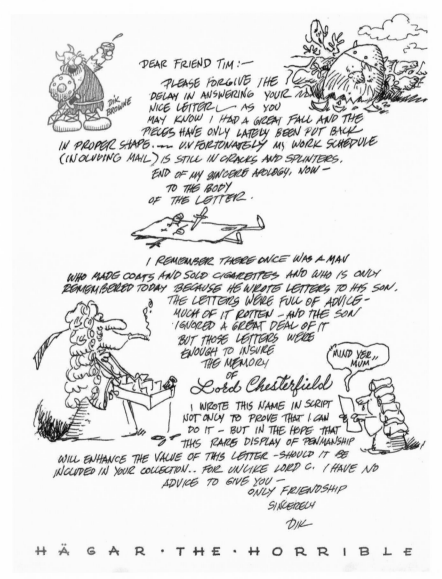

departing in possession of a joke and a picture

A typical letter from Dik Browne, this one to Tim Dumas, son of Jerry.

and in the mid-1970s, his personal stock would form the nucleus of the Museum of Cartoon Art, located initially near Walker's home, in Greenwich, and later along the Connecticut–New York border, a few miles north. Framed strips took up every inch of wall space in his study—pen-and-ink originals by his friends in the Connecticut School and classic strips by Frederick Burr Opper, George McManus, Rube Goldberg, and Walt Disney.

He was a genuinely funny man: the "Titian's workshop" metaphor, which suggests an assembly line, doesn't work without an actual Titian at the heart of it. Walker had a special genius, though it usually didn't show outwardly with him any more than it did with Charles Schulz. In company you might easily mistake him for a pharmacist or a civics teacher. But his mind was configured in a way that couldn't help but turn sensory stimulus into some sort of a gag, the way a silkworm can't help turning mulberry leaves into filament. Walker came up with the most distinctive feature of *Hi and Lois*—using thought balloons to show the unspoken sentiments of the toddler Trixie—after reading *Main Street* and seeing how Sinclair Lewis used interior monologue.[26] It was Walker who devised the glossary of terms for comic strip devices. "Indotherms" are the wavy lines indicating that a pie, for instance, is still hot. "Lucaflects" are the windowlike highlights indicating that a balloon or a Christmas ornament is shiny. "Emanata" are the lines that surround a face registering a state of surprise. "Plewds" are beads of sweat indicating that a character is working hard. All of these were invented as an inside joke, circulating at first in the National Cartoonists Society newsletter. Like so many jokes, they are now an accepted part of reality.

There was a bookish side to a lot of cartoonists and illustrators, and sometimes it came out in the work itself. Walker gave me a *Beetle Bailey* pencil sketch that I'd liked in which the character Zero asks another enlisted man, Plato, what all his books are for. "They contain all the knowledge of the past," the brainy but kindly Plato says to his moronic friend, "to guide our actions in the future." Zero replies, "What happens if a couple of

invented as an inside joke

Pencil sketches by Mort Walker—a sample of the tongue-in-cheek terminology he invented in the early 1960s for graphic techniques used by cartoonists. In 1980 it achieved book form—*The Lexicon of Comicana*.

178

Plewds (from the Greek god of rain, Pluvius) are one of the most useful devices to show emotion. Here's one example:

LADY DISCOVERS HER SLIP IS SHOWING

A FEW MORE PLEWDS.. HER SHOULDER STRAP BROKE.

AN EIGHT-PLEWDED LADY. WE'LL LEAVE HER PLIGHT TO YOUR IMAGINATION.

Other emanata reveal internal conditions.

MAN WITH SQUEANS. SLIGHTLY DRUNK

MAN WITH SQUEANS AND A SPURL-- LOADED

SQUEANS, SPURL, CROTTLE EYED, SURMOUNTED BY THRUSH-- IT'S "NEVER-AGAIN" TIME!

Emanata can come from things as well as people to show what's going on. Here's a few:

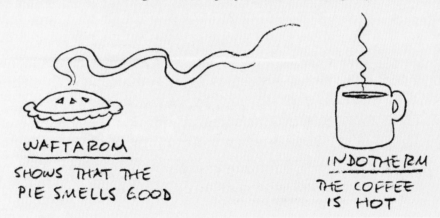

WAFTAROM

SHOWS THAT THE PIE SMELLS GOOD

INDOTHERM

THE COFFEE IS HOT

pages get stuck together?" The gruff, marauding Hägar has a son named Hamlet, slight and curious, far more interested in the life of the mind than the manly practice of arms. His ambition to become a dentist is scoffed at by his friends until they learn that it involves pulling teeth. Jerry Dumas was probably the most overtly bookish among the group, and a stylish writer as well. He created illustrated spreads for *The New Yorker* and drew delicate illustrations for poems. His family memoir about growing up in the 1930s on the east side of Detroit, *An Afternoon in Waterloo Park*, is quietly haunting, a small classic. Dumas was also a storyteller with a sharp eye for his fellow cartoonists. He had not been to war, but he had been to college, and he had a peculiarly oblique and readerly perception of what passes for the ordinary. This was embodied in *Sam's Strip*, which Dumas created with Walker in 1961. The strip deserved more of an audience than it ever got, becoming a cult favorite among comic strip fans only after its demise, which occurred in twenty short months. Posthumous success, as Dumas would note, is the second-best kind. But *Sam's Strip* earned a kind of immortality with its forays into the postmodern. The first three panels of the very first strip have no characters in them at all because the characters haven't been invented yet and are still taking shape behind the scenes. When the title character, Sam, finally shows up in the fourth panel, he is only partly drawn, and the artist can be seen still at work inking him in. Sometimes Sam rented out space to other strips: stunningly rendered action scenes, worthy of Alex Raymond or Hal Foster, might suddenly intervene for a couple of panels. Taking a cue from television, Sam toyed with the idea of selling some of his space to advertisers. Once, after the public announcement that Charles Schulz had negotiated a deal with the Ford Motor Company for the use of *Snoopy* characters, Dumas had Charlie Brown whoosh by in a Ford Falcon, out of the blue, edging Sam off the road. In the course of its life, *Sam's Strip* brought back characters from classic features—*Krazy Kat, Hogan's Alley, Happy Hooligan*, most of them by then long gone—to perform in the funny pages again. Humpty Dumpty and the Mad Hatter,

from John Tenniel's *Alice's Adventures in Wonderland*, might stop by. Stock images from old editorial cartoons—a battered Planet Earth wearing a Band-Aid—made regular cameos, as did urbane characters from *New Yorker* cartoons, invited into the strip (as Sam explained) to lend it a bit more class. On one occasion Sam hosted a Comic Characters Convention, the panels overflowing with twenty or thirty figures, from Opper's Happy Hooligan to Thurber's famous barking seal. (At the banquet, Sam had to remind everyone that the pies were just for eating.) All of this was drawn painstakingly from scratch—every delicate line of a Tenniel, every goofy stroke of a George Herriman. The Comic Characters Convention sequence, which ran for a week, took three weeks to draw.[27]

If Dumas pushed the boundaries of the comic strip toward the absurdly self-aware, Stan Drake pushed them in another direction, toward unabashed efficiency. Putting three weeks' work into one week's output was not, for him, a strategic imperative. Perhaps because several times he found himself between marriages and needed to take on enormous amounts of work just to pay alimony—he frankly admitted as much—Drake was always looking for ways to save time without sacrificing the quality of his work, which he never did. His fascination with cars was in keeping with his interest in modern advances of all kinds. He was the first cartoonist I knew who started using an electric eraser, a gun-metal device manufactured by Bruning that looked like something appropriate for enhanced interrogation. I remember my father shaking his head at this development, as if learning that Daumier had switched to Magic Marker, though he eventually bought an electric eraser, too. My siblings and I established that it was no good for cleaning teeth.

Maxfield Parrish once called himself "a mechanic who likes to paint." Drake, along with *Snuffy Smith*'s Fred Lasswell, was an experimenter and a tinkerer in that same vein. At one point Drake was taking medication that had the effect of turning his urine blue; he played around with the dosage in order to make it green on St. Patrick's Day. Had the science of hair transplants

stock images from old editorial cartoons

As depicted in Mort Walker's glossary—and the kind of cliché celebrated and mocked in *Sam's Strip*.

been as surefire then as it is now, Drake would have been at the front of the line; as it was, he resorted to an intricate double comb-over that had a tendency, in a slight breeze, to decouple and produce wings. When he was drawing *Blondie* and working with a writer who lived in Florida—it was Dean Young, who had taken over from his father—Drake became one of the first cartoonists to use a fax machine. (Actually, it was a Qwip device, that clunky precursor to the fax, which involved having to lay the handset of the telephone into a cushioned cradle that could receive and send an electronic signal.) Early on, when doing *The Heart of Juliet Jones*, Drake experimented with Xerox machines, discovering that you could take a photograph of, say, the Manhattan skyline, or trees in a forest, or boats in a marina, and by adjusting the setting to high contrast, produce an image that looked like a pen-and-ink drawing. Reduced to proper size, it could be pasted into place as a ready-made background.[28] Or it could be used on its own for what is known as a "talking building" composition. This was a venerable compositional technique, used by many cartoonists, which typically showed a facade with many windows, the speech balloons emanating from one of them.[29] It was perfect for establishing a location and setting a mood—the reader's imagination provided the interiors: the Eames chairs and Calder mobiles in a chic penthouse; the glass desk and executive telephones in a corporate office; the rutted mattress and dripping faucet in a Bowery flophouse.

From time to time Drake was known to lift drawings he had done for the strip years earlier—for instance, a generic head shot of Juliet Jones looking happy or shocked—and using them once again, making a photostat copy and pasting it into place. Faces that filled a panel were a time-saver anyway, even if you had to draw them from scratch, because it meant there was no need for any background detail. Drake would ask rhetorically, Do you know how much work it takes to draw a window that looks like a real

window? Or what about something as simple as a doorjamb? "It sounds so stupid, but it has to be in perspective, it has to be ruled in pencil, and all the little wood layers in a doorjamb, in order to look real, must be there the way it looks. Then you have to ink all this in—a lot of little tight ruling that has nothing to do with creativity."[30] So he became increasingly generous with the use of head shots, noting that it sometimes saved him from having to draw an entire city block. Besides, he liked drawing faces, especially the faces of attractive women. Back in his days at Johnstone and Cushing, he had honed his skills by tracing the faces of movie stars, thousands of times,

until the muscle memory of his fingers could produce "handsome" and "beautiful" without conscious direction. Drake was unapologetic about his shortcuts. He wasn't crossing some sacred line of purity—"For chrissake," he would say, "the whole business is make-believe."

Golf was the athletic activity that united more of the Fairfield County cartoonists than any other, but in the early days they had tried bowling, and some of them, like Charles Saxon, never gave it up. In terms of social class, bowling is just about at the opposite end of the spectrum from the habits and self-perception of the people Saxon satirized in his drawings—people with whom he also lived and socialized. Saxon did play golf, but all his life he bowled on Friday nights with a group that included *The New Yorker*'s Whitney Darrow Jr. and the writers John Hersey and Vance Packard. He was otherwise tweedy and had the benign, settled, watchful eyes of a whale in a children's book. His hands, unexpectedly for a cartoonist, were big, like a bricklayer's; the thick fingers seemed clumsy until they began to move. His friend Edward Sorel, also a cartoonist and illustrator, figured that Saxon got away with poking fun at the people he lived among by maintaining that he was really one of them

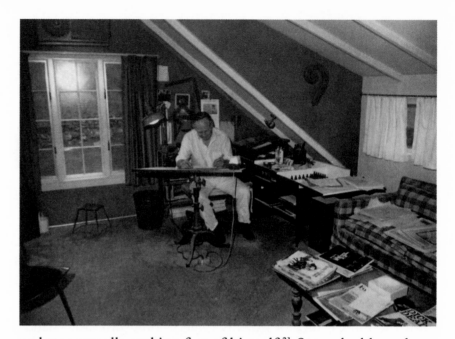

and was actually making fun of himself.[31] Saxon had been born Charles Isaacson to a musical family in Brooklyn; his parents were musicians, and a great-uncle had been the court violinist to Queen Victoria. He himself played drums. Maybe it was the musical background, but more than any other cartoonist I know his line seemed to flow—it was spare and exact, but had an effortlessly aerodynamic quality to it. It was the kind of effortlessness that took work: Saxon would do a drawing again and again, the flaws invisible to anyone but him. By the time he was done, his desk was encircled by crumpled paper.[32] Sometimes his style had no ambition beyond beauty and sentiment—as in a *New Yorker* cover from 1959, showing the lit windows of the New Canaan railway station on a snowy day at dusk. More frequently Saxon sought to gently capture a certain range of attitudes: unearned insouciance, implacable contentment, cozy self-absorption, comfortable smugness. Nor were these attitudes solely the province of human beings. I have drawings by Saxon of a camel (insouciant) and a satyr (contented), but he could endow a flowerpot or wicker chair or croquet mallet with emotion and aspiration. A Saxon geranium wanted its cuttings to go to Yale. Saxon had

a fine sense of language and an appreciation for spoken cliché, which were as important to his cartoons as the drawings were. Unlike some *New Yorker* cartoonists, he wrote his own gags. One of his best-known cartoons shows the usual cast of plump executives gathered around a boardroom table. The chairman says, "Of course, honesty is one of the better policies." In another, a Waspy father in fall-catalog clothing walks with his young son on a forest path under a glorious autumnal canopy. He says to the boy, "It's good to know about trees. Just remember that nobody ever made any big money knowing about trees."

Saxon was mystified and hurt when changes at *The New*

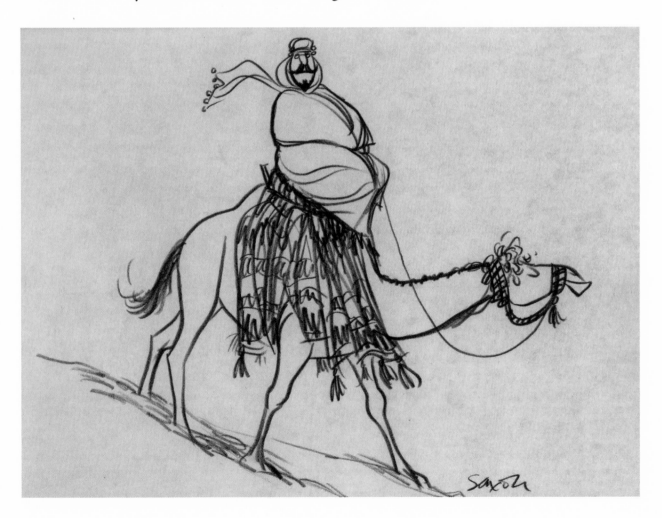

Yorker—precipitated by the departure of William Shawn—brought a sudden end to what had been a defining relationship on both sides for more than three decades. It was especially painful because there was no other place for him to go—his species of painting and cartoon had flourished in a single ecological niche. Jerry Dumas remembered standing with my father by the fireplace of our home one evening as Saxon lamented that the magazine had bought nothing from him for several years. "I don't know what I'm going to do," Saxon said.[33] He suffered a heart attack not long after that conversation, knocking over a table in his living room as he fell. His last words, spoken to the paramedics, might have been a caption for one of his own cartoons: "I guess I'd better die; I just broke our best lamp."[34]

the kind of effortlessness that took work

Charles Saxon, charcoal drawing of a satyr for a party invitation, c. 1985.

INDIAN
SUMMER

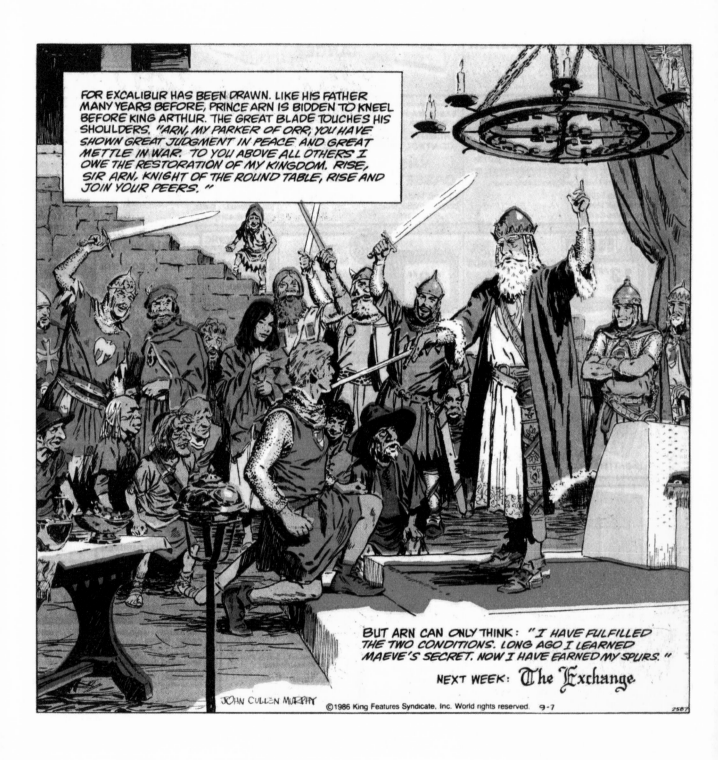

FOR EXCALIBUR HAS BEEN DRAWN. LIKE HIS FATHER MANY YEARS BEFORE, PRINCE ARN IS BIDDEN TO KNEEL BEFORE KING ARTHUR. THE GREAT BLADE TOUCHES HIS SHOULDERS. "ARN, MY PARKER OF ORR, YOU HAVE SHOWN GREAT JUDGMENT IN PEACE AND GREAT METTLE IN WAR. TO YOU ABOVE ALL OTHERS I OWE THE RESTORATION OF MY KINGDOM. RISE, SIR ARN, KNIGHT OF THE ROUND TABLE, RISE AND JOIN YOUR PEERS."

BUT ARN CAN ONLY THINK: "I HAVE FULFILLED THE TWO CONDITIONS. LONG AGO I LEARNED MAEVE'S SECRET. NOW I HAVE EARNED MY SPURS."

NEXT WEEK: The Exchange

JOHN CULLEN MURPHY

9-7

2587

It hadn't been my plan, but I worked with my father on *Prince Valiant* for nearly three decades. Hal Foster, the strip's creator, turned the illustration over to him in 1970. Foster was nearly eighty, and arthritis had set in. The strip was published only on Sundays, but there could be more lines and more ink in a single panel of *Prince Valiant* than in a month of *Peanuts*. It was a demanding effort. Foster and my father had known each other for years. They were a generation apart, but they had gone through the same vigorous form of training, admired the same classic illustrators, and saw themselves within the same evolutionary phylum that extended back to figures like Arthur Rackham, Gustave Doré, and William Heath Robinson. The transition from Foster was a natural one. *Big Ben Bolt* was placed in the hands of others, and my father devoted himself fully to *Prince Valiant*.

A few years later, Foster took the second step: he decided that he wanted to hand over the writing of the strip to someone else as well. This was a significant turn of events. I had been a reader of *Prince Valiant* since boyhood, and loved the language and the noble rhythms of the story line. I was majoring in medieval history at college—a coincidence—and intending somehow to become a writer. Given all those childhood hours in the studio,

the cartoonists themselves turned out to be the ephemeral part

Previous pages: A watercolor by my father of a country road in Connecticut, painted toward the end of his life. Opposite: John Cullen Murphy, *Prince Valiant*, the knighting of Prince Arn, 1986.

I felt as if I had been working with my father for years. With this in mind, I tried my hand at a couple of *Prince Valiant* story sequences—about twenty-six weeks' worth in all—and sent them to Foster, whom I had met a number of times, but did not know well. One summer evening he called and invited me to dinner. He drove down from Redding with his wife, Helen, and we met at a restaurant in Greenwich called the Homestead, where the two of them tucked heartily into the lobster thermidor and I, from nerves, could barely eat.

Foster had some of the look of Walter Cronkite and the manner of God's Canadian younger brother. He was tall and trim, with white hair and a white mustache of a kind that, like gray fedoras, seemed to have become obsolete on the day of John F. Kennedy's inauguration. I'm not sure who besides Helen called him Hal, but I never did—it was always Mr. Foster. The very idea of calling him Hal brought to mind the story of Gouverneur Morris, who, on a bet, dared to give George Washington a convivial slap on the back one evening, only to be reduced by the general's withering glare. Foster's past was of a sort guaranteed to make a youngster feel he might never catch up. Born in Halifax in 1892 to what he referred to as "shabby gentility"—the family's once ample seafaring fortune reduced to a swordfish saw, some old logbooks, and a brace of dueling pistols—he had been deemed by his teachers to be unfit for much of anything except maybe drawing pictures, which he did indeed enjoy doing. As a young man Foster worked as a fisherman, a gold prospector, and a fur trapper. He was once fired from a job in a store in Winnipeg for taking the day off to go duck hunting. But he continued drawing pictures, and was eventually hired to depict garments in pen and ink for the Hudson's Bay Company catalog. His first assignment was to draw women's underwear, the full-body drop-seat variety, with lace around the ankles. Eventually he moved up to drawing corsets.[1] In time Foster met an American woman—Helen Wells—from Kansas, and after their wedding he rode his bicycle from Winnipeg to Chicago, where he enrolled in the school of the Art Institute. His subsequent work in advertising caught the eye of

the syndicate developing a new comic strip, *Tarzan of the Apes*. Foster launched it as a successful serial in 1928, with a color Sunday page following a few years later. By then, the Depression had taken hold and steady work of other kinds was not easy to find. "I sold my soul to the funny papers," he would later say, but it's also true that his soul was avidly sought. The creator of *Tarzan*, Edgar Rice Burroughs, came to admire Foster's work deeply.[2] Six years later, Foster created *Prince Valiant*. The sale of his soul on this occasion, to King Features, was even more lucrative—William Randolph Hearst agreed to a fifty-fifty split of the revenue. The strip was an immediate hit. Among the fans was the Duke of Windsor, who called it "the greatest contribution to English literature in the last century," an accolade Foster accepted with ambivalence. As a native Canadian, he maintained a certain affection for the Crown, but unlike the duke, he was a man of firm and simple values: "Never shoot a sitting bird. Never take more fish than will fit in a frying pan. Never take more liquor than you can hold like a gentleman." It was easy to see why Foster and my father got along.

As the coffee arrived, Helen heeded some silent signal and excused herself. I was now sitting alone with Foster, on a breezy veranda, and he duly brought up the subject of my work. "What did you think?" I asked. His countenance was serene yet uncompromising, the face of someone who knows your best interests better than you do. He replied with two words: "No good."

No good! The conversation could easily have come to an end right there. But Foster had more to say, and having donned the black cap and pronounced sentence he now visibly relaxed and offered a wide-ranging tutorial. A strip that appears only on Sundays, he said, bears a special weight—it has to accomplish a great deal, with so much time in between to forget—but in general it follows the same rules as any other dramatic strip. The plot has to have a long-term narrative arc, but each episode also has to have its own satisfying trajectory. The first is like the earth moving around the sun, the second like the earth spinning on its axis. Something has to *happen* every Sunday. At the same time, you need to start each strip in a way that provides access to people reading for the first time as well as a reminder to those who don't remember what happened last week. And you need to end each strip in a way that makes people want to read it next Sunday.

Another thing: You have to treat the words differently in a strip like this one, which doesn't use speech balloons. When you run text along the bottom, as *Prince Valiant* does, and as *Tarzan* did, the temptation is to think of it as a caption. *But it isn't a caption!* In each panel, the pictures and the words have to function as a one-two punch. If the words just describe the picture, then why do we need the picture? Or, if you prefer, why do we need the words? In every panel, words and picture play different roles. Maybe the picture indicates what's happening "now" and the text uses the moment to step ahead into the future. Maybe it's the other way around. But always—*always*—a one-two punch. He brought up *National Geographic* by way of example—how the photo captions weren't so much captions as mini articles, opening doors to ideas and information that you'd never get just from the wonderful pictures. The image might be of a Mongo-

lian woman sewing a blanket in a yurt, but the caption might explain (Foster was making this up) that at night around the fire she would chew goat intestine to prepare the next day's thread, chomping a thousand times exactly in accordance with some ancient oral tradition, and that the blankets would be used under saddles on the small Mongolian horses whose ancestry went back to the days of Genghis Khan.

You also have to understand, Foster went on, how each panel relates to the one that comes before and after. Panels are separated by a white gutter with nothing in it, and that white gutter is the most active space on the page. You probably think nothing happens in that space, he said. But almost *everything* happens in that space. That's where the reader's imagination fills in the story, and the more a reader can fill in, the more the strip can accomplish each week, and the faster the pace. So you don't want to be plodding or literal as you move from one panel to another. You want the reader's imagination to fill in the gaps—to make leaps of inference, the wider the better. If Prince Valiant in one panel listens attentively to some scheming merchant's outlandish plan, and in the next panel he's getting his ears boxed by Aleta, you know what happened between: he heard the merchant out, took the bait, set his course, failed to think things through, and then belatedly told his sensible wife. You don't need to show all that—it happened in the gutter, plain as day.

That said, Foster went on, don't think it's all about plot. It isn't. Plots provide structure and enable movement, the way a skeleton does, but they don't provide character. *Characters* provide character. This is true in humor strips in a two-dimensional way: A gag about Dagwood only works because we know who Dagwood is. We know who Blondie is. It's even truer in a story strip, and it's true in a three-dimensional way. Personality, motivation, emotion—these are as important as any plot. *More* important, actually. Especially when you're trying to be realistic. *Prince Valiant* is a strip in which people actually age. Val was just a boy when the strip started, Foster said. Who knows how old he is now, exactly, but he has a wife and four children. He

has aches and pains. One more thing about plots. There are only about five or six of them, when you get right down to it. Boy meets girl. Boy loses girl. Betrayal by a bad guy. Payback by a good guy. The impossible quest succeeds—and maybe that's a bad thing. The impossible quest fails—and maybe that's a good thing. And when the story seems slow, bring on the elephants: those glorious, oversize newpaper panels—the original art as big as a poster—where both the writing and illustration could achieve their greatest scope.

Foster went on in this way for a little while longer. And then, unexpectedly, a few moments before Helen returned, he invited me to try again. I continued to send him stories and scripts, three or four times a year. The first one he actually used was for an episode that started running in 1973. Several years later, when Foster gave up the writing for good, I took over, with his blessing. He passed along his own beautifully bound sets of Greek myths and Norse legends, and the works of O. Henry and de Maupassant.

•

I don't have the actual data—it surely doesn't exist—but if you were to plot the graph, over the entirety of human history, of the percentage of children who worked for a living alongside at least one of their parents, the line would run flat along the top for a few million years and then rapidly plunge downhill. Among the hominids at Olduvai Gorge, the proportion was probably one hundred percent. In antiquity, the people who didn't work with their parents were mainly soldiers and slaves. In the Middle Ages, as slavery declined, the people who didn't work with a parent were mainly clergy (though some of those "nephews" were right there at the altar with Dad). Then, as economies diversified and people moved to towns and cities, the proportion began to undergo an accelerating decline. Today, in the developed world, people who work with a parent tend to be confined to specific groups: shop-keepers, artisans, small farmers, people in family businesses, philanthropists, participants in organized crime, royalty.

And cartoonists. More than most occupations, doing a comic strip embodies a way of life that harkens back to medieval guilds. There's a body of arcane knowledge and a sense of remoteness from outside concerns. There's the musty and comfortable Old World workshop. There's a bias toward family members and those already connected to the guild, and a long period of apprenticeship. There are trade secrets, backroom deals, and a pecking order. There are people who work in the shadows, essentially as ghosts, waiting their turn. Al Williamson was a superb artist in the Alex Raymond tradition who had his own credited work (*Secret Agent X-9*, *Flash Gordon*, and countless horror and fantasy comic books) and at various times also assisted my father and others. In the early 1960s, he and Archie Goodwin published a brilliant parody called "The Success Story," about a craven and untalented cartoonist named Baldo Smudge who hires others to write, pencil, and ink what turns into an enormously popular strip. Smudge figures that none of them will discover that he's a fraud, doing no work at all, unless they all happen to run into one another at once—as, of course, they do. Smudge kills them off to preserve his secret. (The parody appeared in the first issue of *Creepy*, so naturally Smudge himself is done in when his decomposing victims emerge from the swamp, seeking vengeance.)[3] Once, when Roy Crane, the venerable creator of *Buz Sawyer*, was being honored for his work, he stepped up to the microphone and thanked Edwin Granberry, who had written the strip for decades, and Henry Schlensker, who had drawn it

about a craven and untalented cartoonist

A panel from Al Williamson's mordant classic "The Success Story," 1964. (*Creepy* © 2017 New Comic Company)

for decades. A stage whisper was heard in the momentary silence before the applause began: "Then what's *he* doing up there?"[4]

It always felt appropriate that *Prince Valiant*, with its medieval ambiance, should be the product of a guildlike environment. Everyone in the family posed for pictures and was at some point drawn, literally, into the strip. My sister Meg did the lettering and the coloring. You saw the same thing with other strips. *Blondie* eventually passed from the hands of Chic Young to his son Dean. *The Captain and the Kids* passed from Rudolph Dirks to his son John. *Steve Roper* and *Mary Worth*, both by Allen Saunders, stayed in the family for another generation. Ferd Johnson (*Moon Mullins*) and Art Sansom (*The Born Loser*) brought sons into the business. The strips *B.C.* and *The Wizard of Id* skipped a generation—they were taken over by Johnny Hart's grandson, Mason Mastroianni. Bil Keane's *The Family Circus* is now done by his son Jeff. Dik Browne invited his sons, Chris and Chance, to help with the writing of his strips very early on.[5] Chris would go on to draw *Hägar* and Chance to draw *Hi and Lois*, which is written by Mort Walker's sons Greg and Brian, who also write for *Beetle Bailey*, which is drawn by Mort but inked and lettered by Greg.

To me, working with my father was a seamless extension of a relationship that had always been close. For him, at the very least, it provided another chance to throw around the phrase *père et fils* in public. Working with your father on a comic strip entailed certain complexities, and these were universal in cartoonist families. He knew more about the realities of the business than you did, and he always would. He was also older, and his sensibility would sometimes skew in a direction different from a younger person's in terms of what was permissible and what was in keeping with a strip's basic nature. And if he was the artist, not the writer, he could typically work a lot faster than you. People often asked, "Which comes first, the writing or the drawing?"—a question that would answer itself if you gave it a moment. Ideas always took precedence—had to—and they could be very slow in coming. "The writing consumes a lot more time than the drawing," Foster had warned, and he was right. This was as true for

funny strips and gag cartoons as it was for dramatic strips. When the young Bud Sagendorf was apprenticing with Elzie Segar on *Popeye*, they'd go fishing together to hatch ideas, and Sagendorf recalled that the standard ratio was five days of fishing to two days of drawing.[6] In the case of a dramatic strip, having the basic plotline was just the beginning. It had to be broken down into its component parts according to all the basic rules Foster had laid out. And you could use only so many words in each panel—otherwise the picture would be overwhelmed. The task of writing was laborious.

I followed Foster's working method. In the early days, when my father was first drawing *Prince Valiant*, Foster would send him three pages for each Sunday strip. One page was the text that had to be lettered, panel by panel. A second page was a set of panel-by-panel descriptions: here's what's happening, here's what I want you to show. The third page was a penciled layout that presented the page as Foster conceived it, with detailed sketches of the characters and action—a visual version of the descriptions. These penciled pages—the size of a sheet of typing paper, as compared to the two-by-three-foot rectangle of board the actual strip would be drawn on—were in Foster's hands small works of art in themselves. Sometimes Foster would add a fourth page of drawings, if there was something technical he needed to explain or an object—a helmet, a tapestry, a piece of jewelry—that he wanted to look a particular way. There might be a fifth page of commentary on a panel my father had already drawn, noting perhaps that, as a nobleman, Prince Valiant would not display anger in a way that "puts him on the same level as a commoner" but rather would convey emotion "with a jut of his chin and a raised eyebrow." And every so often he'd add a sixth page, providing an illustrated snapshot of his life in lieu of a letter. I remember one page that came with two sketches—the first of himself sipping a drink while on a raft in a pool; the second of himself slaving away at a drawing table in a halo of plewds, heaps of discarded paper presumably strewn all around on the floor. The two sketches were labeled: "You picture me thus . . . But it

the pictures and the words have to function as a one-two punch

Following pages: On pages 202–203, a Hal Foster script and a layout for the drawn page that goes with it, 1978. On pages 204–205, a Foster layout and the actual finished page by my father, 1977. On pages 206–207, a Murphy page in its original black-and-white state and then with the application of color, 1987.

OUR STORY, 1- Prince Arn awakes from the depth
of his sorrow, for it is spring and he is young.

2- As he wanders southward he meets
many young men bound for Orden where a King will
celebrate his marriage.

3- The noise of revelry comes up
to them. Old King Hrothgar wants to let everyone
know he can choose the fairest maid in the land
to share his wedding bed.

4- Then Arn sees the bride and one
of his companions whispers: " What sort of man
can her father be to give his daughter into the
soiled hands of Hrothgar...?'

5- "... ~~For~~ A MONTH ~~z~~ AGO Hrothgar demanded of Cnut
that he be given his daughter, Grace, as his
bride. ~~and his~~ army of berserkers ~~stood~~ ready →STOOD
with sword and flame to enforce the demand.
What else could he do?"

6- A richly decorated boat crosses
the fjord and a dirty but richly decorated
Hrothgar is helped out to meet his promised bride.

7- The bethrothal ceremony is weird.
Cattle are sacrificed, an ancient druit chants
runes and then.....

8- Hrothgar walks away to the
mead casks with his tipsy ruffians, leaving his
betrothed standing alone.

 Next week- TThe Neglected Bride

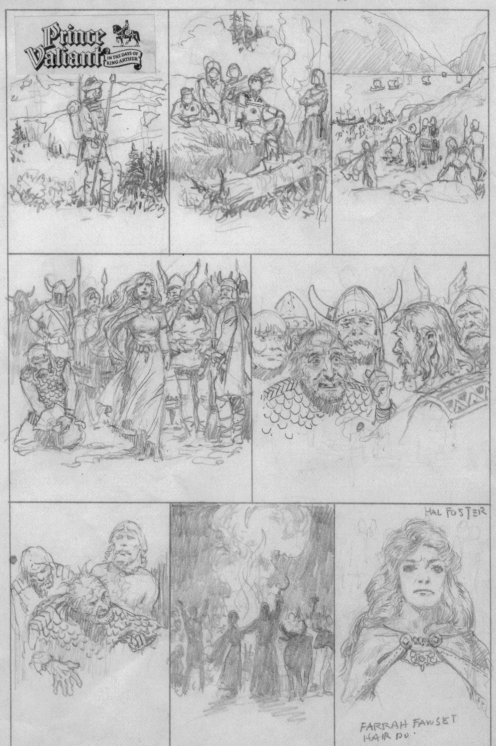

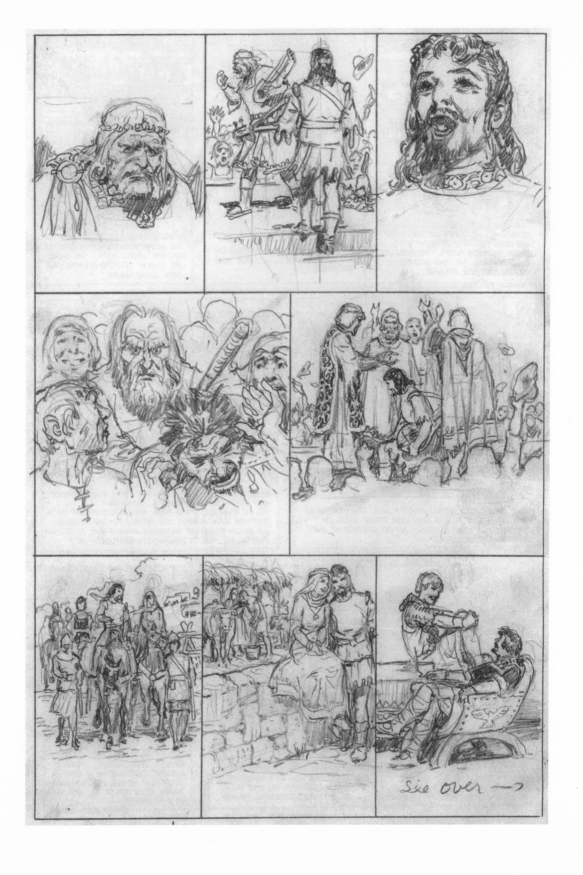

see over ⟶

Our Story: ONE THING A BULLY CANNOT STAND IS RIDICULE, AND THE LAUGHTER OF THE CITIZENS IS LOUDER THAN THE APPLAUSE OF HIS HENCHMEN.

THE NEXT CONTESTANT IS ANNOUNCED, BUT LAZARE REMAINS ON THE STAGE AND SIGNALS HIS RUFFIANS TO CONTINUE THE NOISE.

THEN, ABOVE THE NOISE, RISES A GLORIOUS VOICE, RICH AND PURE. *"BERTRAM!"* EXCLAIMS A LISTENER, *"OUR RIGHTFUL KING OF MINSTRELS HAS RETURNED!"*

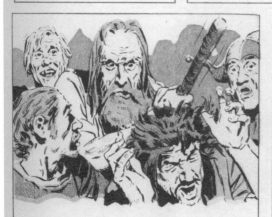

AN AGED CITIZEN BECOMES ANNOYED AT THE HECKLING: *"SHUT UP, YOU LOUT!"* AND EMPHASIZES HIS DISPLEASURE WITH HIS STAFF. HE SETS AN EXAMPLE TO HIS FELLOW LISTENERS AND SOON THE NOISE CEASES.

SO IT IS NOT AS LLANDULF, THE HUNTER, THAT HE WINS THE LAUREL, BUT AS BERTRAM, THE MINSTREL. ONCE AGAIN HE IS 'KING OF MINSTRELS,' LAZARE'S POISONED CUP HAD FAILED TO DESTROY HIS VOICE.

FOLLOWING THE CELEBRATIONS, THE PARTY RETURNS TO THE CHATEAU FOR A WELCOME REST AFTER ALL THE EXCITEMENT.

SIR RAYMOND IS BUSY WITH THE BUSINESS OF THE FIEF. BERTRAM SPENDS HOURS TRYING TO DISCOVER THE EXACT COLOR OF ELEANOR'S EYES AND GASTON AND JOAN ARE WITH THE ANIMALS AS USUAL.

"SIR DINADAN, SHALL WE RETURN TO CAMELOT AND HEAR THE CLANG OF ARMOR, OR LINGER HERE AND HEAR THE TINKLE OF WEDDING BELLS?" *"SADDLE THE HORSES AND LET'S BE OFF!"* CRIES DINADAN.

NEXT WEEK - The Castaway

20/98 3-13

Prince Valiant
IN THE DAYS OF KING ARTHUR
BY JOHN CULLEN MURPHY

Our Story: PRINCE VALIANT AND HIS MEN ARE FREE OF HIPPOPOLIS AND HAVE TRADED THEIR FINERY FOR WARM NATIVE DRESS. WINTER IS DRAWING NIGH IN THE NORTHERN WORLD. SOON THE SNOWS WILL HINDER THE SEARCH FOR A NEW ROUTE TO THE EAST.

BEFORE THE ESCAPE, GALAN HAD TAKEN A LAST SIGHTING WITH *THE PATHFINDER* FROM THE PILLAR AT HIPPOPOLIS. NOW A DISTANT POINT ON THE HORIZON BECKONS. IT IS MANY DAYS BEFORE THE NEXT PILLAR IS FOUND AND *THE PATHFINDER* CAN BE USED AGAIN.

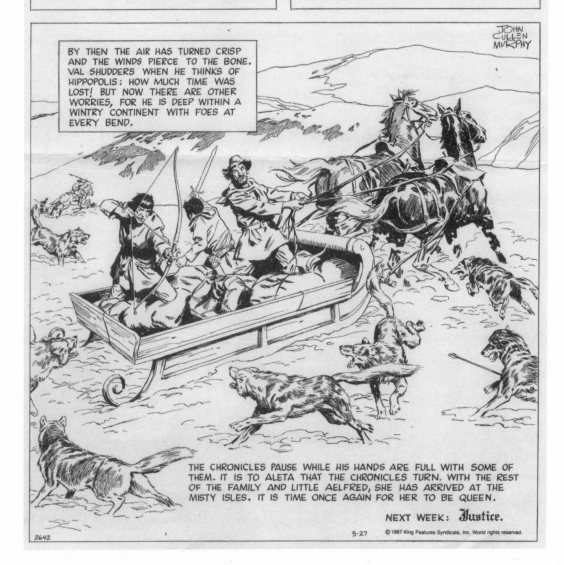

BY THEN THE AIR HAS TURNED CRISP AND THE WINDS PIERCE TO THE BONE. VAL SHUDDERS WHEN HE THINKS OF HIPPOPOLIS; HOW MUCH TIME WAS LOST! BUT NOW THERE ARE OTHER WORRIES, FOR HE IS DEEP WITHIN A WINTRY CONTINENT WITH FOES AT EVERY BEND.

THE CHRONICLES PAUSE WHILE HIS HANDS ARE FULL WITH SOME OF THEM. IT IS TO ALETA THAT THE CHRONICLES TURN. WITH THE REST OF THE FAMILY AND LITTLE AELFRED, SHE HAS ARRIVED AT THE MISTY ISLES. IT IS TIME ONCE AGAIN FOR HER TO BE QUEEN.

NEXT WEEK: *Justice.*

2642

9-27

Our Story: PRINCE VALIANT AND HIS MEN ARE FREE OF HIPPOPOLIS AND HAVE TRADED THEIR FINERY FOR WARM NATIVE DRESS. WINTER IS DRAWING NIGH IN THE NORTHERN WORLD. SOON THE SNOWS WILL HINDER THE SEARCH FOR A NEW ROUTE TO THE EAST.

BEFORE THE ESCAPE, GALAN HAD TAKEN A LAST SIGHTING WITH *THE PATHFINDER* FROM THE PILLAR AT HIPPOPOLIS. NOW A DISTANT POINT ON THE HORIZON BECKONS. IT IS MANY DAYS BEFORE THE NEXT PILLAR IS FOUND AND *THE PATHFINDER* CAN BE USED AGAIN.

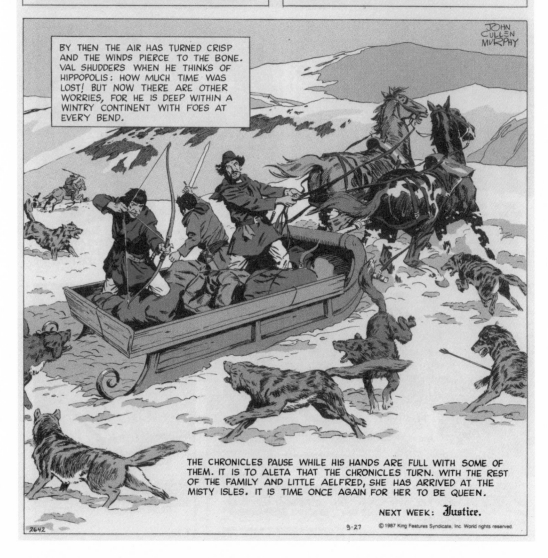

BY THEN THE AIR HAS TURNED CRISP AND THE WINDS PIERCE TO THE BONE. VAL SHUDDERS WHEN HE THINKS OF HIPPOPOLIS: HOW MUCH TIME WAS LOST! BUT NOW THERE ARE OTHER WORRIES, FOR HE IS DEEP WITHIN A WINTRY CONTINENT WITH FOES AT EVERY BEND.

THE CHRONICLES PAUSE WHILE HIS HANDS ARE FULL WITH SOME OF THEM. IT IS TO ALETA THAT THE CHRONICLES TURN. WITH THE REST OF THE FAMILY AND LITTLE AELFRED, SHE HAS ARRIVED AT THE MISTY ISLES. IT IS TIME ONCE AGAIN FOR HER TO BE QUEEN.

NEXT WEEK: Justice.

9-27

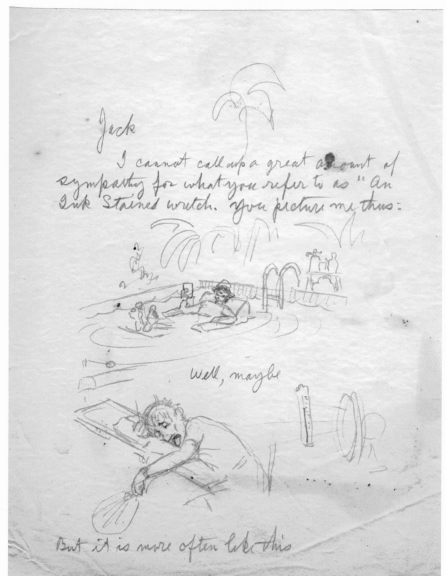

Jack

I cannot call up a great amount of sympathy for what you refer to as "an ink stained wretch. You picture me thus:

Well, maybe

But it is more often like this

is more often like this." These disembodied drawings, minutely crafted in the manner of an engraver's cartouche, were some of my favorite things Foster did—reminiscent of those orphaned Leyendecker sketches my father had picked up long ago for a song.

By writing the descriptions, I was explicitly telling my fa-

ther what to do, which seemed at odds with the natural order of things—but, perhaps for that reason, curiously satisfying all the same. And my father knew where to draw the line. On my page of instructions, I might write: "Prince Valiant and his men watch helplessly as a thousand Visigoths suddenly crest the hill." He might respond, "How about I draw ten and suggest the rest?" Or I might write: "Aleta's face when she gets the news should register shocked consternation and a glimmer of contentment that her prediction had been borne out." He might respond, "For goodness' sake, the face will be an inch high when it's published. How about just plain 'surprise'?" On one occasion, for a very large panel depicting a royal wedding, I suggested that he make some of the people among the throng look like current heads of government or members of modern royal families—Queen Elizabeth, Prince Philip, Prince Charles, Ronald Reagan, Nancy Reagan, King Juan Carlos, Margaret Thatcher. He did as I had asked, then began to worry that this quiet joke would detract from the majesty and solemnity of a sacred event. He made copies of what he had done, for posterity, then went back and gave the identifiable men beards and disguised the famous women with wimples or hats.

There were continual conversations about the direction the strip should take. They were generally aimless and unpredictable, as creative conversations often are. My father had a knack for being companionably present in an undemanding way. The sound of stiff, frosty grass being crunched underfoot is one I always associate with him, because he liked to listen to it while walking wordlessly. In the studio, you could sit for a long period in silence, reading or working, the faint sound of his scratching pen like that of a mouse behind a wall. From time to time a neuron would fire and he would speak. "People forget that Bobby Kennedy used to work for Joe McCarthy," he might point out. Or, "Always remember, yellow objects cast purple shadows." Or, "A vertebra of Charles I was made into a saltcellar." Or, "Popes always seem to have time for the Harlem Globetrotters." Comments like these couldn't help but encourage a bit of talk. Then it would be back to work.

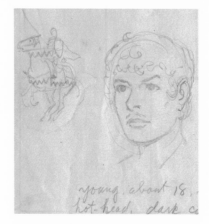

young, about 18.
hot-head, dark c

35'

minutely crafted in the manner of an engraver's cartouche

Scripts sent by Foster often included graphic digressions in pencil— miniature tutorials in themselves.

look like current heads of government or members of modern royal families

Until appearance-altering beards and wimples were added—reflecting last-minute second thoughts—the onlookers in this *Prince Valiant* episode from 1987 included (from the top) Nancy Reagan, Ronald Reagan, Prince Philip, Queen Elizabeth, and Prince Charles.

My father's stock of general knowledge was broad and deep, and he could size up an audience. There was never an edge to his remarks, or if there was you didn't necessarily know where to find it. Asked once after the 1960 elections how he could have voted for Nixon, he replied, "Because Franco wasn't running"—with a giveaway flare of the nostrils to indicate that you could take this as a joke, if you liked. He deployed his conversational talents wisely, and often in unexpected ways. One day, in 1967, he brought me to a Dutch Treat Club luncheon, in New York. We shared a table with Lowell Thomas, the man who as a war correspondent during World War I first brought Lawrence of

Arabia to public notice. My father asked him the sort of question an artist would ask: "What was the first thing you noticed about Lawrence?" Thomas said, "His head was too big for his body." The speaker that afternoon was Eugene McCarthy, the devout Catholic senator from Minnesota whose antiwar campaign had become a serious political threat to President Lyndon Johnson. My father supported Johnson and had no patience for McCarthy, but he knew I'd want to meet him, and after lunch took me over to say hello. I was nervous, anticipating a sudden squall of an argument between the two of them over Vietnam. What my father did instead was ask McCarthy if he had read Evelyn Waugh's biography of Edmund Campion. Indeed he had. We spent the next few minutes safely in the sixteenth century.

When thinking about possible plots for the strip, my father would often begin with a method similar to James Stevenson's parallel columns of nouns. In his mind he would put the main characters in one column—Prince Valiant, Queen Aleta, their children, the bumptious Sir Gawain, the noble King Arthur, the archenemy Mordred, and all the rest. In the other mental column he arrayed a master list of situations: blackmail, romance, kidnapping, illness, injury, murder, revenge, betrayal, shipwreck, inheritance, disinheritance. Then he would run through all the possible combinations, like one of Alan Turing's bombe machines at Bletchley Park. It got us started, anyway. His real genius—shared by my mother—lay in creating backstories, perhaps not surprising for someone who had saved all his paperwork from kindergarten. At restaurants the two of them would notice someone across the room:

Mother: That man by the window. Dining alone.
Father: In the bow tie? The widower?
Mother: No, table next to him—reading a letter from his estranged son.
Father: Ah, the Englishman. Can't go home of course.
Mother: We think so differently over here about that kind of scandal.

Father: It was only whist—who cares?

Mother: The sister in Dorset wasn't sorry. The house is hers now.

Father: But the son wants it. Why else would he write?

On it went. When it came to moving the action along in *Prince Valiant*, mysterious backstories had a propulsive power. Arn, one of Prince Valiant's sons, meets the woman he will marry when his vessel is shipwrecked on "an isle beyond the north wind." Her name is Maeve, and she roams the island with a pack of wolfhounds. It was my father who suggested that she harbored a terrible secret, one that would provide a motivating force in story lines for years to come: "Maeve is actually the daughter of Mordred. Maybe even the product of a morganatic marriage! She knows the truth, but no one else does. And she won't marry Arn until he discovers and accepts who she is." When it came time to create the actual character, my father used my wife, Anna Marie, as the model. Nothing preserves family bonds like a Polaroid fixative stick.

she roams the island with a pack of wolfhounds

John Cullen Murphy, *Prince Valiant*. Val's son Arn is smitten by Maeve, whom he encounters by accident— and eventually they marry. She proves more than his equal.

"BAD LUCK," SAYS MAEVE. AND WITHOUT ANOTHER WORD SHE PULLS AN ARROW FROM HER QUIVER.

2688

JOHN CULLEN MURPHY 8-14

UNERRINGLY IT COVERS THE DISTANCE AND FINDS THE MOVING TARGET. THE BUCK IS BROUGHT DOWN....BUT SO, IN A WAY, IS SIR GUY. ARN'S COMPANIONS MUTTER ANGRILY AMONG THEMSELVES. "SIR GUY HAS BEEN INSULTED BY THIS....THIS....WOMAN!" SIR GUY HIMSELF SAYS NOTHING. HE JUST GLARES. NEXT WEEK: Battle Lines?

My father and I talked by phone almost every day, often more than once. He was in Cos Cob, I was generally elsewhere. But it was always better to come to the studio in person. He would knock the ashes from his pipe, rise from the drawing board, step past the dented copper washtub he used for trash, and come forward ostensibly to shake your hand, but in reality to show you items of interest freshly laid out on a flat surface nearby. My father was a pack rat—a trait, I acknowledge, that we share—and when he dove into his boxes and closets in search of something specific, he would generally emerge with a great deal more. One day it might be the scores of black-and-white photographs he'd taken in the Aran Islands in the late 1940s, on a morning when the Irish president, Eamon de Valera, had come for a visit and strolled on the beach with the townspeople of Kilronan. I'd seen watercolors he'd done of this same moment—de Valera looking jaunty yet aloof in a black beret—but never the original pictures. Another day he might produce a few pages of his vocabulary homework from third grade, written in fountain pen in a hand that had already acquired a familiar cast. "A *refulgent* smile— very bright. *Condign* punishment—well-deserved. *Sacerdotal* rites—priestly." The network of family was immensely important to him—on this earth, what else could you really count on?— and his vast personal Genome Project existed on thousands of bits of paper: his uncle and namesake's discharge papers from the army; his grandfather's First Communion certificate; his mother's marriage license. One afternoon he found an envelope that contained a brittle clip from the *New York Herald Tribune*, together with a glossy photograph. Both showed me at the age of four, dressed up as the Yellow Kid for a syndicate promotion. My father holds me in his arms in front of the old Hotel Astor, in New York. He is standing on a ladder that raises us to the level of a street sign that has been changed from "Times Square" to "Newspaper Comics Square."

There would be letters to look at: fan mail or requests for autographs or invitations to do a radio show or appear on television. And half-finished pencil portraits he'd been asked to draw

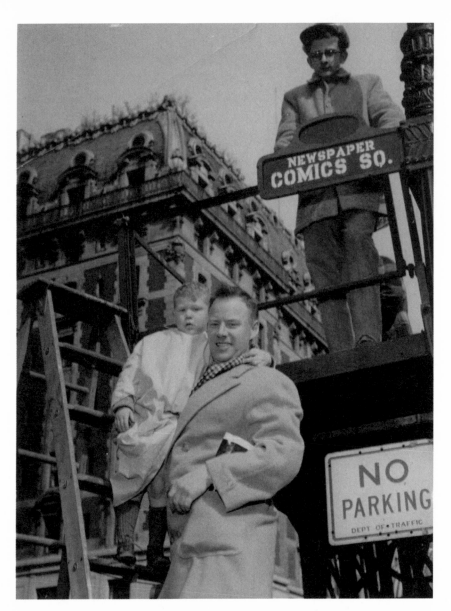

dressed up as the Yellow Kid for a syndicate promotion

In my father's arms, enlisted by King Features in 1956 to mark the sixtieth anniversary of R. F. Outcault's *Hogan's Alley*.

of local notables—a beloved school janitor, a long-serving traffic cop. My father regarded himself as the unofficial mayor of Cos Cob—he made the rounds of the little shopping district just about every day after lunch—and these minor artistic obligations were bound up, as he saw it, with the privileges of seigneurial rank. Spread out on the flat surface would also be copies of

the strips he'd drawn in pen and ink in recent weeks, along with proofs that showed the way a page would actually be printed. At last you could see how lettering, pictures, and color had all come together. My father was especially proud of the oversize panels he composed every so often, where he could work on a large scale, like a true illustrator. On occasion I pointed out how many of the background characters in these panels seemed to resemble him, with their gray beards and thinning hair ("A common type back then," he would say) and their exaggerated expressions of joy or anger.

Looking down all too often from an easel was his brother Bob, the general, whose vaguely censorious oil portrait my father struggled to complete over a period of twenty years. John Singer Sargent once defined a portrait as "a likeness in which there is something wrong about the mouth"—a maxim known to everyone in our family—and Bob's mouth had gone through many iterations, removed each time with a scrape of the palette knife.[7] I wish I had a record of them all, strung together like the montage of movie kisses that brings the film *Cinema Paradiso* to a close. In his various attempts my father captured nearly every band of the oscular spectrum between grim and prim, but the sought-after "friendly resolve" remained elusive.

My mother would often come out to join us—to inspect a new painting or convey some news or plan a dinner party. Her eyes might fall on a pencil sketch of a retiring mailman, a wordless glance being enough to convey "I see you said 'yes' to something else." She took a position on her role in such matters similar to the one spelled out by Walter Bagehot in *The English Constitution*: a constitutional monarch possessed the right to be consulted, the right to encourage, and the right to warn. My mother, too, was generous with her time—she had been the civic force behind a new library—but she was also immensely practical. Once, in the early 1950s, my father was late with his work and needed to deliver a strip to New York in person. He had no money for train fare and the banks were closed. My mother remembered that she had affixed a silver dollar, wrapped heavily

how lettering, pictures, and color had all come together

Following pages: A proof moves from color markup to published form. Letters and numbers indicate specific shades.

Our Story: PRINCE VALIANT RIDES HOMEWARD, SINGING. HE HAS JUST ACHIEVED ONE MORE GOOD DEED TO ADD TO HIS SAGA AND IS QUITE PLEASED WITH HIMSELF. HE IS FAST BECOMING A LIVING LEGEND.

POETS, TROUBADOURS AND STORYTELLERS HAVE IMMORTALIZED LANCELOT, TRISTRAM, GALAHAD AND PERCIVAL. NOW THEY FIND A ROMANTIC SUBJECT IN PRINCE VALIANT.

WHEN THEY TELL HOW HE SINGLE-HANDED, SLEW A TERRIBLE DRAGON HE MERELY SMILES: "IN EGYPT THEY CALL IT A CROCODILE."

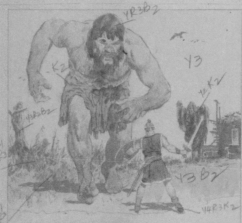

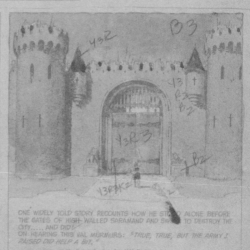

THE EPIC POEM DESCRIBING HIS CONFRONTATION WITH HORRIT, THE WITCH, AND HER GIANT SON, THE TERRIBLE THORG, SURPRISES VAL. "WELL," HE ADMITS, "HE WAS LARGE!"

ONE WIDELY TOLD STORY RECOUNTS HOW HE STRODE ALONE BEFORE THE GATES OF HIGH-WALLED SARAMAND AND SWORE TO DESTROY THE CITY.... AND DID!.
ON HEARING THIS VAL MURMURS: "TRUE, TRUE, BUT THE ARMY I RAISED DID HELP A BIT."

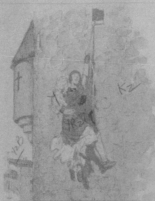

TO MAKE A GOOD STORY BETTER THE STORYTELLERS EXAGGERATE A TRIFLE AND TELL OF HIS RESCUE OF FAIR PRINCESSES (ALWAYS BLONDE) FROM GRIM ENCHANTED TOWERS.

THESE EXAGGERATIONS ARE NOT WELCOME TO THE HUSBAND OF A QUEEN. PRINCE VALIANT FEARS NOTHING SO MUCH AS THE TEMPER OF HIS SMALL WIFE.

VAL IS NOT A PRUDE. IT JUST SO HAPPENS THAT IN ALL HIS FAR ADVENTURINGS HE HAS NEVER MET LOVELINESS TO EQUAL THE LOVELINESS OF ALETA.

NEXT WEEK—Homeward Bound

Our Story: PRINCE VALIANT RIDES HOMEWARD, SINGING. HE HAS JUST ACHIEVED ONE MORE GOOD DEED TO ADD TO HIS SAGA AND IS QUITE PLEASED WITH HIMSELF. HE IS FAST BECOMING A LIVING LEGEND.

POETS, TROUBADOURS AND STORYTELLERS HAVE IMMORTALIZED LANCELOT, TRISTRAM, GALAHAD AND PERCIVAL. NOW THEY FIND A ROMANTIC SUBJECT IN PRINCE VALIANT.

WHEN THEY TELL HOW HE SINGLE-HANDED, SLEW A TERRIBLE DRAGON HE MERELY SMILES: *"IN EGYPT THEY CALL IT A CROCODILE."*

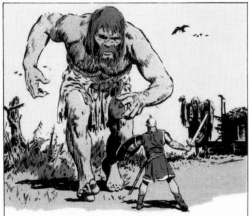

THE EPIC POEM DESCRIBING HIS CONFRONTATION WITH HORRIT, THE WITCH, AND HER GIANT SON, THE TERRIBLE THORG, SURPRISES VAL. "*WELL*," HE ADMITS, "*HE WAS LARGE!*"

ONE WIDELY TOLD STORY RECOUNTS HOW HE STOOD ALONE BEFORE THE GATES OF HIGH-WALLED SARAMAND AND SWORE TO DESTROY THE CITY..... AND DID!
ON HEARING THIS VAL MURMURS: "*TRUE, TRUE, BUT THE ARMY I RAISED DID HELP A BIT.*"

TO MAKE A GOOD STORY BETTER, THE STORYTELLERS EXAGGERATE A TRIFLE AND TELL OF HIS RESCUE OF FAIR PRINCESSES (ALWAYS BLONDE) FROM GRIM ENCHANTED TOWERS.

THESE EXAGGERATIONS ARE NOT WELCOME TO THE HUSBAND OF A QUEEN. PRINCE VALIANT FEARS NOTHING SO MUCH AS THE TEMPER OF HIS SMALL WIFE.

10-1

VAL IS NOT A PRUDE. IT JUST SO HAPPENS THAT IN ALL HIS FAR ADVENTURINGS HE HAS NEVER MET LOVELINESS TO EQUAL THE LOVELINESS OF ALETA.
NEXT WEEK—Homeward Bound

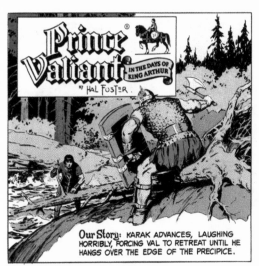

Our Story: KARAK ADVANCES, LAUGHING HORRIBLY, FORCING VAL TO RETREAT UNTIL HE HANGS OVER THE EDGE OF THE PRECIPICE.

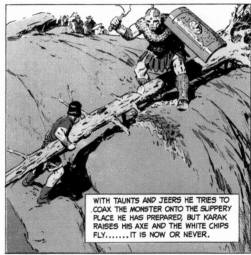

WITH TAUNTS AND JEERS HE TRIES TO COAX THE MONSTER ONTO THE SLIPPERY PLACE HE HAS PREPARED, BUT KARAK RAISES HIS AXE AND THE WHITE CHIPS FLY.......IT IS NOW OR NEVER.

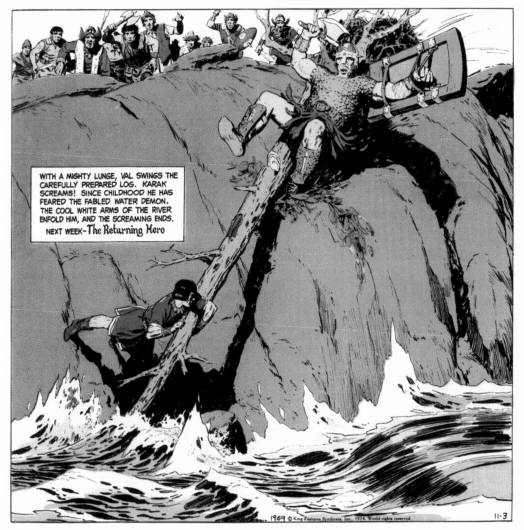

WITH A MIGHTY LUNGE, VAL SWINGS THE CAREFULLY PREPARED LOG. KARAK SCREAMS! SINCE CHILDHOOD HE HAS FEARED THE FABLED WATER DEMON. THE COOL WHITE ARMS OF THE RIVER ENFOLD HIM, AND THE SCREAMING ENDS.

NEXT WEEK—The Returning Hero

in adhesive tape, to the belly of one of my newborn sisters—a bit of do-it-yourself treatment for an umbilical hernia. A dollar, she pointed out, was enough for a round trip. The adhesive was unraveled on the train as the conductor waited. To the extent that my mother's powers had a genetic basis, we could guess where they came from. She was descended from an Irish family that had split in two in the early nineteenth century. One branch was that of the eldest son, who inherited the farm and most of the property. The other branch—my mother's—was that of the younger brother, who inherited nothing but a box of tools. A century and a half later, the first branch still occupied the farm. The second branch ran one of the largest construction companies in Ireland.

·

A strip like *Prince Valiant* needed to intersperse tales of high adventure with moments of domestic rambunctiousness and familial warmth. Prince Valiant inhabited a war-torn age—*Mad* magazine once published a parody of the strip, calling it *Prince Violent*—but the story also needed a certain amount of humor. Some subject areas, such as religion, had never come up much in the past—it was a topic on which the comics were notably shy—but how could you avoid matters of faith in a historical strip of this kind, set in a time of religious ferment? Increasingly we decided that you couldn't. As for fantasy, there had always been room for it in the strip, though kept within bounds; as Foster once explained, people were cottoning on to the fact that there weren't dinosaurs around in the Middle Ages, even if the news hadn't reached everywhere yet. But there were dragons and witches in the earliest days of the strip, and prophecies, dream sequences, and mythic episodes in its later days. The geographical scope of *Prince Valiant* was global—in Foster's time, Val had reached Africa and the New World, and in our own he would go to India and China. So "Where next?" was always a question. As were the inner dynamics of Val's family life—births, deaths, marriages, animosities, and the vagaries of physical separation. I

especially proud of the oversize panels he composed every so often

John Cullen Murphy, *Prince Valiant*, 1974—"Bring on the elephants," Foster used to say of pictures that took up most of a page.

can remember asking my father if he thought we were ready for another child—communication is important in any sort of marriage, and you need to be able to talk openly about these things.

The sheer size of the audience for comic strips was hard to get your head around. A strip that appeared in a thousand newspapers was easily reaching a hundred million people every day. *Prince Valiant*, which appeared in about 350, had a potential Sunday audience of tens of millions. Among those readers there would always be some who might be a source of embarrassment. Having the Duke of Windsor identify himself as your number one admirer was a mild annoyance—his life list of enthusiasms doesn't stand up to scrutiny. But the main lesson of a mass audience was that someone was bound to be paying attention.

Prince Valiant was prized for its historical accuracy and was based on a great deal of research. If you called something a Frankish short sword, it had to look like one. Catapults had to function the way catapults actually did. The breeds of horses had to be correct. Anachronism—using a type of weapon or mechanical technology that didn't come into use until long after Prince Valiant and his friends were in their graves—was a constant menace. Foster had taken enormous liberties, to be sure. He wanted authenticity, but sometimes it had to be what he once characterized as a fake authenticity. As he candidly admitted, he had allowed himself to roam across nearly half a millennium of history in search of usable material. The strip ostensibly takes place soon after the end of Roman Britain, in the fifth century AD; historically, Viking marauders and jousting knights came later—but what the hell. So there are plenty of Vikings in the strip (Prince Valiant himself is a Viking) and there is plenty of jousting. The castles resemble a conflation of Mont Saint-Michel and the Blue Mosque—nothing like the palisaded fortifications above crude earthen ramparts that would have been the fifth-century reality. Many things were completely off-limits, however—no printing presses, no clocks, no reading glasses, and no gunpowder—unless you ventured

east across the steppes to an even more ancient civilization in China, as characters in the strip eventually did.

Slip up on something small and seemingly inconsequential and you'd hear instantly from a sharp-eyed specialist in Melbourne or a single-minded autodidact in Coeur d'Alene. Most of those who wrote to us about *Prince Valiant* were enthusiastic and helpful, if on occasion mildly reproachful. "I was glad to see Sir Kay make an appearance," one man wrote from Abilene, Texas, "and looking hale and hearty to boot—much better than he appeared at his death in 1942." One episode showed mirrors being used to reflect sunlight and set attacking ships alight— according to Plutarch, this was something that Archimedes had done during the siege of Syracuse, in 216 BC. A team of physicists at Caltech forwarded several pages of unfathomable calculations: Plutarch's account was preposterous. The depiction of men on horseback using stirrups provoked continual controversy— scores of letters over the years. "Medieval-style armed combat between mounted knights, of the kind depicted last Sunday, was made possible by the stirrup," one man wrote from Cambridge, Massachusetts. "But stirrups weren't brought to Europe from Asia until several centuries after Prince Valiant would have been living." True enough—and we'd long been conscious of that fact. Stirrups were unknown to the Romans and would have been unknown to King Arthur, if there ever was such a man. But the strip needed jousting, so the knights needed stirrups. A woman in Schenectady enclosed a clipping from the strip showing laundry drying on a line, and asked, "What is this—clothespins? I studied the drawing carefully: perhaps those are some rudely split pegs, or even twigs? But no, they are indeed clothespins, down to the round heads!"—a design of Shaker origin, apparently. Another woman, this one in England, wrote in response to the depiction of a blacksmith's forge, enclosing several photographs: "The anvil the smithy used, with its prominent single horn, was of a type not introduced until the 1500s. Surely your smithy would more likely have been using a block anvil with a tapered base like the Romano-Celtic one excavated at Stanton

Low, near my home in Buckinghamshire, in the late 1950s. Either that or your smithy was possessed of remarkable foresight." This was the kind of informed communication from an alert and cordial amateur that could shine a ray of light into an otherwise dreary day.

On one occasion my father received a note of appreciation for *Prince Valiant* from the actress Greer Garson, and, in a gesture of proud understatement, left it on the kitchen table for a week or so to impress any of us who might chance upon it. To him, Greer Garson was a cultural touchstone—right up there with Loretta Young, who had the additional advantage of being a Catholic—but for the younger set the name carried all the iconic allure of Bess Truman or Ezra Taft Benson. When at last he drew attention to the letter, he was surprised to get no whoop of recognition in response. Explanation was pointless. He left for the studio with a Parthian shot, observing that Garson had been "quite a beauty in her day."

Every afternoon brought mail from *Prince Valiant* fans, and it was clear that certain readers had a more intense relationship with the strip than even its creators did. When I took over the writing, one man sent a letter to me saying that he had been clipping and saving the Sunday pages since February 13, 1937, when *Prince Valiant* made its debut, and had also kept track on index cards of all the plotlines and every new character, "with marginal glosses noting mistakes and inconsistencies over time." Would this material be of use? It proved immensely valuable. To inhabit the spirit of another person's creation is no

Slip up . . . and you'd hear instantly from a sharp-eyed specialist

The anvil in this 1986 *Prince Valiant* panel is an anachronism, as a reader in England pointed out. What could the creators have been thinking?

AND IN THE FORGES OF VIKINGS-HOLM THE SMITHIES' HAMMERS SING A CLANGING SONG OF WAR.

NEXT WEEK: Strategy

2556

easy thing. I had followed the strip all my life, but it had been running for twenty years before I began to read it, which meant a thousand Sundays of backstory. Prince Valiant had already fled to the Fens from his home kingdom of Thule, driven out by an evil usurper. He had been accepted into the world of Camelot and become a knight. He had bested a rival for the hand of Aleta, Queen of the Misty Isles. He had come away from his encounter with the witch Horrit burdened by her prediction that he would "never know contentment." He had faced a hundred challenges. Staying true to the strip's history and its animating sentiments was essential: there's a reason why these kinds of comic features are called "continuity" strips. But the same mandate held, one way or another, for strips of all kinds. Gags were rejected all the time because they weren't funny enough, but even funny gags were rejected because they pushed beyond the boundaries of a character's natural outlook or a strip's founding conceit. "Beetle wouldn't say something like that." "Trixie wouldn't think something like that." These are the sort of comments you would often hear.

It may seem odd that something as inherently ephemeral as a comic strip—coming to life every day in a medium that is quickly discarded—should also convey a feeling of permanence and stability. If there was an illusion of stability about this world, it lay in part in the stability of the work itself. Although many strips did not last long—life expectancy at birth might be just a few years—those that gained traction could go on for many decades. One, *The Katzenjammer Kids*, is today well past the century mark. Three others (*Gasoline Alley*, *Snuffy Smith*, and *Popeye*) are nearing it. Many are past fifty. In only a few strips have characters visibly aged over time, much less died. *Gasoline Alley* has been true to the human life cycle, but at a glacial pace. So has *Prince Valiant*, whose title character was about twelve when the strip first appeared, was married in the 1940s, had four children by the end of 1962, a fifth in 1979, and became a grandfather in 1987. For all that, Prince Valiant has looked more or less the same (a robust forty-five or so) for many years, though

King Arthur would grow old and die. But in the moment, from week to week, strips appear static, the way continents do, though intellectually we know that continents can't have been static, and aren't. There was a time when Blondie was a flapper, and when she and Dagwood weren't married. There was a time when Beetle Bailey was a college student, not an army private. In most strips, the physical appearance of the characters doesn't evolve very much at all, even when changing times demand some adjustment in content. Gender roles couldn't remain locked in the 1950s, so in *Hi and Lois* there came a point when the person wearing the apron wasn't Lois but Hi, and all the jokes about bad

strips depend on and create the comfort of constancy

A 1949 Mort Walker cartoon in *The Saturday Evening Post*—before *Beetle Bailey* became a strip. Continuity of character is more important than continuity of context. Beetle was originally a college student.

" OKAY, BEETLE, HEADS WE JOIN THE ARMY TAILS WE GO ON STUDYING FOR FINAL EXAMS "

cooking or broken dishes were now aimed at him. Everyone in the Flagston family, like everyone else shown in any comic strip car, now wears a seat belt. But the strips depend on and create the comfort of constancy. Chip, the teenage son of Hi and Lois, has been getting his driver's license for about forty years. Helga will forever be smarter than Hägar, and indeed most women in most strips will be smarter than most men. *Beetle Bailey*'s Zero will never gain an IQ point, but will remain unwittingly perceptive. Superman's cape will always billow in the wind even when there is no wind.

The cartoonists themselves turned out to be the ephemeral part. I remember a gathering in the mid-1980s at the Museum of Cartoon Art, which occupied a high ridge just beyond the westernmost edge of Greenwich. The moment seems more distant than it is—as if on the other side of a veil. So much had yet to happen. The Internet and *Harry Potter* were years away. The Soviet Union still existed. So did the Berlin Wall. No one had heard of Osama bin Laden. Iraq had not been invaded even once.

It was a beautiful fall afternoon, a classic Indian summer day, and the wide circular porch, fronting to the east, afforded a vista of Fairfield County stretching to the horizon, the hills flecked with orange and red. Mort Walker had founded the museum a decade earlier, and his own collection formed the heart of its holdings, which now ran to tens of thousands of original strips. I don't remember the specific event that day—a retrospective of some sort, in all likelihood, honoring one of our friends. It seemed to have pulled every local cartoonist out of the hollows, and the intricate web of relationships seemed almost visible. They had drawn one another into their strips. They had appropriated anecdotes from each other for their own creative use. They had traded originals, stepped in to take up the pen during crises, and made the requisite calls to Reno and Wheeling and Biloxi when strips were dropped from papers. The weather that day was perfect, warm air gently stirring hems and collars. It was one of those moments when you wished you could hit pause, because fast-forward was coming next.

My father didn't say as much out loud, but he was clearly having the same thought that I was. He pointed to several of his friends on the porch. "The other day I played golf with Dik Browne, Chuck Saxon, and Whitney Darrow Jr.," he said. I could imagine the scene all too well, given my father's bad asthma, Saxon's bad kidneys, and Browne's bad everything. It would not have been ept or gainly. My father said, "We had enough working body parts for only one complete golfer." He added, "Of course, they charged us for all four."

•

In bags and boxes at my home I keep hundreds of the old Polaroids my father took of himself. He is in his mid-thirties when the pictures start. He is in his mid-eighties when they stop. His hair recedes and whitens. A beard appears. The exaggerated facial posturing ("Happy!" "Courage!") never really changes, but the trim former army officer slowly morphs into Don Quixote. A fastidious and deranged scholar could probably link each picture to specific panels of *Prince Valiant* and *Big Ben Bolt*. The whole half-century arc of these two comic strips, and by extension an entire cartoon community, its waxing and its waning, is embodied in these browning squares of paper. Looking at them, I can't

help but recall a comment by Al Hirschfeld: "The whole trick of an artist is to stay alive." It was a trick Hirschfeld at least had mastered. Working always from an old barber chair, he lived to be nearly one hundred.

A few years ago I was speaking with Jerry Dumas, at the time eighty-three, about the Connecticut School, and he mentioned the map of Fairfield County that he and Mort Walker had drawn four or five decades ago. Dumas still had a copy, he said, but one day he had looked at it and begun putting a red line through the names of those who had died. *Nancy*'s Ernie Bushmiller, 1982. *Scorchy Smith*'s Noel Sickles, 1982. *Hägar*'s Dik Browne, 1989. *Quincy*'s Ted Shearer, 1992. *Hubert*'s Dick Wingert, 1993. *Popeye*'s Bud Sagendorf, 1994. *Amy*'s Jack Tippit, 1994. *Superman*'s Curt Swan, 1996. *Juliet Jones*'s Stan Drake, 1997. *Winthrop*'s Dick Cavalli, 1997. *Rip Kirby*'s John Prentice, 1999. *The New Yorker*'s Whitney Darrow Jr., 1999. *Boomer*'s Mel Casson, 2008. *Joe Palooka*'s Tony DiPreta, 2010. The county was quickly depopulated, and he put the map away. Dumas himself is now gone.

The concentration of cartoon talent in that small corner of the world was a product of special circumstances. Those circumstances have disappeared. Newspaper comic strips are not the force they once were, and few magazines still publish gag cartoons. Look day survives at *The New Yorker* and several other places, and some of the cartoonists who participate still make Tuesday or Wednesday a day for lunch or drinks, but it is much diminished from the vast communal pilgrimage it used to be.[8] The New York newspaper strike of 1963 had many repercussions, one of them being the death, within a few years, of the Hearst flagship, the *Journal-American*, whose funny pages were the best in the country. Making it there was like opening at the Roxy; now it was history. To cut costs, newspapers began printing comic strips smaller and smaller, until the funny strips were barely legible and the dramatic ones had shed their grandeur. By way of protest, Walker once drew already compressed versions of Beetle and Sarge into one of his strips; editors were unmoved.[9] *Prince Valiant*, which traditionally filled an entire page, was dis-

assembled, the panels rearranged like building blocks so that the strips appeared on a third or a quarter of a page. Sometimes this meant letting newspapers tinker with the artwork to fill the allotted space, photographically stretching a panel high or wide like an image on Silly Putty. The noble figures came to look like images in a fun-house mirror. Prince Valiant sometimes resembled Sylvan Byck. In any case, tricks like these would never have been enough to save the print-newspaper industry from its fate. Ravaged by competition from other media, hundreds of papers have stopped their presses during the past two decades. Sunday circulation has been dropping by two or three million readers a year.[10] Comic strips have found a presence online, but they are not a form of public expression—right under your nose, unavoidable, day after day—the way they were. What has taken their place, as a phenomenon that lives in print, are graphic novels of great artistry. Someday they may become a mass medium transcending divisions of age and class. They have not become that yet. One of the most prominent of the graphic novelists, Daniel Clowes, the creator of *Ghost World* and *Eightball*, has observed that being the world's most famous cartoonist is like being the world's most famous badminton player.[11]

The Commodore Hotel, the longtime venue for Sports Night and other cartoonist events, is gone—gutted, sheathed in glass, and turned into a Grand Hyatt. The Plaza Hotel, the longtime venue for the Reuben Awards, is now partly condominiums and partly a shopping mall; there is still a hotel, but the original furnishings were auctioned off in a liquidation sale. New York remains the center of the publishing industry, but the commuter railroad is no longer a necessary lifeline: the Internet makes it possible for artists to send their work from anywhere. Fred Lasswell, who had lived in Connecticut but moved to Florida—many others would follow—was one of the first to send his work to the syndicate by e-mail. Connecticut also has a state income tax now, though higher taxes are not what has made Fairfield County unaffordable—Wall Street is responsible for that. In the early 1980s I remember a yacht appearing in Greenwich Harbor bear-

the last time I spoke with him

Cartoonist friends sent drawings during my father's final illness, in 2004. The ones here are from Johnny Hart (top) and Arnold Roth (bottom).

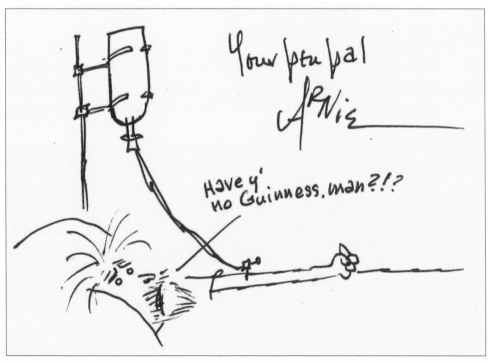

ing the name *Arbitrage*, and it was like the ominous moment when the first Western naval steamships appeared at Edo. There would be no turning back. Meanwhile, the passage of time has brought many venerable strips to an end, though others, like *Prince Valiant* (illustrated after my father's time by Gary Gianni and then Thomas Yates, and written by Mark Schultz) still thrive. Newer strips such as *Dilbert* and *Pearls Before Swine* have won millions of followers, but their creators are geographically dispersed. Online, writers conjure a dystopian future for certain "legacy" strips, as with the fanciful news of a "gritty, in-your-face reimagining" of *Beetle Bailey* by Frank Miller, known for the graphic novels *300* and *Sin City*. The report quoted Miller as saying, "The new Beetle has just returned from his fifth deployment since 9/11. He's twice-divorced and has a son who hates him for always being off at war. He's an alcoholic, suicidal, he has impulse-control problems and is covered with tattoos."[12]

My father died in 2004, drawing *Prince Valiant* up until a few months before the end, when his strength began to ebb and he needed assistance with many routine tasks. The first time I held him up in the bathroom he said, "It's just like the Polo Grounds." The three other members of the golfing foursome he mentioned on the porch had departed long before. My father had been living with cancer for some years, but what took him down, at the age of eighty-five, was a fall that knocked him out and caused a swelling under his skull. The last time I spoke with him, he was in the hospital, where he had been given a craniectomy to relieve the pressure on his brain. He was in good spirits, but no matter the circumstances he almost always was. The only hint of the valedictory on his part was an injunction to be nice to one of his old army pals, a crashing bore who also cheated at tennis. What he actually said was, "The sins of the father must be visited by the son." I've always wondered whether the opportunity for a bit of wordplay was more important than actual concern for his friend. My father explained the medical procedure he had just undergone, noting that he now had a big hole in his head, and who knew what was leaking out. "But you know

what?" he went on, tapping his temple. "Those old Fordham football scores? They're still there!"

I remember talking with Dik Browne one afternoon in the mid-1970s about Fairfield County and how the Connecticut School even then was winding down. We were having lunch at his house in Wilton; he would soon move to Sarasota. His wife, Joan, was with us, and the television was on in the background. Joan by then was suffering from emphysema and she moved about the house on a motorized scooter, hooked up to a tank of oxygen. For some reason, Dik wanted to change the channel, but every time he used the remote, wielding it clumsily with his arthritic arm, he also caused the seat on the scooter to rise. When Joan used her controls to fix the seat, the channel would change. For several minutes the two of them engaged in electronic warfare. Dik was probably thinking, "I can *use* this!"

When the fun was over, he came back to what we had been talking about. He was under no illusions—holding on to no cat. He said, "I feel right now the way I used to feel as a kid when the movie was over. The credits would start to roll. The lights would start to come up. And I would walk slowly backwards up the slanting aisle, watching the screen, just trying to make it last as long as I could."

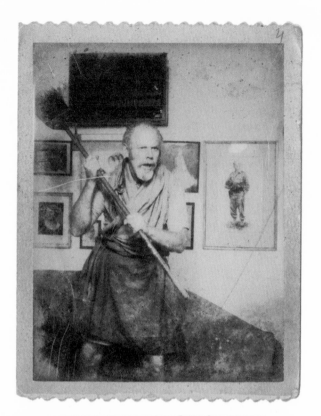
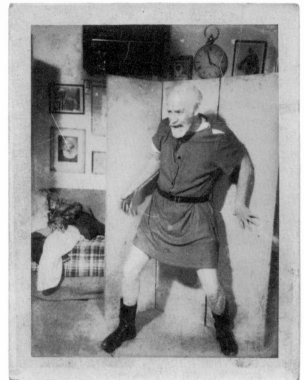
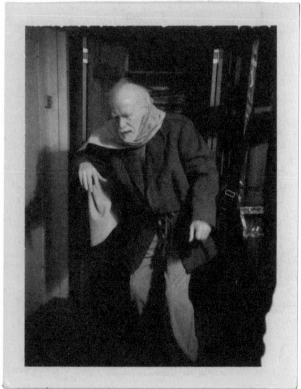
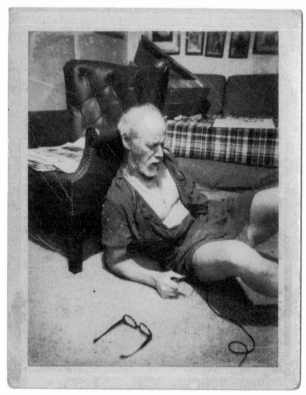

EPILOGUE

From a distance I can see and understand much that was only dimly visible when I was younger. A community that seemed to me unusually close-knit and welcoming, as indeed it was, also had its share of ordinary human commotion: the family troubles, the money troubles, the dashed ambitions, the chance misfortunes, the good luck that led to bad, the charming foibles that spiraled slowly into conditions with Greek or Latin names. There were members of the group who did not get along very well, and husbands and wives, not married to each other, who got along too well. Although the community reflected its immediate surroundings acutely, and reflected more generally the attitudes of a certain segment of middle-class America, it was hardly a microcosm of the country as it actually was, much less of the country we were rapidly becoming. It was mostly white, mostly male, and mostly accepting of the traditional order of things.

Politically, a majority of the cartoonists would have called themselves liberal. Socially and temperamentally, they were conservative. They believed in the basic American institutions and subscribed to the serviceable founding myths. They were the children of men and women who had been born in the nineteenth century. They remembered horse-drawn milk wagons.

Their childhood photographs, featuring sailor suits and Buster Brown haircuts, rendered in sepia, look today like something from a history textbook. They had marveled at Lindbergh's solo flight, remembered Prohibition, lived through the Depression, served in the war, and emerged into an era of American power and prosperity—and were unapologetically grateful for that. When called to Washington to meet with the president, whoever he might happen to be, they went with excitement and pride. You don't find much anger or discontent in their work. The ambience of the comic strips was shot through with the cardinal virtues and the deadly sins, rendered with bold brushstrokes and in Technicolor. It was not an ambience of irony, cynicism, uncertainty, despair, or alienation, where the colors are mixed in brooding, complicated ways. There was sophistication and wit in their work, but also a kind of modesty, clarity, and innocence.

This extended to their peculiar form of self-regard. One question that people always asked my father and his friends was whether they considered themselves artists. Cartoonists didn't find the "artist" question to be a very important or fruitful one. They didn't go around asking it of themselves, and would have been embarrassed to be seen as putting on airs. They were well aware that some scholars and critics had staked out a case for cartooning as an "art form," like Hopi dolls or Shoowa textiles, a position that seemed to them oddly ambiguous and a little unfair—endowing the product but not the producers with elevated cultural status. Somehow, in this view, cartoons and comic strips had turned into art unintentionally, even though the makers had only been primitive artisans—the sort of people who might be turned away from the MoMA reception for the art form itself. As it happened, the makers were not much interested in exploring this theory of transubstantiation, and were content to describe themselves with words like *cartoonist* and *illustrator*. There was something about the unrelenting dailiness and the deadlines, and the similarity of skills and training among the practitioners, that also pushed the identity into the realm of *craftsman*.

As for the ultimate significance of what they did, was it any-

thing more noteworthy than bringing laughter (and adventure) to other human beings, while keeping the show on the road? What any civilization mostly needs is not the world-altering legacy of a few but the numberless people of talent who play a role and play it well, and maybe play it a little better than before— sustaining their contemporaries in the brief moment we have together. This is all that most writers and comedians, priests and doctors, ballplayers and musicians ever achieve, and it's legacy enough. Though in this case there was more to the legacy than that. In cautious and individual ways, without much by way of precedent, the cartoonists of the 1950s and '60s widened the boundaries of what you could show and say in newspapers and magazines. They encouraged and trained hundreds of young people who wanted to get into the business. And the increasing virtuosity of their techniques, whether in funny strips or dramatic ones, opened a door to the graphic renaissance of today. None of this was really on their minds—they were just making ends meet while doing something they enjoyed. That said, I've always suspected that, deep in their hearts, cartoonists harbored a view precisely opposite to that of the scholars and critics: that they themselves *were* artists of some kind, but that their strips and cartoons might not really be Art, at least not in the high sense of the term. Of course, if the work survived for two thousand years, maybe it would turn out differently. Time loves to play that trick. "Those cave paintings in France might have just been a shopping list," Dik Browne once told me. Now they're a World Heritage site.

Whatever it was they were creating—art form, art, Art, ottwoik, or something else entirely—cartoonists did want to see the work preserved, as increasingly it has been. Many thousands of original strips from the Connecticut School repose in the cavernous vaults of the Billy Ireland Cartoon Library & Museum, at The Ohio State University, along with hundreds of thousands of other original strips and more than two million clippings and color pages from the newspapers in which they appeared. The strips lie in banks of flat files. The metal drawers are wide

and thin, and you can read the labels—*Steve Canyon, Original Sunday Panels, 1957–1958*; *Eugene Craig, Editorial Cartoons, 1961–1968*—as you walk the narrow aisles of the repository. Temperature and humidity are under tight control. The drawers slide out clinically and protective coverings are pulled back—yes, that's her, that's *Juliet Jones*—then noiselessly slide back in.

I once visited a museum that provides a final home for ventriloquist dummies after their owners retire or pass on. In a large room the dummies sit on theater seats by the hundreds, never to speak again. But comic strips can speak, and when they do, they speak in the language of their time. Historians and anthropologists will consult them one day—indeed, they already do. And I consult them, too. In my own little museum, scattered about the house, I have pen nibs, inkwells, brushes, and dried-out tubes of paint scavenged from the old studio. I have pencils my father last sharpened and erasers last kneaded by his fingers. And of course I have his drawing table. On walls or in drawers I keep scores of original strips by members of the Connecticut School along with yellowing sketches dashed off for an imploring youngster on Sports Night or at the Reuben Awards, or on visits to the bullpen at King Features.

A world still lives in all these bits and pieces. It is one where *Beetle*'s Sarge eternally yells "%$!!&#!!" and where Chuck Saxon's exurban gentry sip inexhaustible third Manhattans. Where the black footprints of the *Family Circus* kids loop aimlessly forever around the neighborhood and where Trixie of *Hi and Lois* is trapped in time with her unutterable insights. Where unseen characters scheme and seduce behind the walls of talking buildings, and thought balloons containing only a "!" or a "?" add endless mystery to *Rip Kirby* and *The Phantom*. It is a world where Prince Valiant's duel with Mordred never concludes, Ming is forever Merciless, and none of the men have nipples.

And where, in a stack of Polaroids bound in rubber bands, the long ago is never far away.

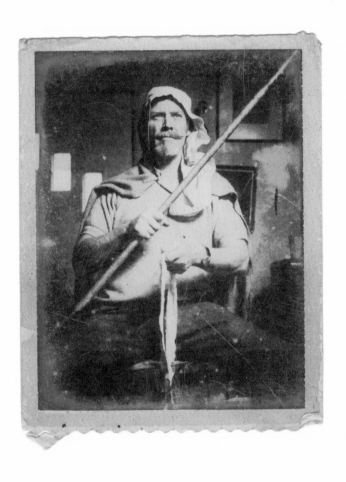

NOTES

THE CONNECTICUT SCHOOL

1. The historian Ron Goulart recalled some of its members in an eight-part series published over the course of 2016. The series began with Goulart, "Connecticut Cartoonists #1: The Alex Raymond Circle," *The Comics Journal*, January 28, 2016, http://www.tcj.com/connecticut-cartoonists-1 -the-alex-raymond-circle/.

2. A. S. Hamrah, "The Beckett/Bushmiller Letters," *The American Reader*, http://theamericanreader.com/the-beckettbushmiller-letters/. The correspondence originally appeared in *Hermenaut* no. 15, 1999.

3. Mort Walker, interview with the author, August 2013.

4. Dik Browne, interview with the author, July 1974.

5. Brian Walker, "The Dik Browne Story," in Dik Browne, *The Best of Hägar the Horrible*, ed. Brian Walker (New York: Henry Holt, 1985).

6. Sarah Boxer, "A Gaggle of Cartoonists, but It's Not All Smiles," *New York Times*, February 14, 2000.

7. James Stevenson, interview with the author, December 2015.

8. Matthew J. Bruccoli, *The O'Hara Concern: A Biography of John O'Hara* (New York: Random House, 1975), 172.

9. The accident and the events leading up to it are recounted in a number of sources. One comprehensive account, and one of the best and most detailed accounts overall, can be found in Brian Walker, "He Was Completely Absorbed with *Rip* and Seeking His Own Pleasures," introduction to Alex Raymond, *Rip Kirby: The First Modern Detective*, vol. 4, ed. Dean Mullaney (San Diego: IDW Publishing, 2011). See also Arlen Schumer, "Alex Raymond's Last Ride," *Hogan's Alley*, March 2012 (reprinted from *Hogan's Alley* 3). Other information, about events before and after the accident, was provided by Jerry Dumas, interview with the author, August 2013.

10. Randy Kennedy, "The Draw of a Mail-Order Art School," *New York Times*, March 20, 2014.

11. James E. B. Breslin, *Mark Rothko: A Biography* (Chicago: University of Chicago Press, 1993), 61.

12. Armando Mendez, "A Place in the Sun: Stan Drake and *The Heart of Juliet Jones*," in Stan Drake and Elliot Caplin, *The Heart of Juliet Jones: Dailies*, vol. 1, ed. Charles Pelto (River Forest, IL: Classic Comics Press, 2009), 12, 16.

13. Letter from Jerry Dumas to the author, August 2013.

14. See, for instance, Jack Wasserman, *Michelangelo's Florence Pietà* (Princeton, NJ: Princeton University Press, 2002).

15. George Bridgman, *Constructive Anatomy* (London: The Bodley Head, 1920), 12.

16. Mort Walker, interview with the author, August 2013.

17. A full account of this episode can be found in Cullen Murphy, "Deliverance," *The Atlantic Monthly*, November 1987, 22–23.

18. "Newspaper Circulation Volume," Newspaper Association of America, March 2015.

19. *Statistical Abstract of the United States*, Bureau of the Census (Washington, D.C., 1999), 874.

20. Mort Walker, *Mort Walker's Private Scrapbook: Celebrating a Life of Love and Laughter* (Kansas City, MO: Andrews McMeel, 2000), 154.

21. Neal Thompson, *A Curious Man: The Strange & Brilliant Life of Robert "Believe It or Not!" Ripley* (New York: Three Rivers Press, 2013), 255.

22. See John Cullen Murphy and Elliot Caplin, *Big Ben Bolt: Dailies*, vol. 1 (River Forest, IL: Classic Comics Press, 2010).

23. Brian Walker, "The Cartoonists' Cartoonist," in Dik Browne, *The Best of Hägar the Horrible*, ed. Brian Walker (New York: Henry Holt, 1985).

24. Joseph P. Mastrangelo, "Treasured Castoffs and the King," *Washington Post*, November 14, 1981.

25. Jeet Heer, "Pulp Propaganda," *The New Republic*, November 2015, 55–59.

HOME AWAY FROM HOME

1. There are many fine illustrated histories of classic comic strips and cartoons. They include Brian Walker, *The Comics: The Complete Collection* (New York: Abrams ComicArts, 2011); Bill Blackbeard, *The Smithsonian Collection of Newspaper Comics* (Washington, D.C.: Smithsonian Institution Press, 1977); Jerry Robinson, *The Comics: An Illustrated History of Comic Strip Art* (Milwaukie, OR: Dark Horse Comics, revised edition 2011); and *King of the Comics: One Hundred Years of King Features*, ed. Dean Mullaney (San Diego: IDW Publishing, 2015). See also Maurice Horn, *The World Encyclopedia of Comics* (New York: Chelsea House, 1976); and Steve Duin and Mike Richardson, *Comics Between the Panels* (Milwaukie, OR: Dark Horse Comics, 1998). The magazines *Hogan's Alley* and *The Comics Journal* are continual sources of sharp criticism and historical investigation. *Nemo: The Classic Comics Library*, a magazine published in the 1980s, is always worth revisiting.

2. Don Markstein, "The Gumps," *Toonopedia*, http://www.toonopedia.com
/thegumps.htm. "Crash Kills Cartoonist Sidney Smith," *Chicago Tribune*,
October 21, 1935.

3. Helen M. Staunton, "History Page Evolves from Hearst Memo" (originally
published in 1947), *Stripper's Guide* (blog), posted May 14, 2007.

4. Maurice Horn, ed., *100 Years of American Newspaper Comics: An Illus-
trated Encyclopedia* (New York: Gramercy, 1996), 55–56.

5. Robert C. Harvey, "Raymond, Alex," *American National Biography On-
line*, http://www.anb.org/articles/16/16-01350.html. See also Harvey,
"Alex Raymond: Becoming a Cartoonist," *The Comics Journal*, September
15, 2016, http://www.tcj.com/alex-raymond-becoming-a-cartoonist.

6. Robert C. Harvey, *Meanwhile . . . : A Biography of Milton Caniff, Creator of
Terry and the Pirates* (Seattle: Fantagraphics, 2007), 122–23.

7. Bob Dunn, *Knock Knock Who's There?* (Racine, WI: Whitman, 1936).

8. "Syndicate Production Chief: Frank Chillino," *Cartoonist PROfiles*, Decem-
ber 1990.

9. Testimony Before the Senate Subcommittee to Investigate Juvenile Delin-
quency, April 21, 1954, https://archive.org/stream/juveniledelinque54unit
/juveniledelinque54unit_djvu.txt.

10. Bill Amend, *FoxTrot* comic strip, July 17, 2005.

11. "The Press: Tain't Funny," *Time*, September 29, 1947.

12. Cullen Murphy, "Ms. Buxley?" *The Atlantic Monthly*, December 1984.

13. Interview with Bud Sagendorf, "Comics Join New Topics with Old Favor-
ites," *Abilene Reporter-News*, January 7, 1973.

14. Jeet Heer, "A Cat-and-Mouse Game of Identity," *Toronto Star*, December
11, 2005. Herriman is the subject of an acclaimed recent biography: Mi-
chael Tisserand, *Krazy: George Herriman, a Life in Black and White* (New
York: Harper, 2016).

15. The strip is reproduced on the blog *Smurfswacker*, "Comics and Censorship:
You Can't Say That!" September 13, 2013, http://smurfswacker.blogspot
.com/2013/02/comics-and-censorship.html.

16. An example of censorship by an Arab-language newspaper can be found in
Mort Walker, *Mort Walker's Private Scrapbook: Celebrating a Life of Love
and Laughter* (Kansas City, MO: Andrews McMeel, 2000), 157. See also
Cullen Murphy, "Ms. Buxley?"

17. Martin Sheridan, *Comics and Their Creators: Life Stories of American Car-
toonists* (Westport, CT: Hyperion, 1977), 21.

18. Peter and Tanner Saxon, son and daughter-in-law of Charles Saxon, inter-
view with the author, November 2016.

19. "The Hirschfeld Century: An Interview with David Leopold," New-York
Historical Society, May 15, 2015, available at http://behindthescenes
.nyhistory.org/the-hirschfeld-century.

20. Brian Walker, interview with the author, August 2013.

21. Martin Sheridan, *Comics and Their Creators*, 287.

22. James Stevenson, *The Life, Loves and Laughs of Frank Modell* (Raleigh, NC:
Lulu Press, 2013), 46; Michael Maslin, "James Stevenson's Secret Job at *The
New Yorker*," *Inkspill* (blog), posted May 18, 2013.

23. James Stevenson, interview with the author, December 2015.

24. Ben Yagoda, *About Town: The New Yorker and the World It Made* (New York: Scribner, 2000), 63; R. C. Harvey, "Otto Soglow and the Little King: The Silent Runs Deep," *The Comics Journal*, August 12, 2015.

25. Brian Walker, "Creating Hägar," in Dik Browne, *The Best of Hägar the Horrible*, ed. Brian Walker (New York: Henry Holt, 1985).

26. Jud Hurd, *Cartoon Success Secrets: A Tribute to 35 Years of CARTOONIST PROfiles* (Kansas City, MO: Andrews McMeel, 2004), 122–23.

27. Ibid., 127.

28. Steve Duin and Mike Richardson, *Comics: Between the Panels* (Milwaukie, OR: Dark Horse Comics, 1998), 45.

29. Susan Zalkind, "Grandfather of the Selfie," *The Baffler* 29, 2015. Richard B. Woodward, "Norman Rockwell's Neighborhood," *Smithsonian*, December 2009.

30. Stan Drake and Elliot Caplin, *The Heart of Juliet Jones: Dailies*, vol. 1, ed. Charles Pelto (River Forest, IL: Classic Comics Press, 2009), 16.

31. The same point about Sterne has been made by the Belgian comics historian Thierry Smolderen, who refers to Sterne's playful diagrams as "literary arabesques." Thierry Smolderen, translated by Bart Beaty and Nick Nguyen, *The Origins of Comics: From William Hogarth to Winsor McCay* (Jackson, MS: University Press of Mississippi, 2014), 48–50.

THE ART OF WAR

1. Stan Drake and Elliot Caplin, *The Heart of Juliet Jones: Dailies*, vol. 1, ed. Charles Pelto (River Forest, IL: Classic Comics Press, 2009), 11.

2. Robert C. Harvey, "Breger, Dave," *American National Biography Online*. See also "The Press: Cartoonist Soldiers," *Time*, April 5, 1943.

3. Ron Goulart, "World War II Gave Rise to Numerous Comic Strips and Brought Fame to the Artists Who Drew Them," *World War II*, September 1996.

4. Mort Walker, *Mort Walker's Private Scrapbook: Celebrating a Life of Love and Laughter* (Kansas City, MO: Andrews McMeel, 2000), 48.

5. Macy Halford, "An Artist's War," *The New Yorker*, December 5, 2011.

6. Jerry Dumas recounted Saxon's story; interview with the author, August 2013.

7. "The Passing of a Giant: Roy Doty, 1922–2015," *The Comics Journal*, March 27, 2015.

8. Sarah Lyall, "Charles M. Schulz, 'Peanuts' Creator, Dies at 77," *New York Times*, February 14, 2000.

9. Alan Gardner, "Mel Casson Passes Away at Age 87," *The Daily Cartoonist* (blog), May 30, 2008.

10. R. C. Harvey, "A Ringmaster Dies: Bil Keane, 1922–2011," *The Comics Journal*, November 16, 2011, http://www.tcj.com/a-ringmaster-dies-bil-keane-1922-2011/.

11. Inside cover, *United States Marine Corps Headquarters Bulletin*, December 1944.

12. Brian Walker, "The Dik Browne Story," in Dik Browne, *The Best of Hägar the Horrible*, ed. Brian Walker (New York: Henry Holt, 1985).

13. Jeet Heer, "Pulp Propaganda," *The New Republic*, November 2015, 54–59.

14. Caniff also turned over the profits from a published collection of the cartoons to the Army Relief Fund. R. C. Harvey, *Meanwhile . . . : A Biography of Milton Caniff, Creator of Terry and the Pirates* (Seattle: Fantagraphics, 2007), 484.

15. The diaries and letters—along with many notebooks, sketchbooks, and individual pencil drawings and watercolors—are held in the Anne S. K. Brown Military Collection of the John Hay Library, Brown University, Providence, Rhode Island.

CONDUCT UNBECOMING

1. The story of Johnstone and Cushing has been comprehensively and entertainingly told by the writer, editor, and historian Tom Heintjes, and much of the information here comes from his work. See Tom Heintjes, "Funny Business: The Rise and Fall of Johnstone and Cushing," *Hogan's Alley* 10, September 2012. Recollections of life at Johnstone and Cushing also turn up regularly in interviews conducted by Jud Hurd (for instance, with Drake and Browne) for his *Cartoonist PROfiles*.

2. Steve Duin and Mike Richardson, *Comics: Between the Panels* (Milwaukie, OR: Dark Horse Comics, 1998), 244.

3. Stan Drake and Elliot Caplin, *The Heart of Juliet Jones: Dailies*, vol. 1, ed. Charles Pelto (River Forest, IL: Classic Comics Press, 2009), 12.

4. Brian Walker, "The Dik Browne Story," in Dik Browne, *The Best of Hägar the Horrible*, ed. Brian Walker (New York: Henry Holt, 1985).

5. State of Connecticut, 1950 Census, Connecticut State Library, Hartford, Connecticut.

6. John Christoffersen, "United versus United Nations," *Los Angeles Times*, January 9, 2004.

7. "Ask the Archivist: Genesis Hi and Lois," *Comics Kingdom* (blog), October 9, 2014.

8. *Cover Story: The New Yorker in Westport*, exhibit at the Westport Historical Society, Westport, Connecticut, January–April 2014.

9. R. C. Harvey, "Tales of the Founding of the National Cartoonists Society," part one of three, *The Comics Journal*, June 7, 2010.

10. "'Joe Palooka' Hanging Up His Gloves at 54," *New York Times*, November 25, 1984.

11. Al Capp, "I Remember Monster," *The Atlantic Monthly*, April 1950, 54–57.

12. Sam Tweedle, "Ham Fisher vs. Al Capp," *Confessions of a Pop Culture Addict* (blog), October 1, 2011; Elliot Caplin, *Al Capp Remembered* (Bowling Green, OH: Bowling Green State University Popular Press, 1994), 75.

13. Michael Schumacher and Denis Kitchen, *Al Capp: A Life to the Contrary* (New York: Bloomsbury, 2013), 172. See also Elliot Caplin, *Al Capp Remembered* (Bowling Green, OH: Bowling Green State University Popular Press, 1994), 71–75; and Steven Heller, "Just How Bitter, Petty, and

Tragic Was Comic-Strip Genius Al Capp?," *Atlantic Monthly*, February 28, 2013, https://www.theatlantic.com/entertainment/archive/2013/02/just-how-bitter-petty-and-tragic-was-comic-strip-genius-al-capp/273595/.

14. Some of the subgroups are identified in Ron Goulart's "Connecticut Cartoonists" series in *The Comics Journal*, which began in January 2016: http://www.tcj.com/connecticut-cartoonists-1-the-alex-raymond-circle.

15. Fran Sikorski, "The Fairfield County Irregulars," *Ridgefield Press*, Weekend Magazine, February 22–23, 1989, 1.

16. Mort Gerberg, *Cartooning: The Art and the Business* (New York: William Morrow, 1989), 18.

17. Ibid.

18. Judith Martin, "Cartoonists' Elite: Clubby Lunches and Just One Stop . . . Where Gags Are 'Ideas,'" *Washington Post*, January 23, 1972.

19. Gerberg, *Cartooning*, 19.

20. Andreï Makine, *The Life of an Unknown Man*, trans. Geoffrey Strachan (Minneapolis: Graywolf Press, 2010), 78.

21. Testimony Before the Senate Subcommittee to Investigate Juvenile Delinquency, April 21, 1954, https://archive.org/stream/juveniledelinque54unit/juveniledelinque54unit_djvu.txt.

22. Jud Hurd, *Cartoon Success Secrets: A Tribute to 35 Years of CARTOONIST PROfiles* (Kansas City, MO: Andrews McMeel, 2004), 126.

23. The story is told in Thomas Heintjes, "Funny Business," *Hogan's Alley* 10, September 2010.

24. Hurd, *Cartoon Success Secrets*, 189.

25. Jerry Dumas, interview with the author, August 2013.

26. Mort Walker, interview with the author, August 2013.

27. The feature's short life is captured in its entirety in Mort Walker and Jerry Dumas, *Sam's Strip: The Comic About Comics* (Seattle: Fantagraphics Books, 2009).

28. Hurd, *Cartoon Success Secrets*, 185.

29. Drake explained some of his techniques in a 1969 interview. See Jud Hurd, *Cartoon Success Secrets* (Kansas City, MO: Andrews McMeel, 2004), 70–81. The use of talking buildings by Drake is discussed in Eddie Campbell (blog), "'Look,' Browne said, 'St Patrick's day is coming up. You're taking a pill that is turning your urine blue . . . ,'" http://eddiecampbell.blogspot.com/2007/03/look-browne-said-st-patricks-day-is.html.

30. Hurd, *Cartoon Success Secrets*, 77.

31. Edward Sorel, "It Was Nice," *American Heritage* 48:7, November 1997.

32. Peter and Tanner Saxon, interview with the author, November 2016.

33. Jerry Dumas, interview with the author, August 2013.

34. Glenn Collins, "Charles Saxon, 68, a Cartoonist for 92 Covers of *The New Yorker*," *New York Times*, December 7, 1988.

INDIAN SUMMER

1. Virginia Irwin, "Man Who Draws Prince Valiant," *St. Louis Post-Dispatch*, February 6, 1949, reprinted in *Stripper's Guide* (blog), May 1, 2014. Bio-

graphical and other information about Foster and his background, as set out in this paragraph, derives from a number of sources—Foster has been profiled in many books and articles. Among the best of the books are Brian Kane's *The Definitive Prince Valiant Companion* (Seattle: Fantagraphics Books, 2009) and *Hal Foster: Prince of Illustrators, Father of the Comic Strip* (Lebanon, NJ: Vanguard, 2001). Equally informative but with a different focus is Gary Gianni, *The Prince Valiant Page* (Santa Cruz: Flesk, 2008). See also Arn Saba, "Drawing Upon History," *The Comics Journal* 102 (September 1985); and Richard E. Marschall, "The Master, Hal Foster," *Nemo* 9 (October 1984).

2. Steve Donoghue, "Prince of a Lost Realm," *Open Letters Monthly*, September 1, 2009, http://www.openlettersmonthly.com/book-review-prince-valiant-vol-hal-foster.

3. Robby Reed, "Pages from EERIE #13, reprinting a story from CREEPY #1, by Archie Goodwin and Al Williamson," *Dial B for Blog* (blog), September 2007, dialbforblog.com.

4. Jerry Dumas, interview with the author, August 2013.

5. "Brian Walker, Greg Walker, and Chance Browne on *Hi and Lois*," in Jud Hurd, *Cartoon Success Secrets* (Kansas City, MO: Andrews McMeel, 2004), 233–42. See also Brian Walker, "Creating Hägar," in Dik Browne, *The Best of Hägar the Horrible*, ed. Brian Walker (New York: Henry Holt, 1985).

6. Lynne Baranski, "Cartoonist Bud Sagendorf Takes Popeye into His 51st Year," *People*, February 4, 1980, 96.

7. Laura Cumming, "Facing the Truth About Portraiture," *Guardian*, November 15, 2006.

8. Liza Donnelly, "Look Day for Cartoonists at *The New Yorker*," lizadonnelly.com, posted June 14, 2012.

9. Mort Walker, *Mort Walker's Private Scrapbook: Celebrating a Life of Love and Laughter* (Kansas City, MO: Andrews McMeel, 2000), 217.

10. "Newspaper: Circulation by Publication Type," Pew Research Center, 2015.

11. Robert Ito, "The Making of Daniel Clowes and a Golden Age for Comics," *California Sunday Magazine*, February 7, 2016, 54–63.

12. "Beetle Bailey Rebooted as 'Sexy, Ultra-Violent Noir Graphic Novel,'" *Duffel Blog*, December 22, 2013.

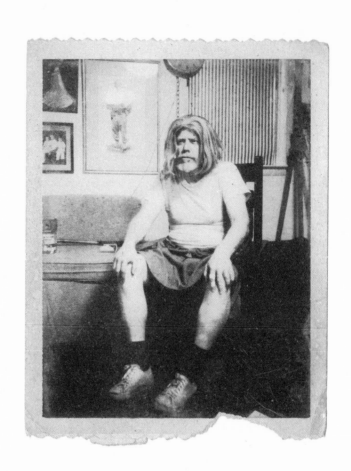

ACKNOWLEDGMENTS

This book owes its existence to decades of family life. My mother and my brothers and sisters gave generously of their memories and their time. They read drafts of the book and rooted around in basements and attics for drawings and documents. Above all, they are my family, and they share in this story. The book is dedicated to them.

Graydon Carter, the editor of *Vanity Fair*, got the book rolling by encouraging me to write for the magazine about the community of cartoonists that formed the background to my childhood. I'm grateful to him for that and for a great deal more. Brian Walker, Mort Walker's son, whom I have known for most of my life, has been an adviser and sounding board on this project almost from the start. Brian is a prominent historian of comic strips and he writes *Hi and Lois*. Sixty years ago we attended each other's fifth-birthday parties.

Mort Walker, now ninety-four, is among the last of his generation of cartoonists; on many occasions over the years, he put time aside to talk with me about his life and work. So did Jerry Dumas, who passed away in 2016, not long after sending me a series of long, funny handwritten notes (with drawings) about topics I raise in the book. Others associated with the world of cartoons and comic strips who provided help and counsel include Chance Browne, Gail Dumas, Tim Dumas, Rick Marschall, Peter and Tanner Saxon, Edward Sorel, Josie Merck, the late James Stevenson, and Greg Walker. Brian Kane, an art historian who has written extensively about *Prince Valiant* and whose knowledge of comics is both broad and deep, never failed to surprise me with what he could pull from his memory or his files. He was also ready at all times to lend a hand on short notice. Gary Gianni, the illustrator who first took over *Prince Valiant* from my father, has also written about the strip, and he gamely hunted down photographs on my behalf.

Many friends and colleagues read versions of the book at various stages:

Katherine Bang, David Friend, Toby Lester, Mark London, Cullen Nutt, Mark Rozzo, Martha Spaulding, Douglas Stumpf, Scott Turow, and Charles True-heart. And I am indebted to Melissa Goldstein, Sarah Grogan, Bob Hayes, and Cary Sleeper. They shouldered a variety of responsibilities: taking pictures, making scans, tracking down permissions, handling logistics.

Gathering illustrations for the book served as a welcome reminder that institutions are not faceless. Brendan Burford, the general manager for syndication at King Features, provided essential help, and I'm grateful as well to his colleagues Claudia Smith and Scott Olsen. Most of my father's wartime drawings and paintings are preserved in the Anne S. K. Brown Military Collection at Brown University's John Hay Library. Peter Harrington, the curator, put me back in touch with this material and arranged for its reproduction. Susan Zalkind, of Boston, is the great-great-great-granddaughter of the influential *Punch* cartoonist Edward Linley Sambourne, and she made the introduction to Sam Butler and Shirley Nicholson at 18 Stafford Terrace—Sambourne's home in London, now open to the public. Butler and Nicholson provided some extraordinary photographs. The greatest repository of cartoons and comics in the world is the Billy Ireland Cartoon Library & Museum at The Ohio State University, and the staff there was uniformly knowledgeable, efficient, friendly, and patient. Susan Liberator, the librarian and an associate curator, proved to be an unerring guide, as well as a skilled detective, over a period of many months. I would add my thanks to Jenny Robb, the curator of the Library & Museum; Caitlyn McGurk, an associate curator; and Marilyn Scott, an assistant curator.

Jonathan Galassi, the editor of this book, provided shrewd advice both about the nature of the writing and about the design of the presentation. It made all the difference. I'm grateful for the work of the entire team at Farrar, Straus and Giroux—particularly Carolina Baizan, Karla Eoff, Jonathan Lippincott, Jeff Seroy, Rob Sternitzky, Scott Auerbach, and Stephen Weil—and for the guidance of my agent and longtime friend Rafe Sagalyn.

My wife, Anna Marie, has always been my first reader and best editor. As noted elsewhere, she inspired an enduring character in *Prince Valiant*—the redoubtable Maeve, wife of Prince Arn. In life as in the funny pages, her husband just tries to keep up.

—Boston, 2017

INDEX

Page numbers in *italics* refer to illustrations.

Unless otherwise indicated, images are from the author's collection.

Pages 8–9, *Big Ben Bolt*, © King Features Syndicate, Inc., world rights reserved. Page 14: Courtesy of Mort Walker and the family of Jerry Dumas, used by permission. Page 20: Courtesy of Mort Walker, used by permission. Page 21, top: Courtesy of James Stevenson, used by permission. Page 21, bottom: Photograph © SEPS, licensed by Curtis Licensing, Indianapolis, Indiana. Page 22: The Ohio State University, Billy Ireland Cartoon Library & Museum. Page 23, top: Herbert Gehr/The LIFE Picture Collection/Getty Images. Page 23, bottom: The Ohio State University, Billy Ireland Cartoon Library & Museum. Page 28: Reprinted by permission of the Norman Rockwell Family Agency; © the Norman Rockwell Family Entities. Illustration provided by Curtis Licensing. Page 30: George Bridgman, *Constructive Anatomy*. Page 32: Courtesy of the family of Jerry Dumas, used by permission. Page 33: Courtesy of Mort Walker and the family of Dik Browne, used by permission. Pages 42–45: The Ohio State University, Billy Ireland Cartoon Library & Museum. Page 46: Courtesy of the Charles M. Schulz Museum and Research Center, Santa Rosa, California. Page 47: Courtesy of Mort Walker, used by permission. Pages 48–49: *Big Ben Bolt*, © King Features Syndicate, Inc., world rights reserved. Page 50, top: *Hi and Lois*, © King Features Syndicate, Inc., world rights reserved. Page 50, bottom: Photograph by Chance Browne; courtesy of the family of Dik Browne, used by permission. Pages 52–53, *The Heart of Juliet Jones*, © King Features Syndicate, Inc., world rights reserved. Page 54, top: *The Little King*, © King Features Syndicate, Inc., world rights reserved. Page 54, bottom: Milton Caniff Collection, The Ohio State University, Billy Ireland Cartoon Library & Museum. Page 56: *Prince Valiant*, © King Features Syndicate, Inc., world rights reserved. Pages 58–59: *Prince Valiant*, © King Features Syndicate, Inc., world rights reserved. Page 60: The Ohio State University, Billy Ireland Cartoon Library & Museum. Page 62: Photograph by Victoria Garagliano/© Hearst Castle®/CA State Parks. Page 64: James Montgomery Flagg. Page 65: Milton Caniff Collection, The Ohio State University, Billy Ireland Cartoon Library & Museum. Page 66: Bettman/Getty Images. Page 67: *Big Ben Bolt*, © King Features Syndicate, Inc., world rights reserved. Page 68: Walt Kelly Collection, The Ohio State University, Billy Ireland Cartoon Library & Museum. Page 69: Courtesy of Mort Walker, used by permission. Page 70: *Big Ben Bolt*, © King Features Syndicate, Inc., world rights reserved. Page 72: Martin Sheridan, *Comics and Their Creators* (Boston: Cushman and Flint, 1942; Westport, CT: Hyperion, 1971). Page 73: Courtesy of Mort Walker, used by permission. Page 74: Reprint courtesy of Classic Cool/Milton Caniff Estate. © 2017 Classic Cool/Milton Caniff Estate. All rights reserved. Page 75: Photograph copyright © The Harold R. Foster Estate, and appears with the estate's permission. Page 76: *Sam and Silo*, © King Features Syndicate, Inc., world rights reserved. Page 79: Courtesy of the family of Dik Browne, used by permission. Page 81: Otto Soglow/The New Yorker Collection/The Cartoon Bank. Page 83, top left and right: Memorial Art Gallery of the University of Rochester; photograph courtesy of Dartmouth College Library. Page 83, bottom left and right: Reprinted by permission of the Norman Rockwell Family Agency; © the Norman Rockwell Family Entities; Norman Rockwell Museum Digital Collection. Page 84: Courtesy of 18 Stafford Terrace (Linley Sambourne House), Kensington, London. Page 86: *Sam's Strip*, © King Features Syndicate, Inc., world rights reserved. Page 92: *Prince Valiant*, © King Features Syndicate, Inc., world rights reserved. Page 94: Laurence Sterne, *The Life and Opinions of Tristram*

Shandy, Gentleman (London: T. Becket and P. A. Dehondt, 1762). Pages 98–99: Anne S. K. Brown Military Collection, John Hay Library, Brown University. Page 100: Courtesy of Mort Walker, used by permission. Page 102: Courtesy of Joseph G. Farris, used by permission. Page 103: Courtesy of Peter and Tanner Saxon, used by permission. Page 105: Courtesy of the family of Dik Browne, used by permission. Pages 106–107: Anne S. K. Brown Military Collection, John Hay Library, Brown University. Page 112: Courtesy of Joan Byrne Murphy, used by permission. Pages 114–17: Anne S. K. Brown Military Collection, John Hay Library, Brown University. Page 119: Anne S. K. Brown Military Collection, John Hay Library, Brown University. Pages 121–23: Anne S. K. Brown Military Collection, John Hay Library, Brown University. Page 127, top: Courtesy of Joan Byrne Murphy, used by permission. Pages 131–33: Anne S. K. Brown Military Collection, John Hay Library, Brown University. Page 136: Anne S. K. Brown Military Collection, John Hay Library, Brown University. Pages 139–40: Anne S. K. Brown Military Collection, John Hay Library, Brown University. Pages 142–43: *Prince Valiant*, © King Features Syndicate, Inc., world rights reserved. Page 144: Courtesy of Joan Byrne Murphy, used by permission. Page 146: Milton Caniff Collection, The Ohio State University, Billy Ireland Cartoon Library & Museum. Page 147: Bristol-Myers Squibb Company. Page 149: Courtesy of Cait Murphy, used by permission. Page 152: The Ohio State University, Billy Ireland Cartoon Library & Museum. Page 154: Artwork copyright © and TM Rube Goldberg Inc. All rights reserved. RUBE GOLDBERG ® is a registered trademark of Rube Goldberg Inc. All materials used with permission. rubegoldberg.com. Page 155, bottom: The Ohio State University, Billy Ireland Cartoon Library & Museum. Page 159, top: Courtesy of the family of Dik Browne, used by permission. Page 163: Bernard Hoffman/ The LIFE Picture Collection/Getty Images. Page 164: The Ohio State University, Billy Ireland Cartoon Library & Museum. Page 167: Courtesy of Joan Byrne Murphy, used by permission. Page 169: Courtesy of Joan Byrne Murphy, used by permission. Page 171: National Cartoonists Society. Page 172: *Hägar the Horrible*, © King Features Syndicate, Inc., world rights reserved. Page 175: Courtesy of Mort Walker, used by permission. Page 177: Courtesy of Tim Dumas, used by permission. Page 179: Courtesy of Mort Walker, used by permission. Page 180, top and bottom: Courtesy of the Jerry Dumas family, used by permission. Pages 181–82: *Sam's Strip*, © King Features Syndicate, Inc., world rights reserved. Page 183: Courtesy of Mort Walker, used by permission. Page 184, top and bottom: *The Heart of Juliet Jones*, © King Features Syndicate, Inc., world rights reserved. Page 185, top: *The Heart of Juliet Jones*, © King Features Syndicate, Inc., world rights reserved. Page 186: Courtesy of Peter and Tanner Saxon, used by permission. Pages 190–91: Courtesy of Joan Byrne Murphy, used by permission. Page 192: *Prince Valiant*, © King Features Syndicate, Inc., world rights reserved. Page 195: Photograph copyright © The Harold R. Foster Estate, and appears with the estate's permission. Page 199: *Creepy*, © 2017 New Comic Company. Pages 205–207: *Prince Valiant*, © King Features Syndicate, Inc., world rights reserved. Pages 208–209: Murphy family collection. Page 210: *Prince Valiant*, © King Features Syndicate, Inc., world rights reserved. Page 212: *Prince Valiant*, © King Features Syndicate, Inc., world rights reserved. Page 217: *Prince Valiant*, © King Features Syndicate, Inc., world rights reserved. Page 218: *Prince Valiant*, © King Features Syndicate, Inc., world rights reserved. Page 222: *Prince Valiant*, © King Features Syndicate, Inc., world rights reserved. Page 224: Courtesy of Mort Walker, used by permission. Page 226: Murphy family collection. Page 229: Courtesy of Joan Byrne Murphy, used by permission.